WINONA RYDER

THE BIOGRAPHY

Nigel Goodall

Andrews UK Limited

Contents

For my daughter Kim, with love.

And for those who adore the talent of an enduring star.

About the Author

Nigel Goodall wrote *Winona Ryder: The Biography*, the first British biography of the American Actress, in 1998. It was nominated for the Samuel Johnson Prize for Non-Fiction, became a *Daily Telegraph* bestseller, and the source for several major TV documentaries transmitted in the UK, USA and Canada. The book also won Nigel recognition as Winona's key biographer. Now long out of print, this digital edition has been completely revised by restoring passages cut out of the original manuscript together with the addition of new material.

Nigel is also the author of more than 20 books including several bestselling biographies of Johnny Depp, all of which have been translated into various languages throughout the world. Both *What's Eating Johnny Depp* and *The Secret World of Johnny Depp* still remain on his publisher's bestseller list.

Among the other biographies Nigel has written are Christian Slater, Demi Moore, Ray Winstone, David Tennant and Kylie Minogue. His Winona research archives serve as a primary resource for television, magazines and libraries.

Nigel, who has also written articles for magazines such as *Record Collector* and *TV Times,* lives in Sussex, England, from where he travels occasionally to New York, San Francisco and Los Angeles for research and author interviews.

Author's Note

From Original Print Edition

In August 1996, I asked Winona Ryder's publicist, Mara Buxbaum, whether Winona would be interested in cooperating with a biography to be published in the landmark year of her twentieth film, *Alien Resurrection*. Although the production process for one reason or another delayed publication, this biography is intended to reflect that benchmark of achievement as Winona celebrates her first decade in the entertainment industry.

Within a few days, Mara wrote me a polite refusal saying that Winona had a great deal more to do professionally, and that she was much too young to start thinking about a biography. Certainly both points are true. However, not since Natalie Wood has an American actress successfully maintained a screen career from adolescence to adulthood in the full glare of the Hollywood spotlight.

Although now barely into her mid-twenties, Winona Ryder has already cemented her reputation as one of the most admired and brightest young stars in Hollywood today. Her first starring role was only her second film ever and, since then, in little more than twelve years, she has established herself as the most significant and exciting actress of her generation.

Those who know me are aware that I did not need much persuasion to decide to go ahead with this book. For me, it has been a fascinating and worthwhile exercise both personally and professionally to study this very intriguing actress, a process that began from Winona's first moments on screen when I realised, as did the rest of the cinema-going public, that Winona Ryder was, and remains, someone to watch.

Nigel Goodall, April 1998

Acknowledgements

A book such as this cannot be completed without the help, patience and support of many people.

My love and thanks to my daughter Kim for her support and encouragement during the writing of this book; Hannah MacDonald for her suggestions; Robert Smith and my publisher John Blake for their confidence and commitment; my editors Charlotte Helyar and Sonya Perkins for their patience and understanding; Jon Davies for his creativity in designing the original print version (and Neil Rees for the striking cover of this digital edition); and Adam Parfitt for taking care of the nuts and bolts. Thanks too, to Greg Hatfield and Alison Denham at my American distributors, Seven Hills; and to Paul Andrews and Joe Larkins at my digital distributors, Andrews UK Limited.

Gratitude is most certainly due to Keith Hayward for his invaluable help with research as well as some lively debates on the merits of Winona's career (although he was wrong, of course, most of the time); to Peter Lewry for generously accessing so much useful material.

Organisations and individuals who helped out along the way were Kate Bradford and David Freed at Twentieth Century-Fox; Chris Warrington at Fox Pathe Home Entertainment; Nigel Flude at Polygram Filmed Entertainment; Charlotte Tudor at Corbett *& Keene*; Becky Goodrich at CIC; Stephen and Gwen at Video Searchers for turning up some of the early obscure stuff; Cheryl Newman at *Premiere* magazine; Joe Hipgrave at Index On Censorship for *The Crucible* UK Premiere material; Claire Thornton for getting me to the *Alien Resurrection* UK national press show; Matthew Knight at Public Eye Communications; Georgina O'Neil at Entertainment Films; Danielle Soupe at Columbia-Tristar; Hannah Whitlow at *Empire* magazine; Chris Samson and

Eric Reed at the *Petaluma Argus Courier*; Dr Kim Jamieson for the Petaluma School District; Paul Robinson at BMG for *The Crucible* soundtrack which became my constant companion during the research and writing of that chapter; Michael Wilson for generously locating an endless supply of cuttings, magazines and pictures; Neil Milner who very kindly sent me issues of his *Winona* fanzine, did his best to satisfy my demands for obscure information, and even tracked down a workprint copy of *Bram Stoker's Dracula*; Scott Coldwell who was equally generous for allowing me to sleuth his Winona collection of magazines, photographs and memorabilia; Stefan Fox and the staff at the Virgin Multiplex in Pevensey for their tireless hospitality every time Winona movies were on; Roy Galloway at Eastbourne's Curzon Cineplex for the one-day presentation of *Edward Scissorhands* and his invitation for me to introduce the movie at both showings; everyone who sat through *The Crucible* and *Alien Resurrection* with me countless times; and all those friends, colleagues and family who provided support and encouragement in various combinations and whose social circles I had to withdraw from during the writing of this book - no doubt their lives improved immeasurably as a consequence of not having to listen to my Winona-isms!

My very special gratitude is due to the Polly Klaas Foundation, the American Conservatory Theater, and the American Indian College Fund, all of whom confirmed some factual information, any surviving errors are, of course, entirely mine.

I would also like to thank those who maintain the following Internet sites for their often unsung research efforts; Eric Harshbarger's *Authorized Winona Ryder Site* (alas no more); *the Alt. Fan. Winona Ryder Newsgroup; Winona Ryder Illustrated;* Vicki McKay's *A Fan's Page for Johnny Depp*; Shaun Fleming's Glen Shadix official website; the *Internet Movie Database*; and *Demon Internet* services.

I would also like to thank the following magazines and newspapers for their coverage of Winona over the years, all of which I consulted during my research; *Sassy; Rolling Stone; Los Angeles Times; Premiere; San Francisco Examiner; San Francisco Chronicle; Petaluma Argus Courier; Life; Time; USA Today; The Guardian; Empire; Movieline; Film Review; Now; Flicks; Vogue; Hello; OK Weekly; Film & TV Week; Radio Times; Harpers & Queen; Daily Mail; Harpers Bazaar; Architectural Digest; The Observer; Chicago Sun-Times; The Sunday Times; The Independent; The Face; Sky Magazine; Buzz; Cinemascape; New Weekly; TV Hits; People; Entertainment Weekly; Elle; The Hollywood Reporter; Now; Starlog;* and *Marie Claire.* And thanks to all the journalists who have interviewed Winona, whose articles also formed a valuable part of my research.

I am also indebted to several books: *Totally Uninhabited: The Life and Wild Times of Cher,* Lawrence J Quirk (Robson, 1991); *The Virgin Encyclopaedia of the Movies* (Virgin, 1995); *Burton On Burton,* ed. Mark Salisbury (Faber & Faber, 1995); *Johnny Depp: A Modern Rebel,* Brian J Cobb (Plexus, 1996); *Keanu,* Sheila Johnston (Sidgwick & Jackson, 1996); *Winona Ryder,* Dave Thompson (Taylor Publishing Company USA, 1997); *The Winona Ryder Scrapbook,* Scott & Barbara Siegel (Citadel Press, 1997); *Alien Resurrection Scriptbook,* Joss Whedon (Titan Books, 1997); and *The Making of Alien Resurrection,* Andrew Murdock and Rachel Aberly (Titan Books, 1997).

And above all, thanks to Winona, for inspiring me to write this book and whose outstanding performances and public profile for more than half her life made it possible. I hope that she discovers her inspiration has been rewarded with a book which accurately and fairly sums up her life so far.

Goodbye To Being Good

'Playing cute and confused doesn't interest me anymore. I'm a grown woman and it's ridiculous that I still keep being offered these parts. I'm sick of being nice and I want everyone to know that.'

Backstage at the Dorothy Chandlier Pavilion in downtown Los Angeles, March 1996, Winona Ryder is still shaking from her walk along the red carpet near where the crowds have been gathering since dawn for a place close to their idols on the most important date of Hollywood's glamorous calendar. For the last hour or so, the stars have been arriving for the 69th Annual Academy Awards ceremony. Goldie Hawn had told her how to handle that sort of crowd, 'Turn your head and smile, but don't stop.'

Later Winona could recall how restless she had felt when presenting Bruce Springsteen to the Oscar audience. 'I was a nervous wreck!' she confessed, 'but that only lasted a couple of seconds.' Not even words of assurance from Anjelica Houston could ease her trepidation. 'You look so fabulous,' Anjelica told her. 'You have nothing to be nervous about.' Little more than five minutes later, Winona was crossing the vast Pavilion stage to the microphone centre-stage. 'It's certainly a tremendous honour for me to be here to introduce our next performer,' she paused for a second. 'Because he's a real hero of mine.'

Only miles away on the Twentieth Century Fox studio lot, west of Los Angeles, Winona had been preparing for the filming of her next film, *Alien Resurrection*, and probably trying not to think too much about the Oscars. If the thought had flitted through her mind at all, it was likely to be with a degree of disappointment. One review after another for her performance in *The Crucible* had

predicted an Oscar nomination. Even the buzz around Hollywood blazed much the same message.

As Abigail Williams in Nicholas Hytner's 1996 screen adaptation of Arthur Miller's play written in the 1950's and set during the witch-trials of 1692, she played a teenage servant girl who is spurned by her married lover and begins accusing innocent people of sorcery. For the first time in her career, Winona was playing the antagonist, desperate with lustful anger. 'I've always played the person that you root for,' she explained, 'the person who does the right thing. And to play someone who was responsible, in a way, for all those deaths, was a great challenge.'

But she did it with such demonic and hollow-eyed fierceness that her performance was also universally praised for its powerful portrayal of raw sexuality. 'It was great,' laughed Winona at the thought, 'because it was an opportunity to do it without taking my clothes off and getting sprayed with glycerine and roll around with somebody. To me, it was much more sexual than that. It was a different kind, very aggressive.' It was nevertheless, she continued, 'the best acting experience I have ever had. I can't remember raising my voice in a film before.'

However, perhaps Hollywood and the Academy voters didn't understand or appreciate her efforts as they would someone like Jodie Foster, who works from the outside in. Foster intellectualises a performance before internalising it. Winona does it the other way round. She works instinctively, then brings a creative intelligence to bear. With Winona, the effort doesn't show. She makes it look too easy. It is this that makes her method of the acting spectrum so fascinating.

'She brings a weight and believability that isn't inherent in a role, but she does it very naturally,' confirms Tim Burton, who had directed the actress in two of his movies. 'You don't see her working at it because her process remains invisible.' Winona agrees. 'I try to do things as naturally as possible. I hate rehearsing because I always

like to save everything for when I do it. I just try as much as I can to really be in the moment.'

For Winona, *The Crucible* was only one step in her resolve to shake off any last trace of her cute and adorable teenage typecasting while remaining both visible and successful. By landing a prominent role in the fourth instalment of the *Aliens* saga, she was finally distancing herself from her past – from all those teen roles that have been her signature ever since, aged thirteen, she sidled out of a crowd of teenage children in David Seltzer's *Lucas* and said 'Hi! How was your summer?' At the same time, though, Winona was completely re-establishing herself as loudly as she could, and how better than with *Alien Resurrection*. 'I'm finally out of corsets,' she joked, 'and speeding off into the next century.'

The story of *Alien Resurrection* takes place two hundred years after the conclusion of *Alien 3* and is set entirely on the Company ship 'Auriga,' which is held in deep space. The new Company clones the original Ellen Ripley and the queen alien inside her by splicing her DNA with that of the unborn predator. The new Ripley, the eighth in a series, is the result of a project to create a biological weapon for sale to the highest bidder.

Into this setting comes smugglers ship 'The Betty' carrying cargo of frozen humans to act as hosts for the hostile aliens. Their crew, one of whom is Winona's character, the ship's mechanic and an android named Call are accused of terrorism by the military personnel after she is discovered leaving Ripley's cell. Violence quickly breaks out between the two crews, and in the ensuing chaos, the captive alien specimens escape into the body of the 'Auriga,' now set on a course towards Earth.

Ripley joins up with the crew of 'The Betty' in a race against time to save themselves and to prevent the aliens reaching Earth. The remainder of the movie focuses on their journey through the 'Auriga' back to 'The Betty' with a spectacular underwater alien chase and another up an elevator shaft.

That underwater and elevator sequence commenced the filming of *Alien Resurrection* in November 1996, and represents one of the most challenging movie stunts, and 'the greatest of my entire career,' admits stunt co-ordinator, Ernie Orsatti. For Winona, it was equally courageous as she would overcome several fears that she had not faced since childhood. Fear of heights was one, but greater than that was her fear of water, since she was once pronounced dead in it as a child. She had an underwater near-death experience when she was only twelve years old.

She was at Dillon Beach in Northern California and got caught up on the undertow. 'It sounds very dramatic, but I was under for a long time. Luckily for me a lifeguard pulled me out. I didn't have a pulse and he had to pump the water out of my lifeless body.' For a few frightening moments, Winona had technically died from drowning. Besides that, there was another hazard at stake. 'I had cut school to go to the beach so it was a big deal.' And to complicate matters even more, Winona recalls, 'I was with my stoned friends, who were like, "Ooooh!" and freaking out.'

It was no surprise that Winona had not been underwater since. And although, as she herself explains, 'I'd jump into a pool, I could never force myself to stick my head under.' The studio understood her reluctance. They would simply hire a stunt double in her stead for the scenes through the sunken underwater set that depicted the flooded kitchen of the 'Auriga.' She was simply delighted. However, the idea fell through when Winona sporting a new haircut, cut fashionably short, almost tomboyish, made all the difference to any possible compromise. 'I cut my hair really short and when the director saw me, he said there was no way he could find a stunt double because my face was too exposed as a result of the cut.'

Horror quickly turned to panic as Winona launched into several weeks of training and crucial underwater practice in Hollywood's second largest constructed water tank. Aside from the pool holding 548,000 gallons of water at its lowest depth of thirteen feet, the

set took six days to fill and housed the cooling tower and elevator shaft, essential to the footage of the underwater escape sequence. Winona though, observed Billy Badalato, one of the film's three producers in charge of water safety, remembers how she 'required a lot of practice because this is not something that one normally does on off-time, or is required to do in other roles.'

Despite Winona's concern, she was already pushing herself through an exhausting exercise workout. Trainers Nancy Kennedy and Bobby Strom were recruited to prepare Winona for the physical side of her role. They introduced her to aqua aerobics, martial art boxing, scuba diving, and weight training, all of which, said Strom, 'were ultimately great new accomplishments for Winona.'

At the same time though, continued Kennedy, working out with Winona proved rewarding. 'She was very warm and very relaxed, whereas some celebs are tense and uptight. She would meet me in the morning feeling very low in energy and very sleepy, but by the time we were finished, she would be raring to go.'

But it wasn't, Winona vowed, the extensive preparation that was being reported in the popular press. 'I read that I was training eight hours a day or something ridiculous. I did the working out more for stamina than anything else.' Besides, she continues, 'I didn't want to be the scrawny, wheezy person in the background who wasn't able to keep up with the rest of the actors. Everybody was in such great shape, I thought people would laugh when they saw me, so I had to at least be strong to do some of my own stunts.'

More importantly, it taught Winona techniques for breathing underwater, to hold her breath sufficiently long enough to cross a scene to reach a safety diver. Probably thirty to forty seconds, which for someone fearful of water could be intensely alarming.

Still, with the aqua training, water safety sessions and the help of the on-set divers, Winona worked her way through the underwater filming without too many problems, even though it was, she openly admits, 'the worst physical experience of my entire

life, like literally, I thought I was going to die. I didn't think I was going to be able to do it.'

But she also knew that the role was completely removed from anything she had done in the past. For the first time, she would have to tackle combat and fight sequences. Something she had only touched upon in *Heathers* and *Edward Scissorhands*, but certainly nothing as arduous as she now faced. 'I had to do a lot of running, and a lot of climbing of ladders, and being dragged out of murky pits through flames.' That in itself demanded the training she put herself through, although by her own admittance, 'I have a pretty good metabolism, so I didn't go on a special diet.'

That is probably true. But according to Bobby Strom, 'Winona is not a natural athlete as she's very petite and in fairly good shape anyway, and only trains when her job demands it.' *Alien Resurrection* demanded it. But even then, confessed Winona, 'I'm not sure whether I'm entirely cut out for it. I mean, muscles look weird on me. I'm really small and don't have that kind of body.'

No less daunting was her first day in the water. 'We went in with weights on our feet so we would sink fast,' complained Winona as memories of that childhood experience welled painfully up. 'It was so dark in the tank that everyone around me was kicking. I was terrified, so I headed for the surface but most of the tank was covered so you had to find a hole to get out.'

Even more frightening, Winona continued, was the fact that 'I was gasping for breath, kicking and flailing. I finally got out and grabbed a metal bar.' There and then, she says, she determined that she never wanted to go back underwater. And she told them that. 'But a crew man warned me, "You could get electrocuted if you hang on to those bars," so it was either death by drowning or electrocution!'

Actual filming, Winona explains, was no less terrifying. 'You're holding your breath, and then you hear, "Action!" You start swimming, but you have boots and a costume holding you down.

When you run out of air, you have to make a signal and wait seven seconds for a diver to come and shove this tube in your mouth.' Although it does not appear to have affected her performance, Winona also had to contend with the additional obstacle of ballooning costumes and being surrounded by others equally fearful as herself, while at the same time maintaining her focus on acting. 'It was bad,' she recalls. 'Especially for me, because I was the most afraid and the whiniest of the bunch.'

Nonetheless, Winona was proud of her decision to do all the stunts herself. Not only was she grateful to have simply survived them, but she was also thankful for the fact that she could overcome her fears in the process, or at least get them under control. It was something she discovered some months after finishing the movie when she dived into a friend's swimming pool. That was, she said, 'like a huge thing for me.'

But it was also a determination, praised Ernie Orsatti. 'Trooper and big action star' was how he acknowledged Winona's resilience to her action sequences. 'She was squibbed, got shot, blasted against a wall, fell off a platform, and then down an elevator shaft.' And that, he confirmed, was Winona. 'She did all of it.'

Not all her time on the set, however, was confined to the voracious demands of work. There were some far lighter moments than the three weeks shooting of the pool and elevator sequences. One of those times was during the movie's latter stages, on Valentine's Day, February 14, outside Stage 16 at lunchtime. 'Winona and I are standing behind a festive Valentine's table offering champagne and little party favours that are filled with candy and condoms cleverly disguised as pirate coins,' wrote Sigourney Weaver in the journals she maintained throughout filming. 'The French drink the champagne, the Americans eat the candy, everyone pockets the condoms. A guy comes by who we've never seen before. He picks up a pirate coin, unwraps it thoughtfully, pops it in his mouth, and strolls away, chewing. Winona and I exchange a look. "I hope

it's flavoured" says Winona.' It was typical of what Sigourney had already noted. That Winona was remarkably mischievous as much as she was humorous.

Although leaping at the opportunity of filming *Alien Resurrection*, it was the first time Winona had committed herself to a movie without even reading the script. 'I thought it's gonna be really cheesy, but I don't care, I'll do it anyway even if I have to die in the first scene. I just wanted to tell my brothers I was in an *Alien* movie.' But equally she knew she couldn't turn down the opportunity of starring alongside Sigourney Weaver in one of the classic benchmarks of modern science fiction, and the one most likely to resurrect the series with the same credentials that *Alien* made it's reputation with in the first place. For Winona though, the strategy was simple, 'I'd be insane to turn that down.' Still, she was mystified. 'It's like they found the scrawniest actress in Hollywood and said, "And now you're going to fight aliens!" '

Besides, she continued, 'I would have been killed by my brother, Jubal, if I didn't do it because he gets all the merchandise.' Despite this, she was unable to persuade him to relinquish the comic book store he ran in San Francisco to play one of the frozen soldiers of the cargo that Winona is seen rolling along the docking bay of the 'Auriga.' In the end though, she managed to wrangle her younger brother, Uri, a struggling actor, into the part. 'Yeah, that's my brother,' she proudly announced.

Not only that, Winona loved science fiction. Not surprising for someone virtually brought up on such creature flicks as *Invaders From Mars*. 'Yes. Creepy!' jumped Winona at the recollection of her first fascination with the genre. 'I saw that when I was little. I still remember that scene where the guy realises who his parents are.' From that moment on Winona was hooked. 'I really got into Ray Bradbury and Fahrenheit *451*. I was also kind of raised on *Twilight Zones*.' But *Star Wars*, she insisted 'was more of a boy's thing.'

She also observed that a good science fiction script was simply hard to find. Difficult, too, because, 'they're always so incredibly bad, especially the female parts.' She had the same feeling towards action movies. 'I don't like them very much, but I do get into creature stuff. Somehow human-to-human violence bothers me a lot more than human-to-monster violence. I can accept more easily us blowing away an alien.'

So perhaps it was not so surprising that when Twentieth Century Fox suggested a science fiction vehicle to Winona, she remained incredulous. 'The only way I would do it,' she told them, 'was if it were something along the lines of *Alien,* but that was over because Ripley's dead and nobody can replace her.' But to her amazement, it turned out that Fox had already devised a way to bring back Ripley, and equally important, the series itself.

Winona had seen Ridley Scott's original 1979 masterpiece when she was just eight years old. It was at a theatre in Ukiah, a few miles north of Mendocino, near where she lived at the time. 'I actually sat through it twice,' chuckled Winona at the recollection of the movie that her parents would leave during the chestburster scene. 'My brothers and I hid in the wings while they cleaned the theatre between showings so we could see it again without buying a ticket.'

For Winona, she would see it another fifteen times. 'I was completely obsessed because I had never seen a female character like that, it was the first female action hero I had, that any of us had. It really had a huge impact on me, so much so that I still had the poster in my room at home until I was seventeen, until I moved out of my parents house. And it's still actually there, it's still in my room when I go home.' Even today, Winona admits to gazing up at Sigourney Weaver from her bed through much of her adolescence. 'I never thought I'd have a chance to meet her, let alone act with her, let alone be in an *Alien* movie with her. It's like a dream come true.'

Equally true was Winona's boundless enthusiasm, even flying to the rescue at a time when Britain's Danny Boyle, best known for *Trainspotting*, surrendered his role as director over what industry rumour deemed wavering uncertainty of special effects. According to Jorge Saralegui, Senior Vice President of Production at Fox, Winona was contributory in helping to find a suitable replacement. 'She took on the role of producer and every day for two weeks parked herself in my office determined to help.'

Screening movies and observing different styles of directors, Winona set out to shortlist names that could be regarded as ideal for breathing new life into the *Alien* franchise. As soon as she sat through *Delicatessen* and *The City of Lost Children*, Winona knew their search was at an end. She also knew that Jean-Pierre Jeunet, the French director of those movies, was the only contender. His flare to devise scenes that push the boundaries of cinematic style was evidence enough.

Although he was enthusiastic about the Alien sagas, Jeunet was initially reluctant to take on directing American films. But after meeting with Sigourney Weaver, and then Winona, and realising he had found two actresses he was desperate to work with, he agreed to go ahead with the project. Winona was, of course, delighted. 'He is one of the most original visual geniuses of our time, and Fox hiring him to do it was a real stroke of genius.'

In many ways, he was as instinctive as Winona. His technique of placing the same importance on his camera as on his actors earned him the reputation that Winona so fondly appreciated in his work. If there was any doubt at all about the choice, it would only be that Jeunet didn't speak English. But even that was not a concern as he would simply dispense most of his direction through his interpreter, Nancy Gilmour, or at other times with sketches on storyboards.

On the other hand, it didn't worry Winona in the slightest, as she knew there were more ways to communicate than by words.

'I didn't find the language barrier a problem because he's such an expressive person physically, and it was almost a telepathic relationship. He had a great understanding of the material, so I felt really comfortable.'

Besides, Winona had worked with European directors before, so it was no surprise that she should be excited about working with Jeunet. As she explains: 'He's made this film unlike any of the others. But it's still going to be terrifying in the sense that you're holding your breath. You see so many action movies where's it's like the same sequence over and over just with different actors. And with this it's like the ideas behind the scenes are so original.

'He didn't do anything in this film that's ever been done before,' she continues. 'Sure there's been a lot of running down corridors in the *Alien* movies, but even this is just shot differently, and what we're being chased by is quite different. The element of fear that he brings is, in a way, very European, and it's very different from American action movies. It's much darker and more frightening.'

The feeling was apparently mutual. Throughout shooting Jeunet acknowledged Winona's proclivity. 'She comes on the set completely relaxed and when we say "roll" she is a force of concentration, focused on the immediate scene, no rehearsals are required. This instinctual way of working is a rare quality usually found only in children.'

Winona, Jeunet continued to observe, was an actress who works directly from instinct. 'The most interesting part of her performance is that, although the character has lethal intentions, she didn't play her as cold. She was the anti-terminator.' Equally aware of Winona's intuitivity, Weaver agrees. 'She plays someone who is very passionate, very idealistic, the way Ripley used to kind of be.'

But first and foremost *Alien Resurrection* is what could be regarded as 'pure adrenaline rush cinema.' About people fearing for their lives, and running against time and the elements because they

have no idea of what the aliens are capable of. In those terms it has, as Winona explains, 'the same lurking, you-never-know-what's round the corner quality of the first film.' Weaver confirmed that 'so much of it is original, while the spirit of it is very much a cross between the first and second.' Indeed, continued Winona, 'it's not just a shoot-em-up. This is much more of a suspense movie than an action movie. And entirely different from the others.'

It was also a movie about relationships. Winona understood that as soon as she read the script. It wasn't, as she explains, a buddy movie at all. 'Our characters really grow very close. But it doesn't start off that way. It's actually very moving, the relationship between the two of them. We both kind of want the same thing, but we go about it in completely different ways. She can't believe she's back, she knows what's going to happen, and she knows what we're up against. We have no idea. I've never seen the alien. It's folklore to me, to Call. It's something that I grew up hearing about. The beast that was around hundreds of years before that this woman, Ellen Ripley, saved us all from. She destroyed every trace of it, or so we think.'

Neither did she think she was quite cut out for the drool of the slime from the seven foot aliens. That moment when the beast draws back its lip, opens its mouth, and the metallic tongue issues slowly forth, dripping with goo. Fun at first, she thought, but then, 'it gets in your hair and at those moments you have to think, what did I get myself into? This is really gross.'

That was most evident from the scene where Ripley kneels by the dead alien she has just blasted, looks at it contemplatively, and runs her hand along its black smooth head before reaching into its mouth and ripping out the huge tongue enveloped in dripping slime. 'Here,' Ripley says, handing it to Call. 'It would make a nice souvenir.' As soon as the scene cuts, Winona scampers towards the edge of the set from where David Pirner, her on-again, off again, boyfriend and Soul Asylum frontman, is intrigued as much as

Winona is disgusted. Slime on her fingers, and totally grossed out, Winona wipes off her hand before asking, 'Was I terrible?'

For an actress moving away from the demands of period pieces, it is not difficult to understand her insecurity. The challenge facing Winona was the fact that her character wasn't even human. She was playing an android. Nonetheless she was pleased. 'What I really liked about the character of Call was that she wasn't ultra-violent, and she actually doesn't really kill anybody. She is just a cerebral character. She's all brains, all thinking, and more of a computer person. She's not just a shoot-'em up character at all. She's really very humane.' Clearly, laughed Winona, 'they didn't cast me because of my physique.'

She was equally delighted with her quilted jumpsuit costume that, although practical still managed to disclose an understated sensuality. 'I got to the set the first day and found out that my costumes don't show any skin at all.' She was only too aware that some directors would look for almost any reason to slip her into a skimpy outfit. 'And that's fine because I doubt if I'll ever be happy enough with my body to strip off in front of the camera, and even though my parents were open about sex and nudity, I've always been self-conscious about those things.'

However, maybe Winona's concern was more practical and conscious of the fact that the last time humans battled the aliens, a major Hollywood franchise was nearly destroyed. The *Alien* saga which began so brilliantly with Ridley Scott's elegantly macabre 1979 masterpiece, *Alien,* and exploded into a full-on action epic in James Cameron's 1986 sequel, *Aliens,* came close to being lost forever with David Fincher's *Alien 3.*

That third instalment took a severe beating from the critics, grossed a disappointing $56 million at the North American box office, and delivered an ending that didn't sit well with *Alien* audiences. Certainly not with Winona. 'The idea of Ripley dying wasn't received well, especially in my home. For fans, it was a big

disappointment. I was like, god-damn it, really upset. It took me a long time to get over it.'

Still, Winona loved the aliens. The newborn simply fascinated her. 'It had sixteen puppeteers operating it,' she explained. 'It was kind of better than working with most actors that I've worked with because it was much more polite. It doesn't really talk to you, but it's so expressive. It was very easy to play off.' That is probably true.

Equally true on Oscar night, in March 1997, when Winona's minute elfin frame, still looking like the eternal waif, stepped out to walk across the huge stage was that she was still a favourite of the Academy Award audience. The applause that followed her entrance was warm and appreciative, and the smile on her face reflected her pleasure.

Her choice of dress on this, as on previous Oscar nights, was something of a statement of her passion for classic Hollywood glamour – a beaded black Chanel couture flapper dress with flesh coloured lining that showed how the illusion of nudity had stylishly crept into evening dress. Her hair cropped short and boyishly swept around her pretty face reflected the elegance of her appearance.

In person, Winona has a clear, symmetrical beauty with near perfect features, porcelain skin, and brown velvet eyes that flicker adorably. The effect is like Disney's *Snow White* brought to life. Winona, however, is simply astonished at her pin-up status. 'I can't believe it when I read somewhere that I'm beautiful or attractive.' She remains incredulous. 'I've never really thought much about my appearance. I'm just this short, scrawny, dark haired Jewish girl.'

Ben Stiller, Winona's co-star and director from her 1994 film *Reality Bites,* does not agree. 'It's funny, girls really like her, and guys really like her. Every guy I've ever talked to has a crush on her.' It was a view confirmed by Janeane Garofalo, who played Winona's roommate in the same movie. 'Even little, little kids like her. I think Winona's the poster girl of every trekkie, every computer nerd, every information superhighway addict, every comedy-head

and every comic-book collector. And athletes too. She so gorgeous that she crosses over.'

Garofalo continues. 'And, she's so small. I mean, she's like a little figurine for the coffee table!' Winona, too, shares this observation. 'I blow over when it's windy,' she would often joke, but at the same time acknowledged that perfection is not always attractive. 'I think I have a responsibility to promote that idea to young people. I wasn't always considered pretty. If you look at my early films, I always played the weird girl, the ugly duckling, and I got used to seeing myself that way. I really thought I'd spend my whole career playing the weird, nerdy sidekick of the star.'

For the Oscar ceremony, one year after *The Crucible* disappointment, she introduced a *History of the Movies* montage with a speech that neatly and eloquently encapsulated her love of them. In her celebrated Midwest tone, she reminded us of the times 'when the lights slowly dim in the movie house, there's that moment of great expectation when everything is possible. Last year over a billion of us bought tickets to see a movie. All over the world we sat together in the dark for a few hours and shared the experience of film.'

From Winona To San Francisco

'It was the only time in my life I had no sense of family. Everyone was looking after everyone else's kids, and sometimes I just wanted my own family, to eat dinner with them, to be tucked in by my own parents. I guess I just didn't like being shared. I started fantasising about suburbia.'

Hollywood has always been a magnet for ambitious parents. Behind every child star there is usually a pushy mother doing the rounds of agents and producers, hoping her pretty daughter will make it into the movies. Only a few ever do. And the ones who graduate through to adulthood are even fewer. Elizabeth Taylor, Natalie Wood, Hayley Mills, and Jodie Foster were the biggest names, but none came close to wielding the kind of individuality that Winona Ryder does.

Indeed, Winona herself could practically count on one hand the actors who survive going through adolescence on screen. Maybe that was a result of growing up in the Bay area of California that steered her away from the pitfalls that so many other aspiring young talents fall into around Hollywood. At the same time, though, Winona recognised the benefits of filming during the summer vacations and returning to school afterwards to maintain her education without confining herself to living a sheltered movie star life. Winona acknowledges this gratefully. 'Grades were very important at our house,' she admits. 'We could probably do anything else like smoke pot, have sex, but we couldn't get bad grades at school.'

She was also lucky not to have stage parents in what she defines, that awful sense. Neither would she have to contend with the sort of influences that ruined many lesser talents and certainly crippled less resolute ones. There were, of course, moments when she herself

must have wondered over the times she suffered. It rankled, for instance, being around an actor much older than she was, who was coming on to her. 'He made me uncomfortable, but I never said anything, because he was a big star, and I wasn't.'

To this day, Winona's only regret about the incident is that she didn't speak out, but she also acknowledged the idea of Winona Ryder, fifteen years old, filing a sexual harassment complaint would probably not have sat well around Hollywood. Besides, the annals of Tinsel Town is probably littered with similar corpses of embarrassment. For Winona, though, the dilemma was the same lots of girls have faced no matter what industry they work in. 'He didn't hurt me and I'm not damaged from it, and I'm not scarred, but when I hear stories it makes me sad. I just think I should have said something.'

Nevertheless, Winona was one of the lucky ones. 'I didn't have to deal with any rejection and I had a great family and plenty of support from them.' But, of course, there were others far less fortunate. 'If you look at any other teenage actor, you look at my career, and just think of the kids for whom it didn't go so well.' But with that knowledge there came more, 'I think it's the most dangerous thing to put young people in movies unless they are completely ready, and have really strong parents who don't push them but are there to offer plenty of support.'

Indeed, Winona's parents were forever understanding, but at the same time anxious. 'When I first started,' Winona concedes, 'they were worried because they didn't want me to feel like I'd be any less special if I didn't act. They would always pull me aside when I had to make any sort of decision and say, "You don't have to do this. We love you just the same." '

On the other hand, however, they were completely shocked when Winona told them she had to act. 'Not the movies,' they begged her. And even though they had long loved the cinema, they were simply aghast and concerned that she was too young for a

life that would, they feared, take her away from home. But she was adamant. 'I must act,' she told them. Winona eventually won them over, of course, but not without compromise. To this day, their careful counsel and guidance is something she fosters with her younger colleagues.

Even then, with her own experiences as a child actor, Winona is no less determined about her concern for youngsters who perform in front of the camera. 'Children have this pressure that is so abnormal because the stress is so relentless. There is also a vanity that is unnatural.' Unnatural, that is, 'when you can't get sick or can't get the flu, because if you stay at home it could cost the film company $300,000.'

It was typical of what she herself grew up with on film sets. 'I know it sounds very dramatic but I did see some awful things happen to youngsters.' The worst she remembers was a set being shut down by the production company because a child actor had a pimple on his face. Winona shudders at the ensuing scenes of frantic behaviour and humiliation. 'I told them that if they continued like that I'd walk.' It was a sign of just how quickly Winona's formidable clout erupted into halting such dramas.

But for all its magic, Winona remembers, Hollywood 'represented this strange place we didn't know at all.' Her parents, Michael Horowitz and Cindy Palmer had, after all, circulated on the cutting edge of the counterculture movement of the sixties. Journalists, too, writing magazine profiles of Winona would often summarise her childhood as one being raised on a commune by hippie parents. She even joked they were. But of course, her parents were, far more precisely, intellectuals and scholars who remained true to their ideals. 'It bothers me to have tags slapped on them,' complains Winona. 'I didn't grow up in pot fields, and we didn't live on a commune, but on a piece of land where other people had their own houses.'

Nevertheless, it was an unconventional upbringing, and although Winona herself sometimes refers to the settlement where she lived as a commune, she has a point. Michael was a bookseller, dealing in the literature of the sixties Beat writers and poets of that period. A period of social anarchy when free speech, free love, and free drugs were the buzz words of his generation.

But Winona remains adamant. 'My parents were not these crazy hippies,' she says. 'Maybe my dad was part hippie, but he was more of an intellectual and an observer and a writer. Of course, he experimented and did all that stuff that people did in the sixties, but he was like on the intellectual side of things. He was doing it all because he was curious, and he recorded it.'

Michael's family, although a fusion of Russian and Rumanian ancestry, were Jewish by heritage. The roots to their original name of Tomchin however are less clear. According to family history, Winona's grandparents were the first to arrive on American shores at the height of the East Coast immigration troubles in the early twentieth century. It was here that the confusion evolved.

'They were meeting a family at Ellis Island,' explains Winona, but when asked by the authorities for their name they thought only to give that of their friends, the Horowitzes. They simply felt that they 'had to say they belonged to them.' From then on the Tomchins became known as the Horowitz family, but in reality, it was, as Winona put it, 'a made-up name.'

Other relatives, however, were not as fortunate, many were lost in Hitler's extermination camps during the Holocaust. According to Winona, at least a hundred. 'My grandmother is still alive and has a lot of letters and pictures of relatives, and there's this one particular relative who was my age (26) when she died. She was a violinist and actor, and she looked like me. I have had this feeling for the last eight years that she was there guiding me and helping me with my performances.'

The loss of so many family members however remains an unsettling subject for Winona. It is probably what encouraged her to contribute money to the construction of the Holocaust Memorial Museum in Washington DC, and to narrate an audio book version of Anne Frank's celebrated wartime memoir, *The Diary of a Young Girl*. 'What scares me the most about it is the separation, even more than the deaths. It's (the fact of) families being separated.'

Religion though for Winona remains an indecisive subject at best. 'I love it because its really beautiful,' she once said, 'but hate it because its torn places apart, caused war and death.' She intimates, however, that her personal beliefs lean more towards eastern philosophies rather than anything else. A direction in which Timothy Leary would influence her.

Indeed, when Michael met Cindy, he was already working as an archivist for Leary, and at one time, reported journalist Simon Worral, 'even busted him out of jail and smuggled him to Switzerland.' It was here, Leary recalled, Michael took him a photograph of Winona, no more than a day old, which he signed on the back welcoming a newborn Buddha to planet Earth with his inscription: 'Love the beautiful, newest Buddha girl.' It was also where Michael and Leary, 'probably really high,' Winona laughs, that they went skiing and where 'my dad asked him to be my godfather.'

As for the photo, she elaborates, 'My mom's a Buddhist and I'm in this position that the Buddha is in, and she's like, "Noni, I know that you're special because of this..." and I'm like, "Mom, you probably positioned me like that." ' Nonetheless the picture, now only slightly soiled in a two-inch-by-two-inch frame remains one of Winona's most cherished possessions.

Leary was, of course, a key player in the counterculture movement, and according to President Nixon, was one of the most dangerous people in America. But not as far as Winona was

concerned, he wasn't. 'He's brilliant,' she once said. 'I can talk to him forever. You listen to him speak, and it's like watching a movie or something. You go home after a couple of hours thinking, "That was a good one!" '

Leary's notoriety was in many ways like a movie. America's youth had looked upon him as a prophet of social change and upheaval, while parents consistently dismissed him as anti-establishment who corrupted their young by his plea to 'turn on, tune in and drop out.' Kicked out of West Point Military Academy and dismissed from Harvard University for allegedly experimenting with hallucinating drugs on his students, he became a figure of controversy, praise and ridicule and remained so right up until he died in the spring of 1996.

Winona learned a great deal more about herself from Leary's death than she ever thought possible. Something she still carries with her to this day. Not only did she suspend her career to care for him during the last few weeks of his life, but most importantly, to be with him when he finally passed away. He woke up that morning remembers Winona to announce, 'I am going to die today,' preparing himself and those around him for what he called a great day. 'He wasn't on any drugs, painkillers, nothing at all, and he was just saying the most profound things left and right. When he died he was smiling and his eyes were open, and after, I was still holding him, which was an amazing experience and not so morbid as I anticipated. I stayed with his body for a long time.'

But watching him, concedes Winona, 'made me not so afraid of death. He really gave that to me as a gift. One of the last things he said to me was "don't ever be afraid of this, this is fantastic," and told me he loved me.' It was, she said, a wonderful experience in a sense. 'He just looked so happy. He wasn't in agony, and he couldn't wait.' A lot of people, she continues 'thought it was his way of dealing with death, like he was afraid, but he really couldn't wait. He considered it a journey, and he was very excited about it.'

Winona was not however so affectionate of the vigil devotees that gathered near where Leary lay dying. 'These people were all sitting around really stoned, and I just wanted to go, "He was a person!" He wasn't just all this talk and these words in books! He was my godfather! My relationship with him was one of the most stable relationships I have ever had.'

In fact, she expounded, 'it was very conservative to what people think. We were very very close and he took care of me. He was the most gentle, funny, kind, wonderful man. We would do things together like he would take me to the Dodger games, tuck me up and read me stories. Really took care of me, but it wasn't this big party thing that people tend to think. He was very protective of me.'

Speaking later at his funeral with tears in her eyes, Winona read from the eulogy she had prepared. 'F. Scott Fitzgerald wrote a letter to his daughter in which he said that he hoped his life had achieved some sort of epic grandeur. Tim's life wasn't some sort of epic grandeur. It was flat out epic grandeur. It's easy sometimes to get lost in all the drug stuff that Tim's famous for – all the "turn on, tune in and drop out" stuff, especially in a society that loves a sound bite. But it wasn't Tim's only legacy. It was his vitality, enthusiasm, curiosity, humour and humanity that made Tim great – and those are the real ingredients of a mad scientist. We miss you and we love you, Tim.'

The ceremony took place in a battered airport hangar in Santa Monica, and lasted two hours with a video tribute set to Beatles music, and another in words by the noted spiritual leader Ram Dass. Afterwards, strangely enough, there was kudos for Winona herself. Strange because it was something she probably hadn't even considered. 'People kept saying to me, "We've never heard you talk outside of a movie before." And they were right. I was using my own words for once, I was talking as myself, as me. And I liked it.'

As Winona had already pointed out in her speech, her message was simple. 'He was the first person who made me believe I could do anything. What I learned from him wasn't about drugs, it was about getting by.' Indeed, she vowed, 'he never gave me drugs, and never did drugs around me. Sure, he talked to me about it and took the mystery out of them certainly. But they were a big yawn for me because everyone was doing them around me so I never had any interest in them anyway.'

For Timothy Leary, death was a challenge. Responding to it with characteristic fire, he enthusiastically told the *Los Angeles Times*, 'how you die is the most important thing you ever do. It's the final scene of the glorious epic of your life. It's the third act, and everything builds up to that.' For that reason, more than any other, he awaited death with a sense of adventure, even to the point of considering how to plot suicide on his own homepage of the Internet. But, instead, he died almost peacefully in his favourite bed, and among his most loving friends. Right up to that time, he had continued to inform the world of his drug habit through his computer website, and of his belief in the dream of change, and of his plans for some of his cremated remains to be flown into space that would allow him to 'ride the light.' A prospect that apparently thrilled him.

Although it is true to say that Timothy Leary was a philosopher and a journeyman, an adventurer and a conqueror of the twentieth century, it is more likely that he will be remembered as the LSD guru who railed unrepentantly against the establishment and urged a generation to think for themselves, and always question authority. That was one of the philosophies that he taught Winona.

Once, she remembers, 'he showed me this crazy video that he had done about some psychedelic phenomenon. I didn't understand it at all, and I told him. "You know, Tim, you've always taught me to question authority, and you've always been my authority, but now I'm questioning you." '

23

Besides Leary, Michael's closest friends were some of the most influential figures of the decade. Allen Ginsberg and Lawrence Ferlinghetti were both regarded as founder members of the sixties counterculture movement. Ginsberg was as controversial as he was critical of conventional society. Fiercely opposing the Vietnam War, he was one of the foremost and most outspoken campaigners for the freedom of speech, and of his own homosexual preferences. Through his poetry and radical views he became one of the pioneering forces of the sixties subculture that shaped American music, politics and protests for decades to come.

Ferlinghetti on the other hand, himself a poet, playwright and novelist, played much more of a pioneering role as the founder of the Beat poetry movement and played a key role in its wider development when he started the legendary City Lights Bookstore and publishing house in San Francisco. It is where he published Ginsberg's *Howl and Other Poems*, a volume of verse that led to Ferlinghetti himself being unsuccessfully prosecuted on obscenity charges for the publication of what, at the time, was considered highly offensive material. His trial and subsequent verdict of innocence did nothing more than fetch national attention to the emerging counterculture.

Cindy Palmer, too. Born in St Paul, Minnesota, she had moved to the Bay area with her first husband in 1965 and, like Michael, had been drawn into the birth of the counterculture movement. It was still some years away from the 'flower power' craze of San Francisco that seemed to capture the imagination of the entire world. And in those terms Cindy herself was something of a pioneer. She fully embraced her discovery of this brave new world by directing her enthusiasm towards its constituent parts such as Buddhism, macrobiotics and Aldous Huxley's utopian ideals, emanated, most likely from attending the first hippie 'Be-In' staged by acid-prankster and novelist Ken Kesey in his hometown of La Honda.

He was another cultural and literary figure of the period. Placed midpoint somewhere between the Beats of the fifties and the Hippies of the sixties, he earned his reputation through an LSD preference to liquor, his decisive treatment of women as equals, and a prison sentence for marijuana possession. But despite all of this, his novel *One Flew Over The Cuckoo's Nest* became a metaphor of oppressive American society.

Indeed, it was not surprising that Michael and Cindy should be drawn into what truly seemed a budding new world. Neither was it any wonder that their cultural traditions and hopes for a new future bonded their cohesion. For a while they lived in Michael's native New York with Cindy's children from her first marriage, a daughter, Sunyata, whose name came from the *Tibetan Book of the Dead*, and a son, Jubal, whose name came to Cindy in a dream.

Their first child together however was not born until the autumn of 1971. The couple were staying with relatives in Winona, Minnesota, just fifty miles north of Minneapolis, and planned to be back home in New York before the child's birth. But against all odds, Winona Laura Horowitz, Noni for short, was born on 29 October, and named both after her unexpected birthplace and the Dakota Indian meaning of 'first born daughter.' Not surprising since the picturesque city was named after a Dakota native woman, and a cousin of the Chief Wabasha, when it was an Indian village long before the first European settlers arrived there by steamboat in 1851. To this day, Winona remains one of America's most beautiful Midwest locations as much for its majestic surroundings alongside the great Mississippi River as for its commercial appeal.

But it seemed almost ironic that Michael and Cindy's first child together should be born early into the decade that seemed determined to overturn the ideals of the one before. The very ones that Winona's parents fought so hard for. Even after the promise of that budding new world they so longed for had been lost to another generation, Michael and Cindy remained true to their

ideals, and where better to pursue their convictions than head back towards California while Winona was still an infant.

Their new home was situated on the hippie side of Haight Ashbury, itself an eminent area where many came to explore alternative lifestyles, and to live communally without fear of being moved on for embracing radical views and ideas. Although taking rooms in a house shared with Cindy's ex-husband and his new wife seemed unconventional, it was an ideal settlement. Winona toddled around the Zen preschool she had been enrolled to, or at other times, she would simply hang around her father at the Café Treiste as he drank coffee with Ginsberg, Ferlinghetti, and Leary, now back from his exile in Switzerland.

It was an ideal meeting place, as was the Horowitz home, where they immersed themselves in talk that was seminal to a new generation. Winona too, would join in the discussions with these extraordinary people long before she was to realise their places in history. Throughout her childhood, remarked Leary later, 'she was surrounded by thoughtful bohemic types.' That in itself contributed to the perspective and attitudes she still has today.

Her views on drugs, for instance, are no better expressed than in her journal entry, in which she jokes about her 'fear of marijuana,' which spills over from her general aversion to any kind of recreational drug. 'Sure, I've experimented with stuff,' explains Winona. But curiosity, she admits, is one thing, 'destroying yourself is something else.' She remembers how her parents would take the mystery out of all that. 'I would say, "What's acid like? Everybody is taking acid in my school. What does it do?" And they would say, "Well, you know, this is the bad side of it." So I'd lose interest.' To this day, the only pills she has ever consumed for recreational purposes have been chewable Vitamin C, but she offers no excuse about the impact they made on her life, even though she was no more than five or six years old at the time.

'I was addicted to chewable Vitamin C, that was my favourite thing in the whole world, but my parents would only give me so many.' Whenever they weren't around, Winona would climb up to the top shelf where they were kept, out of harm's way, or so they naively believed. 'I remember I could think up the greatest stories about how they were missing and why. Sometimes it actually worked.' But her obsession ended abruptly the day she was clambering up the shelves when an earthquake struck shaking the house, and sending her crashing to the floor. Frightened and alarmed she stopped there and then. 'I thought it was God punishing me for stealing Vitamin C!' She even stopped lying because of it.

Nonetheless she was grateful to her parents for encouraging other values in her. Attitudes that led to her strict refusal to appear nude or even semi-nude on screen, even though she was surrounded by nudity while growing up. 'There was a lot of free love,' she remembered. 'Everyone was naked, so it was never really a big deal.' There were also the family outings to waterfalls where Winona, Sunyata, and Jubal splashed around naked in the water. If nothing else, it taught Winona to make up her own mind about nudity and respect any need she might have for the privacy and the sanctity of her own naked body.

Although there have been several close calls, the nearest Winona has come to baring herself on film occurred during her 1994 movie *The House of the Spirits*, when she hurriedly slips into a sweatshirt as she bolts from the bed she has been sharing with Antonio Banderas. Of course, the audience sees nothing aside from a momentary shot of Winona's naked back. Even the long shot of the couple lying naked during the love scene on the river edge is never close enough for it to be clearly Winona.

There where, of course, more subtle moments: her 1990 movie *Welcome Home Roxy Carmichael,* for instance, when she innocently

compares her own budding breasts to those of the guidance counsellor with whom she is sharing a changing room.

'Think mine will be as nice as yours some day?' She asks the counsellor shyly.

'I think they're as nice as mine right now.'

'Yeah. You're the first person whose ever seen them.' explains Winona, but again, the audience sees nothing.

Even though she did shoot some semi-nude footage for *Bram Stoker's Dracula*, later cut from the final print, her contract for the film included a clause that forbade nudity, and later, during the filming of *Boys*, she walked off the set rather than concede to a sex scene in a revised version of the script. 'I just couldn't do it,' she swore. 'No matter what, I just couldn't.'

Not that it was the only time she had been asked to do a sex scene. 'I was supposed to audition for *River's Edge* in 1986 and there was a sex scene in it or something, so my parents were like, "No, you can't. You're too young." It's funny because in the scripts for my first four movies, my character was always described as "homely" or "freakish." I was actually really into that because I loved Ruth Gordon and I wanted to be like a cool character actress. And so I think, in Los Angeles, when people would hear that I turned down a movie, or I passed on a project, or I wouldn't come in on something, it made them kind of intrigued.'

Winona spent her childhood immersed in books. 'My dad would give me books at a really early age,' she explained, because he was so impatient for her to read them. Some she was simply not old enough to understand, but that did not deter Michael. 'He could never grasp that, so I'd end up having to read them once, and then have to read them again about a year later, and hope I would get them.' Peeping at the last line would help her decide which ones she would read first. In fact, today Winona claims to own one of

the best first edition collections in the world. She has all of Salinger and George Orwell, a lot of Yeats, Forster, Jane Austen, and Oscar Wilde. 'It's what I spend my money on.'

One of the biggest thrills for Winona however that remains especially close to her heart was the time she visited F. Scott Fitzgerald's apartment. 'Nothing could to top that,' said Winona. 'It took me by storm, to stand there and stare at it, because I'd just read his novel, *This Side of Paradise*.'

From the freedom of convention at Haight Ashbury, when Winona was seven, the Horowitzes moved north along the beautiful Mendocino coast to embrace the edenic setting of Elk in northern California. It was a tranquil part of the world, only a few miles from Greenwood with a reported population of no more than two hundred and fifty people. The previous year Michael and Cindy published their first book, a collection of Aldous Huxley's essays on mind altering drugs, *Moksha: Aldous Huxley's Writings on Psychedelics and the Visionary Experience*, which coincided with the birth of their youngest son, Yuri, named after the Soviet cosmonaut and first man in space, Yuri Gagarin.

Settling on to the 300-acre plot of land, the settlement was managed by a co-operative of seven families and, according to Timothy Leary, was 'one of the most successful upscale hippie communes in the country.'

But, for Winona, 'it wasn't as hippie-do as it sounds. It was more like a weird suburb, with a bunch of houses on a chunk of land.' There was no electricity, no running water and no heating except for a stove, but it was, as Winona points out, 'a great way to grow up.' Even if it did, years later, as one reporter suggested, convince her to cut off the electricity at her Beverly Hills home during weekends. If that was true, maybe it was a result of growing up without it.

Her life in Elk was not as some journalists have made it out to be. She dismisses any talk of the co-operative being a commune

and accuses that it was only tagged as that after she became famous. 'A lot of people connected it with, like, everyone's on acid and running around naked, but it was just like a neighbourhood except it was out in the country.' Journalists just wanted to make her out to be a flower child, but Winona was adamant. 'You have to realise that I was not raised by the fabulous Furry Freak Brothers.'

In fact, quite the opposite, but nevertheless rural. Horses roamed the land around the houses and gardens, enjoying the same unrestricted freedom as the children who lived there. Winona herself would divide her time between delving into her parents library of books and having playful hammock contests with her friends. They would, as she describes, 'make up' unbelievable stories, or invent 'weird' games, and, of course, read by kerosene lamps when dark. 'We had to use our imagination.' It is what kept Winona company during her times of loneliness or boredom.

There were times, though, when she wished her parents had maybe gone the other way, to be more conventional. 'I think I wanted things to be more strict. I wanted rules and a curfew, to have dinner with my family every night, to be like all the kids at school and live in a town, in a little house.' Instead she had grown up surrounded by books, ideas and philosophy, as well as drag queens, gay men and staunch feminists and all sorts, but she never differentiated.

Today she has good and bad memories of her time spent on the commune. 'I had to turn in on myself in a way that most kids never have the chance to do because they're always watching TV.' Once, remembers Winona, 'I got bitten by a rattlesnake and my friend had to chomp my ankle and suck the blood. You didn't have any sense of control, it was the elements and you, because there was no phone if anything happened.'

Overall though, Winona says she had a happy childhood. But years later she told *Vogue* magazine of the times she loathed the lifestyle. 'I hated the whole hippie movement, hated that we lived

on a commune, and that we were always poor. I didn't mind that so much, actually. But if we had to be poor I wanted it to be like a movie. I wanted it to be like *Oliver Twist*.'

What inspired Winona most, though, was her parents: 'While they are both very educated and very smart and could have been anything they wanted to be, they chose to do something they were passionate about. Where they made no money, but they were so happy doing it, and we grew up with an abundance of love and inspiration and conversation.' Every week, Winona remembers 'my dad would get a pint of Haagen-Dazs, and that was our big exciting reward.' A family car, too, was a luxury that drifted in and out of their lives. When it was out, they simply made do, and when it was in, there were usually mushrooms and moss growing out of it.

Equally inspirational years later, albeit for different reasons, was the tutor that Winona worked with during her independent study to complete her high school education. 'She keeps me in line educationally, socially, mentally and physically,' reflected Winona at the time. 'She understands me like nobody else does. I can't do anything without her. I talk to her all the time.'

But probably the biggest influence of all came from the old barn that Cindy had turned into a movie theatre, a sort of informal film society, where she would screen the classic art films that she herself loved best. Winona recalls admission to the theatre was free, although 'it was nice if you donated something,' like food, money, or anything else that family and neighbouring guests had to hand.

Mattresses it seems were a popular donation. Thrown functionally on the ground, Winona would spread herself across one or more as she gazed up at the screen, often too young to understand the movies she was watching. The ones of John Cassavetes, however, did leave an imprint. 'I felt like I was there, like he invited me into his world, and it was wonderful to be invited in.' From that moment she wanted to make people feel the same way.

Winona's early exposure to the movies resulted in some very unexpected heroines for someone her age. When the family later moved south to Petaluma, she installed a second television set in her bedroom and draped her windows in black to watch movies constantly, and would often be allowed to stay home from school if there was a good one on. Sometimes, Winona remembers, 'I'd be grounded if I didn't!' And even when she was, she would still talk her family through the vintage ones always finding something to love in every one of them. At one point, she even announced that she wanted to live in a movie theatre. 'You know, take out the seats, put in a bathtub.'

By the time she was seven, it seemed a virtual history of classic Hollywood had passed before her eyes. One of her favourites, and probably most influential was Greer Garson in 1942's *Random Harvest*. 'I wanted to be like her,' reflected Winona years later. 'Nothing could compare with her face, her expressions. To me, she's still the most beautiful woman in the world. All those old movies affected me, they gave me a tingling feeling when I watched them. I wanted to be part of them, even the ones with the tragic endings.'

Another role model was June Allyson who had the same slightly overlapping front teeth as Winona. As a child, Winona had been very self-conscious about them, and had even thought of having them corrected. Then, 'I saw June Allyson in an old movie on TV and she looked so beautiful.' Instantly, Winona dropped the idea. 'If it wasn't for her I probably would have had it fixed.'

She even got the chance to thank Allyson years later when she finally met her during a film festival in Utah. 'That made my trip!' confessed Winona. 'I nearly passed out from excitement. I went over and grovelled for a couple of minutes, I could hardly get the words out, and then I told her. "You've made my tooth very happy." She was truly flattered.' Interestingly enough, Allyson's own most acclaimed role as *Little Women's* Jo would some forty-five years later, win Winona equal acclaim.

Equally influential was a later generation of actresses, and none was more inspiring than Britain's Sarah Miles in David Lean's epic *Ryan's Daughter.* First released the year before Winona was born, the film was one of the first to awaken Winona's craving to be an actress. 'She bowled me over in that, and everything I've seen her in. I think she's one of the most beautiful women in the world too.'

When Cindy wasn't screening movies, she would supervise the impromptu drama groups that were part of the children's playtime, encouraging the youngsters to express themselves as their idols had done on the screen. In such an environment, and with such an upbringing, it is no wonder that Winona was drawn to the idea of acting. As her father Michael puts it, she was already 'a great teller of tales' with an ability to make the unbelievable believable. And surely that's what acting is. Winona, it seems, was already on course.

The Road To Hollywood

'When I first started out, I was twelve and my agency was sending me scripts and I remember reading them going, "This is terrible. I don't want to do this." And they were like, "You can't say that. You haven't done anything yet." And I said, "But I don't like this, and I am not gonna audition for it"'

By the time Winona was ten, Michael and Cindy had married and were celebrating with the publication of their second book, *Shaman Woman, Mainline Lady*. Winona, of course, read it enthusiastically. 'It's great,' she still raves to this day. 'It's about famous women writers like Louisa May Alcott and Edith Wharton who used opium or whatever while they were creating their masterpieces. It goes all the way up to Patti Smith.'

Interestingly enough, Alcott's *Little Women* and Wharton's *The Age of Innocence* would one day win Winona acclaim for her roles in the screen adaptations of the two novels, even though Winona said that 'all great literature is sacred and should never be touched,' there was one book, however, she declared would never, ever, be made into a movie, not in her lifetime anyway.

Winona had read J.D. Salinger's *Catcher in the Rye* for the first time when she was eight. 'I didn't get it.' Four years later she tried again, and this time it clicked. 'Wow, it was gospel.' She still describes the novel as her all-time favourite, going as far to say, 'it's my personal bible. I bet I've read it at least fifty times.'

But she was simply 'crushed' to discover that a whole generation before her had also been enthralled by it.' I thought it was just my book,' assumed Winona unreservedly. Even Mark Chapman, the murderer of Beatle John Lennon was carrying a copy when he was arrested on 8 December 1980 soon after he had shot five hollow bullets from a .38 revolver into the back of Lennon at around 10.49

pm, outside the Dakota Building in New York, where Lennon shared an apartment with Yoko Ono. In fact, Chapman was still reading passages from the book when the police arrived. He had apparently bought a copy of the novel from a book store in the city early that morning, a paperback edition, inside which, he scrawled 'This is my statement' and signed it 'Catcher in the Rye.'

Less fatefully, of course, for Winona, it was also her father's favourite novel. He too had loved it to the point of speaking only in quotations from it when he himself was at high school. 'If they ever make a movie of it, I would bomb the set,' threatens Winona. 'I would rent a plane or a helicopter and drop bombs on it, destroy it. I'll see that it's just not done.'

The other book special to Winona is Louisa May Alcott's *Little Women* which she read for the first time when she was twelve. 'It really made a strong impression on me. It was one of the only books around that explored women's adolescence. In a lot of books, either you were a girl or you were a woman. You were never in between.'

Once again, the publication of a book prompted the Horowitzes to move, south this time to Petaluma, thirty eight miles north of San Francisco where Winona's parents still live and work. Her father runs Flashback Books, a specialist mail order store of counterculture literature, and her mother, a video production company. 'It was a kind of hick town,' said Winona about one of California's oldest cities. 'It was what I wanted, but I had no idea it was going to be so horrible.'

Winona's dream to 'have a house like all my friends, a neighbourhood and my own room was,' she admits, 'really exciting.' But it didn't last. No sooner had she settled into the family home on the west side of town than she suffered massive depression. It was then her nightmares really began, 'I was afraid of my neighbours, and afraid of the kids at school, because we were the hippie family on the block.' Even the police, too, she remembers, 'picked on us

because we drove this psychedelic van.' The one the Horowitzes affectionately called 'Veronica.'

Even the horror of stealing a comic book turned into an equal nightmare. She was immediately put under citizen's arrest, handcuffed, and hurled into the back of a police car. 'Then the police brought me home, and my parents tried to beat them up.' To journalist Hilary Johnson it sounded 'like the perfect childhood,' especially when it turns out 'that your parents beat up the cops when you get arrested for shoplifting!' Years later, of course, it would come to mean something completely different.

Although at first, Petaluma, it seemed, was not Winona's ideal place to live, it was nonetheless a picturesque city with a population of around forty-five thousand and a unique history of being one of the few untouched by the 1906 earthquake. Indeed, the visual elegance of the Victorian homes and commercial buildings that survived that disaster still draw filmmakers to the city as much as it had done in the early days of Hollywood.

Beside everything else, Petaluma is today a model American community where complete strangers greet each other in the streets, neighbours exchange home-made cookies and get together at Christmas. It's where Winona retreats to between filming. One of the few places she escapes the attention of the paparazzi and the tabloid press.

'I know people say, "you asked for it. You became an actress," but I very much disagree. You should be able to be an actress and have your own life. You give your work to the public, and that should be enough. You shouldn't be chased by cameras.' But in San Francisco, where she now lives, 'people never look at me like I'm a movie star,' she explains gratefully. 'It's like I have a regular job, which is just going off and making movies.'

More importantly, for the Horowitzes, at least, moving to Petaluma was a favourable return to the modern-day comforts of electricity, running water and heating. But for Winona there was

one aspect that was not so pleasing. The frequent reports of missing children and disappearances in the local paper would haunt Winona long after their coverage had disappeared from the front pages.

'It's weird, but from the time when I was really little, I knew what kidnapping was, and it was always my worst fear. I remember so well when Kevin Collins was kidnapped because he lived in our neighbourhood in San Francisco, and my sister babysat for him once. And you probably remember that little girl, Tara Burke.'

But none stuck more forceably than when seven-year old Steven Stayner was literally snatched off the street just a few miles from Elk in December 1972, and was held captive for the rest of his childhood. For eight years Stayner was led to believe that his parents had abandoned him, and it was only after his captor snatched another, a five year old boy, that Stayner managed to break away and walk into a Californian police station with his fellow captive. He was fourteen years old and unsure even of his own name.

Winona's fears were made even worse the day that she and her sister, Sunyata, were followed by some people. Even now, she has little doubt of what their intentions were. 'God knows how many attempted kidnappings there are.' But kidnapping was not her only fear. When Winona was thirteen she asked her parents to construct bars on her bedroom windows because a serial killer was rumoured to be on the loose in northern California, and close to Petaluma. She feared that she may be the next victim of the Green River Killer who had already left his imprint of terror in the Pacific Northwest. For nights on end she would lie awake in bed, scared and unable to sleep. It was the first time she would be plagued with insomnia. Eventually she discovered the only way to induce herself to sleep was through boredom. Her algebra textbook was ideal.

Winona's childhood was further complicated by the difficulty she encountered of fitting in at school. With her close-cropped hair, tomboyish clothes and off-beat interests, one year she took

to worshipping the LA Dodgers and, in particular, their second baseman Steve Sax, to the point of writing 'Winona Sax' on her school notebook. But the day he transferred to the New York Yankees she burst into tears. 'The fucking Yankees. I would never do that if I was a Dodger. It's morally reprehensible.' Years later she would even write a song about it. Her first. She called it *Fuck Steve Sax*. 'It was a love song,' she insists. 'It was! It was about how someone betrays someone.'

Her second song that she began working on immediately after was equally inspirational. It was, this time 'about actors who have bands that are bad, really bogus.' But Winona was adamant, however, that she was the worst musician ever and would never inflict her music on anyone. There was, however, one occasion when she did. It was at her eighth grade talent show when she played *Eye of the Tiger*, the theme from *Rocky III* on drums.

She would always go to the San Francisco Giants baseball games wearing a cap of the archrival Dodgers and be surprised when fans doused her with beer. She was even more crushed when her father, Michael, didn't even try to beat them up. 'She wore the most inconsistent get-ups,' Cindy remembers, 'yet on her they looked great. She has a sense of identity that's pure and more self-confident than anyone else in the family.'

An old class picture from 1978 shows second-grader Winona Horowitz with long, dirty-blonde hair and a bemused smile, wearing a baggy dress over pants and a strange frilly collared shirt. In another period she wore nothing else but vintage boys suits. To the normal kids she was an outcast, but for neighbours, she was the girl they fondly knew as Noni, the kid who wore her hair in a punk pixie cut, and was a little offbeat. Much the same of how she was in school.

In fact, Winona found she had very little or almost no common ground with any of the other kids at school. The books she read were simply light years ahead of those being passed around the

playground or being recommended in class. Even today, Winona often astounds journalists with her passing literary references, and one can only imagine the effect those same references must have had on her less enlightened schoolmates.

Even as the other kids arrived every morning in their parents conventional cars, Winona would descend from 'Veronica', the van her parents painted in wild psychedelic colours. One time, remembers Winona, when Michael arrived to collect her from school wearing a Sex Pistols T-shirt, 'they wouldn't let him pick me up! They didn't believe he was my dad or something.' Winona's musical tastes, too, followed her father's, and when her schoolmates discovered she liked punk, and went to punk shows with her father, she was immediately primed for outcasting.

'I was not Miss Popularity,' Winona confesses, but she also knew it didn't really matter. Besides, what on earth could the other school kids possibly offer to rival the thrill of going to see plays, listening to the Circle Jerks, or being lifted up on stage at a Pretenders concert at the Greek Theater in Berkeley and have Chrissie Hynde sing *2000 Miles* to her. Not quite true, Winona recalls. 'She'd sing a verse, and then I'd sing a verse.'

It probably helped, she says, that 'I didn't have a single friend.' Well, there was one. Heather Bursch. She was the only other girl in school with whom Winona had any common ground with. 'We were the sort of geeks.' Both teachers and pupils would tell them they were losers. 'They would say "You're not going to go anywhere." ' Still, Winona laughs at the recollection today.

'It's funny,' she recalled, but Heather went on to become a top model. 'Now she's in Elle, and I'm sure all those girls are feeling a little bit stupid.'

Winona and Heather would often spend time together after school, inventing hobbies they started 'doing just for fun.' Their favourite was exploring abandoned houses. They would strike out of an evening to find one, roam around it, and then tell each other

ghost stories. 'We did it all the time' admits Winona, 'or we'd have a drink and pretend we were the Jets from *West Side Story*. We knew all the dances and everything. We'd climb on the roofs, with these great walkie-talkies to communicate with each other.'

For Winona and Heather, it was far more exciting than the usual teenage pursuits of parties, even though there was the odd occasion when it came a little scary for them. One night, Winona recalls, 'we started flirting with these guys over the walkie-talkies. They must have tracked us down, because all of a sudden this big truck started coming towards us. We had to dive down on the roof so no one could see us.'

Another of their favourites was raiding Winona's parents liquor cabinet in the middle of the night and then playing a game of basketball at the high school in the dark. Winona recalls it was 'so much fun because you don't know where the fucking ball's going!' On other occasions they would change the letters on the scoreboard. Once, remembers Winona, 'we got it to say, "SLUT REEK" when everybody showed up Monday morning.' And, of course there were the trips of driving around with girlfriends and spying on guys on whom they had crushes. Overall, though, it was no more than harmless fun, or as Winona puts it, 'to be mischievous and freak people out.'

Although Winona and Heather would escape their taunters of an evening, in school it was a different story entirely. There, they had no choice but to grit their teeth and take the abuse.

In class, Winona remained silent at the back of the room, seldom speaking, and never raising her hand to answer a question. Even when she did look up from her studies, the other students, staring and gazing, would do their best to successfully unsettle her.

On one occasion when she did raise her hand, in a history lesson, and asked about what 'we did to the American Indians,' her teacher was so infuriated that she served detention for it. For pointing out that when they taught history, they didn't say anything

about the Native Americans. 'They skipped over the slaughters and robberies and rapes and pillaging. I knew about those things from my parents and the reservation we lived next door to from the time I was five until I was nine. For that, I got detention for a week and was almost suspended. It was my punishment for opening my mouth, but the teacher was not able to answer my questions.'

And if that wasn't enough, every time she passed through the hallway she was greeted with a hail of Cheetos. She did not however expect to be roughed up as well. It was only her third day in the seventh grade at Petaluma's Kenilworth Junior High.

Winona was innocently walking down the school hallway between classes when a group of her less enlightened fellow students turned up. Mainly boys. One of them shouted at her, 'Hey faggot!' Then, without warning, they pounced. 'A group of boys hit me in the stomach and slammed my head hard into a locker,' recalls Winona of the incident. 'I think they thought I was a gay boy,' she says of her cropped hair and boys clothing she often wore in the spirit of the old gangster movies that possessed her at the time.

'They were calling me names, calling me a girl, and I was yelling, "But, wait, I am a girl." ' But they didn't believe her, and she was viciously beaten, ending up with fractured ribs and six stitches to her head.

Although the bullies left her to make her own way home sobbing and in pain, Winona did so with her head held high. After all, to have a bandage around her head was to her Cagney-impressed mind like a gangster's badge of courage. It seemed dramatic. But it was not until she was in the safety of her own home that she was able to turn her injury into art. 'I felt like I was in a movie,' Winona recalls. She went into the bathroom, looked into the mirror, lit one of her father's cigarettes, did a James Cagney impression, and thought 'Yeah!'

Still, years later, Winona would exact her chance for retribution the day one of the girlfriends of the bullies asked for an autograph.

Probing her whether she recalled the boy who was beaten up, the girl's memory confirmed she could. 'Oh, that faggot?' But even then, she had little knowledge of 'that faggot,' as she put it, was indeed Winona. One can only imagine the sense of mortification when Winona confessed 'that was me.' And as for the autograph? 'Well, I didn't give her one,' smiled Winona tactfully.

Even so the incident was enough to persuade Winona that she wasn't going back there. All she could do was fall on her knees in front of her mother and plea, 'Mom, I'm not going back another day.' Outraged by the attack, Michael and Cindy agreed. But they were equally outraged by the school itself. It seemed rather than discipline the bullies for their violent behaviour, the school chose to implicate Winona in their stead. Even more strange, as far as Winona was concerned, was the fact that 'I'm this twelve- year-old, and Petaluma Kenilworth Junior High School, tells me to leave because I was a distraction. I'm sorry that gay bashing was such a distraction for them. I didn't want to go back anyway. I was too scared.'

Kenilworth itself however could not uncover any record of the incident, or indeed of Winona being asked to leave. That's not to suggest that it didn't occur, or that Winona's recollection of events isn't accurate. Far from it. What is questionable, however, is whether the principal at the time had simply overlooked recording the details. Whatever the reasons, today the school is disheartened to discover that Winona's time at Kenilworth was so traumatic, and more importantly, that no explanation can be offered for the absence of school records relating to the attack on her.

During an investigation into the story Winona had told *Life* magazine for a December 1994 feature, Dr Kim Jamieson, the deputy superintendent for the Petaluma School District, could find no evidence, nor could he persuade Michael and Cindy to talk about it. And although the school considered it no more than just colourful copy, he did, however, corroborate that any such

abusive behaviour of students today would simply be targeted as unacceptable by Kenilworth or for that matter, any other junior high in California.

For the next twelve months, Michael and Cindy continued Winona's education at home with tutors establishing her required lessons, and Cindy supervising them. What they hadn't allowed for, however, was how quickly Winona would get through her school work. But there were advantages for Winona. 'I got very bored at home, so I would do my work in an hour, and then I would have nothing to do but read.' It had been the same story when she was three or four years old, remembers Cindy, 'She went through materials so fast, drawing supplies, toys, books, you had to keep giving her stuff to keep her interested. She'd just consume them.'

Books, already a big part of her life, became Winona's friends in place of the ones she didn't have. Characters from Tom Sawyer to Holden Caulfield to Jo March were her allies. 'They kept me from being lonely,' explains Winona of the days her sister and two brothers were at school, and Michael and Cindy were busy writing, 'so I spent a lot of time at the library.'

But no sooner had the incident passed that Michael and Cindy became concerned. They didn't want Winona turning into a teenage recluse, so they decided to enrol her in acting classes three days a week at A.C.T., San Francisco's prestigious American Conservatory Theater in the Young Conservatory, an acting program for young people aged eight to eighteen years of age. The drama school was housed then across the street from the eighty-eight year old Geary Theater before it was later damaged by the Loma Prieta earthquake of 1989, and before its renovated reopening in 1996. 'It's funny,' Winona says, amused by the recollection today, but 'if I wasn't kicked out of school, I would never have gone to A.C.T., and maybe I wouldn't be here (in the movies) today.

From its beginnings in 1965, the A.C.T. remit was to nurture superior repertory performances with intensive actor training from

the conservatory classroom to the theatre stage. It was the first drama training programme that was not affiliated with a college or university accredited to award a master of fine arts degree. Its illustrious alumnus include Annette Bening, Danny Glover, and Denzil Washington. It is today, as it was when Winona studied there, a model for the vitality of the art form.

Winona swiftly settled into A.C.T. much more readily than she had into high school even though she was not instantly captivated by her first roles. Neither, apparently, was her acting ability going to be drawn out of her in a conventional manner. She herself admits that 'at acting school, my problem was not talking loudly enough.' Roles such as Dorothy's Aunt Em in a summer workshop production of *The Wizard of Oz*, or Willie in Tennessee Williams' *This Property Is Condemned* were interesting enough, but they didn't excite her.

'They'd give us these weirdo plays like *The Glass Menagerie*,' but Winona was searching for something more rewarding, 'so I asked if I could find my own monologue to perform.' They agreed. To read from the work of her literary hero, J.D. Salinger would, not surprisingly, be her obvious choice. She adapted an excerpt from another Salinger novel, *Franny & Zooey*. 'I made it like she was sitting, talking to her boyfriend. I had a connection with Salinger-speak, the way she talked made sense.'

From that moment, Winona began to experience emotions that initially surprised her. Ones, she says, she thought didn't belong to her. 'It was the first time that I felt the feeling you get when you're acting. That sort of Yeah!' It was also the first time she felt the need to be selective of her roles, just as she would in her future career.

In 1984, when Winona was twelve, Deborah Lucchesia, a talent scout visited A.C.T. She was working for director Eugene Corr, who was looking to cast a young teenage girl for the role of Jon Voight's stepdaughter in the low-budget movie, *Desert Bloom*. Winona really didn't take too much notice of such talent scouts

visiting, and certainly didn't pay much attention to Lucchesia's presence. Maybe it was that apparent disinterest that made Winona noticeable. Lucchesia evidently thought so, and arranged for Winona to audition for the part that although ultimately went to Annabeth Gish, still managed to secure Winona an agent.

Indeed, Lucchesia was so impressed with Winona's performance that she passed the videotape of her screen test (with River Phoenix) onto an agency, Triad Artists. They immediately called Winona to announce they wanted to represent her without even meeting her, or before she had even done any professional work. That in itself was unusual.

Michael and Cindy however were astounded. They had enrolled Winona into A.C.T. to provide a creative outlet for her, and maybe, just maybe, some stage work. 'We weren't thinking of her being professional,' recalled Cindy. 'We just wanted her to be happy, to be around more imaginative peers.' It just seemed, to the Horowitzes, at any rate, that A.C.T. was ideally placed for her to meet 'brighter kids.'

Although Winona took the intentions of Triad seriously, she had a very clear picture of what she wanted, and what sort of scripts she liked. She was not going to jump at the first offer of work just 'for the sake of a career.' Triad were left bewildered. Never before had they come across a child so determined, or so stubborn. She was after all, only twelve, and still needed to do something professionally. Nevertheless they stuck with it when the easy option would have been simply to drop her from their books. In not doing so, it was a testament to their belief in her. They remained confident, but frustrated, that eventually they would find something that was a suitable property for her. They came across it sooner than they thought.

David Seltzer was looking for a girl to play a slightly off-beat adolescent. It sounded perfect for Winona. He had already sat through tapes of seven other aspiring young actresses doing

the same scene by the time he reached Winona's. He remembers staring at the screen in amazement. 'There was Winona, this little frail bird. She had the kind of presence I had never seen, an inner life. Whatever message was being said by her mouth was being contradicted by the eyes.' His search ended there and then.

Screenwriter for such horror flicks as Richard Donner's *The Omen* and John Frankenheimer's *Prophecy*, Seltzer was now turning his creativity to directing, and moving away from horror to make *Lucas*, a film about the problems of adolescent love and growing up. Whereas Hollywood had cheapened the teenage years into predictable vulgarity, Seltzer remembered how urgent, how innocent, and how idealistic, that time can be. He put sensitivity and values into his movie. Bare breasts, dope, and rock'n'roll was finally replaced with a story of teenagers learning how to be good to each other, and most of all, how to care. It was that theme that lies at the heart of the movie.

The principal parts had already been cast. Corey Haim from *Silver Bullet* would play Lucas, *Goonies* star Kerrie Green as Maggie, and rising heart throb of the time, Charlie Sheen as Cappie. Winona was to be Rina, the girl with a crush on the title character.

It was the story of *Lucas*, a fourteen year old, skinny, bespectacled, bug collector who keeps his alcoholic father hidden away in their trailer park home, and whose interests lean more towards the wonders of science and the beauty of insects than it does towards girls, football or parties. That is until he has spotted Maggie, two years older, red-haired, and vivacious, but new to the school and not yet sure of it's ways. He becomes so thoroughly lovestruck with her that he barely knows what day it is. He certainly doesn't hear Rina's invitation to a movie, or the school dance that she later tries to bait him with.

The trouble is that Rina feels much the same way about Lucas as Lucas feels about Maggie, and Maggie feels about Cappie, the football jock with the heart of gold and a protective older

brother streak towards Lucas, which in turn, outcasts him from his classmates whose savage dislike for the boy is never far from intimidating threats of violence.

The triangle is further complicated by the addition of Alise, Cappie's girlfriend of the last three years. Even when she catches Cap and Maggie talking, she knows something is up, but when Lucas sees them kissing, he's still not convinced that he's lost the game.

Winona was not home the day Seltzer called to offer her the part. She had re-enrolled at 'Petaluma's other junior high' and had just endured a really foul day made worse by an even fouler walk home. 'It was like a hundred miles, the longest walk,' recalls Winona. 'I always carried my book bag with the strap around my head. So when I walked into the house, I practically had whiplash, and my sister goes. "Oh, you got the part in that movie." It was really cool.'

Not so cool though was her first day in front of the huge Panavision cameras when principal photography for the movie began in the summer of 1985 in the northern suburbs of Chicago, and later moved to Glen Ellyn in Illinois just after Winona had completed eighth grade. Looking back, Winona admits she knew absolutely nothing about film language at the time, and was too shy to ask what rolling, speed, slate and action meant, so instead pretended that she did. Neither did she know anything about hitting marks to stay in focus, or reproducing exact physical actions from shot to shot to preserve continuity. It wasn't something she had been taught at A.C.T.

She was even more baffled by the fact that nothing ever seemed to be happening. Scenes for shooting would be elaborately set up, involving hours of preparation, only either to be cut short or totally abandoned, while filming of the story kept shifting from scene to scene, completely out of sequence. Even though Winona was only

to appear in eight scenes, she wondered how on earth she would manage to get into character, and even more so, into the story.

More than that, it also catapulted her into a completely alien environment. Not only did it take her away from home for the first time, but also, as Winona herself explains, 'when you do a film you have people waiting on you and tend to get spoiled. Thank God, I had Heather and Jubal there to keep me down to earth.' Even after a day's shooting, the contrast between life back home in Petaluma and being away on location could hardly be greater. 'We would all go back to the hotel, order up room service, all hang out in one of our rooms and watch TV. Some of us would go over the scene we were doing the next day, and some of us would listen to music.'

Although it was seemingly great fun at first, it did occasionally, admits Winona, get a little tedious. Once, she remembers, 'they called me and Charlie Sheen at seven in the morning and put us into wardrobe and make-up right away. It was disgustingly hot, and they kept saying, "we're going to get to your guys shot, we're going to get to your guys shot." But at seven at night, they said, "we're not going to get to it." We spent all day sitting on the set for nothing.'

With her hair cut boyishly short, the first of Winona's scenes occurs about fifteen minutes into the film, though for some, her role was neither major, nor particularly well-defined, and much too often seems almost to be an afterthought. Nevertheless her performance in those first moments on screen would compound the cinema-going public with general critical opinion that Winona Ryder, the girl with the alert expressive eyes that telegraphed a startling combination of intelligence, gravity and self-possession was indeed someone to watch.

'There is something strangely magical and wistful about her, that is ultimately reflected in her performance,' said Seltzer at the time, and later observed how 'she was sympathetic playing a child who thought she would never be beautiful.' It was, he continues

'very poignant because she was clearly about to blossom into a beautiful young woman herself.'

Winona admits to finding her new world of cinema confusing and distracting, probably made worse by having to contend with her first period while making the movie. It was so symbolic, she recalls now. 'I just remember feeling really horrible and – not to get graphic or anything – you don't know really what's happening, but you do feel this is a really weird moment. I just remember saying this line – "Did you have a good summer, Lucas?" or something – and in the middle of saying it, feeling something inside me. And I just kind of knew it. Even then I was like, I can't believe this is happening to me. It was just a drag. It's not anything I ever wanted to get.

Looking back on the film today, Winona says her memory of the shoot was an impression of haste. She laughs. 'That said, I learned very fast.' It was, after all, she continues 'a great first experience,' even if it did have similar parallels to high school, 'you know, kids gossiping, kind of immature.'

Much the same as the thought of having sex affected her. At the time, 'I imagined I wanted to do it. I wasn't terrified of it.' Even though she jokes of having the experience between the ages of 10 and 20, it was actually when she was sixteen. 'It was just something I remember very vividly. That whole act. It's something I can't be casual about at all. I think I'm much too serious about it in a way, and it ends up becoming an issue.'

Another issue after finishing work on *Lucas* that summer was Winona's return to school and the fact that she wouldn't work again until the next vacation. All the same, there was one detail to resolve before *Lucas* could be set for release. David Seltzer wanted to know how she wished her name to appear on the credits.

She knew she didn't want Winona Horowitz. After all, it was a 'made-up name', and hardly evocative of the elegance of the golden days of Hollywood. With time to think it over, Winona and her

father Michael started to work their way through the alphabet, coming up with every conceivable possible name. At one point they considered Winona Huxley because of her parents' love for the author Aldous Huxley, but 'it didn't sound quite right.'

After a few other contenders, Winona October, amongst them, the name she had been flirting with during filming, but no one in their right mind would name themselves after their birthdate. After gaining some time to think it over, Michael came up with Ryder. It was the one Winona liked most, simply because 'it went with my first name.' It had no particular significance to anything else other than her father was playing an old sixties album of Mitch Ryder at the time, over breakfast. But of course, it would soon come to mean something much more than that.

Hot Actress

'I was really lucky. I didn't have to struggle or do bad movies. I was just found. People really resent me for that.'

The press kit for *Lucas* described Winona as 'fragile with a certain poetic justice.' The critics agreed. The *New York Daily News* credited 'Winona for turning a small part into a memorable one', and *Variety's* Todd McCarthy remarked that Winona 'constantly but quietly stole all Kerri Green's scenes.' Others raved, labelling her performance as 'deft, remarkable, and fetching.'

But the first time Winona watched the film at a screening for the cast , 'I was just really scared to see my face that big. It was such a shock that people had just seen me act.' In the end though, she went to see it another two times. Once in San Francisco when it opened there at the Galaxy Theater in April 1986, and once in Santa Rosa, where, recalls Winona, 'a lady sitting in front of me said to the guy she was with that I looked sad on the screen. I guess she meant the part about being hopelessly in love. I wanted to ask her what she meant, but instead I started really looking at myself on the screen. It's hard to be objective about your own performance.'

Nonetheless the film was barely on general release when director Daniel Petrie sought Winona for a role that would determine the kind of character she would play over the next five years, the alienated teenager.

Square Dance was based on the Alan Hines 1984 novel, and told the story of Gemma (Winona), a deeply religious girl raised in the small rural Texas town of Twilight by her stern and seemingly selfish, chicken-farming grandfather, Pops (Jason Robards). Gemma listens to Christian radio broadcasts while she does the old man's housework, attends church even when it involves

51

incurring his wrath, and whenever she goes out to deliver eggs to his customers, she always sells more than he does.

Disruption, however, soon occurs when Gemma's mother, Juanelle (Jane Alexander, and the movie's executive co-producer) descends upon Twilight wanting to take Gemma back with her to Fort Worth, the city she moved to years earlier after leaving Gemma with Pops, but she rejects her mother's offer until, a few days later, a catastrophe strikes that changes her entire perspective on life. Beecham (Elbert Lewis) an elderly black man she befriended at church is buried alive at the garbage dump, and although Gemma keeps digging, the other rescue workers simply give him up for dead. Even when she finds Beecham's battered old hat, no one seems to care, not least, her own grandfather, who appears as disinterested as the rest. That in itself prompts Gemma to hastily pack her belongings, and set about busing and hiking to the address her mother left on a scrap of paper.

Arriving at the gas station above where Juanelle and her new husband Frank live, Gemma helps her mother out at the beauty salon where she works. It is also where she meets a mentally retarded young man named Rory (Rob Lowe) who spends his days hanging around the same salon because it where his mother also works. For Gemma though, Rory is the only one light from the otherwise sin and corruption that seems to surround her.

A gentle, innocent romance pursues between Gemma and Rory. The couple play house, but no one seems to bat an eyelid, not even Juanelle, at the age difference. Gemma is thirteen (although Winona was the same age she had to have her breasts strapped down to maintain that appearance), and Rory an adult. To everyone else, they are simply two innocents whose talk of marriage gathers no more attention than any of Gemma's preachings from her Bible.

Not so innocently, however, is the moment, far off camera, that insinuates Rory takes Gemma's virginity, and the moment when Gemma, fleeing from a fight with Juanelle, races to Rory's trailer

only to find him in bed with another woman. Hurling her bible at the meddler, we learn, again off camera, that Rory is so overcome with guilt and remorse that he tries to hack off his penis with a pair of hairdressing scissors. He is rushed to the hospital from where Juanelle believes he will never be released, while Gemma is promptly dispatched back to live again with her grandfather.

Square Dance, was released in February 1987 to only a mediocre reception, and by the time it was shown on television some years later, the film had even undergone a change of title to *Home Is Where The Heart Is*. Winona, though, had no cause to regret her decision to accept the role, after all it was only her second film, but more significantly, her first starring role in which she appears in almost every scene of the movie, more in fact than Robards, Alexander, and Rob Lowe. That in itself was an enormous undertaking for an actress so inexperienced. 'The role was a real challenge,' Winona remembers. 'A character that was my absolute opposite.'

All the same, she gave an extraordinary performance of naturalness and instinctiveness that equalled any of her co-stars, and with her initial beauty glowing from the screen, we see the woman that Winona was destined to become.

Once again, as David Seltzer had already remarked, whatever message was being said by Winona's mouth was contradicted by her eyes. Most evident from the scene when she insists she would never return to Twilight, but the message is simple. There's nowhere else she rather wants to be.

The movie was already in production when Winona arrived in Waxahachie, Texas, but she was eased her into the new life immediately. 'I was very impressed by Jason Robards and Jane Alexander,' reflected Winona. 'Both proved to be excellent teachers.' It was particularly fascinating for her to watch how they prepared themselves for their roles. 'I tried most of all to copy them,' to become so immersed in both her character and her own self that the camera would become secondary. It was a complete contrast

to her experience on *Lucas* when, as Winona then observed, 'I was distracted by the kids and the camera.'

Square Dance offered Winona the ideal opportunity to familiarise herself with the technical side of film-making. It also taught her how to deal with things on a personal level. Her biggest problem was the same one she had on the *Lucas* set. 'I'd get restless and anxious. When I'd finally figure out how to play a scene in my head, I wouldn't understand why we had to wait instead of doing it right there and then.'

Waiting for the camera and the lighting to be set up was simply irritating to Winona. 'I worried about losing my concentration.' But rather than let her simply become impatiently bad tempered, Jane Alexander would often sit with her, talking to her, and teaching her, she says, 'to be patient, how to hold onto my feelings and then let it go when it did happen. Jason Robards, on the other hand, 'taught me how to be natural in front of the camera.' She owed much of that to her co-stars, and was quick to acknowledge their influence in that respect. 'If I hadn't worked with people like Jane and Jason, I probably would have blown a lot of roles.'

Petrie described Winona as a great kid, very talented, and very intelligent. 'She's got an actor's intelligence. A kind of wisdom about human relationships that serves her in very good stead when she's dealing with the psychology of the character she's playing, and the psychology of the characters against whom she's playing.' Winona was equally pleased. 'I'm very proud of myself because I've done a good job and been professional, been prepared every day on the set.'

With two well-received screen roles behind her, Winona suddenly found herself in demand, or as Hollywood puts it, a 'hot commodity.' But every new offer she now received had to be carefully considered in terms of her career development and, on a very practical level, her travel arrangements. Winona was still reliant on her parents to make the nine hour journey by road from

Petaluma to Los Angeles, an inconvenience that required her to be discriminating.

Without specifying which roles she turned down, Winona hinted that some 'cheesy horror movies' were certainly made without her. And having from the start selected only character roles, she wasn't about to make any compromises. 'I ignore strategy and advice in general because I can't listen to anybody but myself. So as a result, I've ended up turning down a lot of stuff. Sometimes people would tell me "Oh, you have to do this. This picture is going to be really huge." And maybe it was huge, but I'm not going to do anything for that reason.' Neither did she sell out that commitment even though she acknowledges 'I never had to do the Hollywood thing, move to LA, do commercials or sitcoms, and that probably pisses people off. But I've worked really hard, and I'm not going to apologise for not struggling.'

Neither was she going to apologise for carefully avoiding the brat pack tag that ensnared so many young actors before her. She preferred parts that were never less than literate and by doing those roles she also cemented her reputation in Hollywood as someone serious about becoming a good actress. There was one offer, however, she couldn't resist. The one that would turn her into a fully fledged movie star.

Three years before Winona met Tim Burton, he had established himself as one of the great visionaries of the cinema through his success with *Pee Wee's Big Adventure*. The box-office receipts for the 1985 film had turned him into one of those people around Hollywood who was rated firmly bankable. But since then he had by-passed several movies completely. Even working on a script for a proposed *Batman* movie with screenwriter Sam Hamm was, for a time, put on the back burner. Although the studio were willing to invest in the script's development, they were far less inclined to green light the project.

Instead Burton busied himself looking through the many scripts that had dropped through his door, but found himself more and more disenchanted with the lack of imagination and originality. Then, record industry mogul turned film producer, David Geffen, handed him a script by Michael McDowell called *Beetlejuice*. It was ideal for Burton with not only a ghoulish and bizarre theme but also the potential for an outrageous and imaginative set design as well as innovative special effects.

'It had no real story,' remarked Burton. 'And it didn't make any sense, it was more like a stream of consciousness. It had the kind of perverse sense of humour and darkness that I like, with these strange characters and images floating in and out.'

Described by McDowell as a 'feel-good movie about death' it told the story of Adam and Barbara Maitland, a deliberately uninteresting couple who are killed off in the first ten minutes via an intriguingly absurd car accident. They are, of course, new to the death game, and only realise they are dead when back in their own home they can't see their reflections in the dining room mirror. Making matters worse is the confirming evidence, a conspicuously placed *Handbook for the Recently Deceased*. Nothing, however, not even their established afterlife, could be more demeaning than when the Deetzes, a pretentiously grotesque family from New York buy the house and move in.

Even their quaint spooking techniques to send the family fleeing from the house seem as ineffectual as the Deetzes plan to impress their arty friends with their daughter's claim of ghosts hanging out in the attic. For the Maitlands, there is only one thing left to try. They call in Betelguese (played by Michael Keaton).

Although much of the final movie script was an improvised effort by director and star, much of what ended up in the film was a result of Burton and Keaton working diligently together. 'We worked on the script for a long time,' recalled Burton. 'I remember having script meetings that lasted for twenty four hours over the

course of two days.' And if that didn't prove arduous enough, casting certainly would.

Keaton was the first, and for a long time, the only actor actually to confirm his interest in the movie. According to Burton, the only other actor who 'really wanted to do it' was Geena Davis for the role of Barbara Maitland. The rest of the cast, Alec Baldwin, Jeffrey Jones and Catherine O'Hara may have wanted to be involved, added Burton, but as time went by, and production became delayed and delayed, 'it didn't seem they did.' It was even said in some quarters that Winona too was reluctant. But much to Burton's relief that was untrue.

'I had asked Winona because I had seen her in *Lucas*, and she had a really strong presence,' explains Burton. 'But I'd heard she didn't want to do it because of the satanic thing. I thought she must be a religious person or something, but then I found out that it wasn't true because when I met her she wanted to do it, and she was great.'

In fact, Winona remembers her first meeting with Tim Burton very well because, as she herself explains, 'when I went into the office, he was there, but I didn't think it was him because I didn't think a director could be so young and cool looking.' She, on the other hand, was exactly what he had expected, and more precisely, exactly what he wanted for the part of Lydia Deetz.

'I was in my all-in-black phase,' Winona remembers. 'I had this really gloomy look. In a way, we looked almost alike, we had the same tousled black hair, and we were both dressed primarily in black.' They talked, and Burton offered her the part on the spot. 'The fact that I already looked like the character had to have helped.' For the movie, Winona laughs, she even ended up wearing her own clothes a lot of the time, and required very little make-up. 'My skin was actually that pale.'

Winona's identification with Lydia, however, was not all down to chance. Picking up on one of Burton's own influences, the

brilliant artist Edward Gorey, Winona began to purchase odd dolls that *Rolling Stone* described as distinctly Gorey-esque, the sort of toys that a real life Lydia would be certain to have. It was simply her way of getting into character, or as Burton would describe, 'her method not done too mad.' But it also involved accumulating other personal items, none of which would necessarily be in the script, or indeed, appear on screen, but were nonetheless important. For Lydia, Winona would have an identity bracelet with her character's name on, and rearrange her room at home in the way Lydia would.

She also developed a close companionship with scriptwriter McDowell during filming, and stories of a screenplay that Winona and he were working on a story about a girl who works in a bobby-pin factory whose dreams come true, began to circulate around Hollywood. But Winona dismissed the excitement as simply that. 'People get a little carried away,' she said. 'It's just something I dabble in. I do write a lot, mostly short stories and ideas that could be developed later, but there's no strategy, whatever happens, happens.' But the rumours still continued along the lines that she had written, completed and even sold screenplays. In fact, one of her short stories had seen the light of day, she confessed. 'It got published in some really tiny zine. I did it under another name. But it was the greatest feeling because people talked about it and they didn't know it was me. I can't even describe the feeling. It was like, people liked it, but none of my baggage got in the way.' But otherwise, Winona remained silent on the subject: 'Right now, I'm concentrating on acting.'

And that, right now, meant playing Lydia, the Deetzes' daughter whose character is as gothicly dark as her parents are disgustingly vulgar. She is both the echo and symbol of what is best described as teenage angst with a touch of adolescent morbidity thrown in for good measure, reflected no less, by her black clothing, funeral veils and fascination with the afterlife. It was a role with whom many people still best associate her, even a decade after the movie's release.

Her friends too, loved it best because she made fun of herself in it, especially the way she played up the teen angst element.

But more than that, it tapped into Winona's intense interest in the supernatural perfectly. When she was no more than six years old, she told her mother she wanted to kill herself, 'so I could see what it was like after.' A decade later, that same comment would have simply confirmed what Burton already knew. That Winona was ideally suited to the part of the dark and gloomy Lydia.

And it was nowhere better demonstrated than in one of the movie's most memorable scenes when Lydia discovers the spectral Maitlands draped in their ghost-like bedding sheets, and asks, 'What do you look like under there? Are you gross under there? Are you *Night of the Living Dead* under there? Like all bloody veins and pus?'

For the Maitlands, curiosity quickly turns to dismay as they discover they are visible to Lydia, but not to anyone else. 'Well I read that book on the recently deceased. It says live people ignore the strange and unusual, I myself am... strange and unusual.'

The scene typified the spirit of her character perfectly, but, of course, there were others equally symbolic. Lydia's response, for instance, when her father suggests building a dark room in the basement to satisfy her love of photography is probably the one that rang the bell for most adolescents. 'My whole life is a dark room, one, big, dark, room.' Even the suicidal aspect of her character is nowhere better expressed than when she pens her desperate journal entry of 'I am alone, I am, utterly alone.'

Beetlejuice opened in America on April's Fool Day in 1988. Within two weeks it had taken thirty-two million dollars at the box-office; ultimately its gross topped seventy-three million, and its make-up team earned an Oscar, even though for Winona, she required none. Later, it would return to screens as a highly-rated television cartoon series, and more recently, as talk of a sequel with Keaton resuming the role he had made famous. More importantly,

for Burton at least, the film's success confirmed his belief that Hollywood conventions are simply there to be broken – and that an audience will happily watch you break them as long as they are entertained. Above all, weird was good, weird was acceptable, and weird was successful.

Critical reaction, too, was delightful for both the film as a comedy classic, and the emergence of a new, fully-formed star. The *New York Times* critic Caryn James described Winona's character as 'the most intelligent comic portrayal' in the movie, while another *New York Times* writer, Janet Maslin, thought that Winona's Lydia drifting in and out throughout the movie was 'much creepier than the ghosts themselves.' An observation shared by Glen Shadix who played Otho, one of the Deetzes arty friends from New York. 'It was no secret that Winona was at the beginning of a major career,' he today recalls. 'She was the most possessed and charming 15-year-old I'd ever met. This kid had projects in development and could come up with a movie idea and pitch it from beginning to end in the time it took to eat a tossed salad during lunch in the commissary. And she didn't have a slick child actor bone in her body.'

The only sour note came from Alec Baldwin who, as Burton put it, 'kind of bad-mouthed the movie and me' for allowing his and Davis's characters to come across as boring. Apparently he was upset that several reviewers shared his opinion. 'There was a lot of criticism that the Maitlands were bland and everything else,' Burton conceded. 'But if you didn't have those bland characters for Betelguese and those afterlife characters to bounce off of, it wouldn't be what it is. That was the point in a way.'

Winona returned to school after finishing *Beetlejuice* only to find that things had changed significantly. Her Hollywood profile obviously preceded her, and once *Beetlejuice* opened, that became even more of an issue. Once a no one, a nothing, she was suddenly

the star of what became the tenth most successful movie in America of 1988.

'Oh my God!' Winona elaborates. 'I was returning to school again, but this time it was a horror. I wasn't anonymous anymore. I was that girl in *Beetlejuice*. I was constantly being stared at and bothered by the other students. It was the first time people recognised me, and at first I thought I would enjoy being the object of that much attention. But I hated it.'

Indeed, as she read through the scripts Triad were now flooding her with, her only thought was of escape. It probably pushed her into pursuing a movie project that she herself would consider on reflection, 'a big mistake.'

The focal point of *1969* is the anti-war movement that emerged in the sixties from America's countercultural fringe to become a national political issue. It was a depiction of the times through which Winona's parents, Michael and Cindy, had themselves both lived. But it was thought to be a far more lame reconstruction than their own past, of how the Vietnam War got under way, and how two small-town youths, Scott (Kiefer Sutherland) and Ralph (Robert Downey Jnr) protest for peace against a backdrop of family conflict over the meaning of patriotism between Scott and his father (Bruce Dern) especially. He has already seen his eldest son, Alden already go off to fight, and Scott's refusal to do the same leaves his father both baffled and indignant.

Further clashes arise between Scott who objects to the war over political reasons, and his best friend, Ralph who is far more subtle in his reasoning. He just doesn't want to go away, 'and have my face shot off.' It is what, of course, fatefully happens to Alden, and it's that unhappy fate that brings the entire cast together, and is the catalyst that bridges the gap between father and son, and enlightens them both to the true cost of war. Not, however, before Winona, as Ralph's sister, Beth, makes her own objections clear at her graduation ceremony, falls in love with Scott, and even begs

him not to dodge the draft by fleeing to Canada, but to stay and fight. 'It's inside all of us or it doesn't exist at all,' she argues. 'I don't want to run away. If you died I would die too. We have to make people understand that it's wrong.'

Although Winona admits that she had second thoughts about taking the role of Beth, her performance, as ever, was praised following the film's November 1988 release. The *New York Times* film critic remarked that 'the beautiful actress has such fascinating off-beat timing that she becomes a lot more interesting than her role.' She had nevertheless been appalled by the script's mediocrity to the point that she freely admits, she gave the worst possible audition in the hope that she wouldn't even get the part. But even that didn't get her out of the movie. 'When the call came, I was astonished.' And although she accepted the role, she consoled herself with the belief that 'no one would ever see the film.'

Neither did she take on the role as a career move. In fact, it was the complete opposite. 'I did it because I was sixteen years old, I was really bored, and I wanted to work.' She also wanted to escape Petaluma more than anything else. On returning to school after *Beetlejuice,* she found herself not only a victim of the classmate taunts, but more seriously, of a stalker's attention, a man who knew where she lived, knew her routine, knew everything about her, and made sure she knew he was watching. It is not a subject she is comfortable talking about, even today, and at the time the situation grew so serious that she went into therapy. But in the end, she considered her only protection from the man who made her life impossible was flight.

The only bright spot was her companionship with Robert Downey Jnr. He proved to be an important ally both during and after filming. 'Robert is the only young actor I know who really helped me keep a sense of humour about everything,' she said at the time. 'He reminds me to laugh at what I do, to remember it's all a mirage. The most important advice I ever got was to trust your

instincts and have a good time no matter what – not (just) after a day's shooting but with everything you do.'

Those words rang truer than she could have ever known as she prepared to announce her next movie project. One that her agency, Triad Artists, could have done without.

Que Sera, Sera

'She has a real authenticity as an actor and that's why audiences love her and why she's good in every movie, no matter how good the movie is. There's something very genuine that comes through, a certain humanity' – **Denise Di Novi, Producer**

When Winona said she intended to play the role of Veronica Sawyer in Michael Lehmann's *Heathers*, her parents tried hard to discourage her from making the picture. And even more, so did Triad. They had never even heard of *Heathers*. Neither had they seen a script. Winona herself had received it just before she started work on *1969*, from Michael McDowell, who wasn't supposed to release it. Her agency advised her to pretend the exchange hadn't happened, but it was too late. Winona was adamant. *Heathers* would be her next movie project, no matter what.

Besides, she was already committed to it. The moment she read the script she deemed it 'one of the best pieces of literature I have ever read. It was the closest I've been to anything since *Catcher in the Rye*, and that book changed my life.' She immediately called Lehmann to tell him that she wanted to make the film.

'It wasn't a question of wanting to, or thinking I should, it was a case of nobody understanding this like I do. Of course, I wasn't so obnoxious as to go in and say that, but at the initial meeting (with Lehmann and scriptwriter Daniel Waters), we all knew we were on the same wavelength.'

Nevertheless, Winona confirms, there were people 'who got on their knees and begged me not to do *Heathers*. They told me it was going to ruin my career.' She ignored them, but even then, there were others still 'trying to talk me out of it, because people do that when somebody wants to take a risk which is sort of irritating.' Again she ignored them. 'Whatever you said to me wouldn't make

a difference. Even if you said to me the movie would never be released, or that I wouldn't make any money from it, I wouldn't have cared. I just wanted to say those lines, and I wanted to work with those people. I felt like if I don't do this movie, I'll never be able to live with myself. And I'll kill whoever does do it!'

Her friend from the *1969* set, Robert Downey Jnr not only shared her enthusiasm, but completely approved of her choice. 'Noni was offered nine thousand light comedy feel-good hits of the summer movies, and she chose one where she kills all her friends.' Winona is, continues Downey approvingly, 'a pure-at-heart person who knows that the darkness is all around her. She brings to light that there is truth and love even in the darkest impulses.' But equally astonishing, he added, is her boundless energy. 'She'll call me up and say, "I wrote another script," like "I did another load of laundry." '

Apart from the movie's script, Winona was also entranced to the character she would be playing. 'To me, Veronica was a sort of Humphrey Bogart role, a part for a forty-eight year old man. But it's taking place in high school, and lines like, "Fuck me gently with a chainsaw," coming out of a sixteen year old's mouth, that was a really weird thing.'

Four years later, Winona was still confessing her obsession with the role. 'The person I'd really want to be is Veronica Sawyer. I loved her literal ability, her insight into life, and above all, her honesty. For me, that's the key aspect of any part I play. It has to be honest.' Besides, she continued, 'we're very similar, only she's quicker, she'd say things that I'd think of half an hour later. So now when I'm faced with any sort of decision, I think, what would Veronica do? And it's kind of screwing me up because the answers are usually to do with killing somebody!'

She even took steps to have the words QUE SERA SERA from the Heathers theme song tattooed onto her arm. 'I almost got it once, but they ID-ed me in the tattoo parlour, and the guy

wouldn't do it because I was too young,' reflected Winona with disappointment. 'It's just the greatest saying ever, "Whatever will be, will be." ' She was even planning to have BUDDY HOLLY inked on her ankle as well. 'Then again,' she hesitates, 'I don't know if I'm going to get a tattoo,' displaying an inconsistency that sometimes spills over into her interviews. She has been known to tell one writer that she only eats health food, shares a hot fudge sundae with a second, defends biting her nails to a third by saying it's preferable to smoking, and then chain-smokes with a fourth.

Heathers quickly introduces its main characters over the credit sequences. Three girls all named Heather like nothing better than a nice game of croquet, and Veronica who they have buried up to her neck in the garden with her head as the hoop. From those opening moments, *Heathers* looks like nothing more than a thousand other teen high school movies, but one that soon becomes evidently more twisted than most. And certainly takes on darker tones than any other.

The Heathers (Shannen Doherty, Lisanne Falk, and Kim Walker) are the clique at Westerburgh High, renowned for their sadistic pecking order of bestowing favour or insult on whomever they chose. Winona as Veronica is their only partially willing cohort they pull along in their wake. She is also an expert in crafting other people's handwriting. A skill whose usefulness soon becomes apparent to the Heathers.

But when the vilest of the Heathers (Walker) decides that the school fatty, Martha Dumptruck needs a pick-me-up, and instructs Veronica to write a pornographic love letter in the hand of the school jock, Kurt Kelly, Veronica, already appalled at her new peer group of 'Swatchdogs and Diet Cokeheads,' simply wishes them dead.

In fact, that's not so way out as Veronica thinks. When she and her newly acquired boyfriend, Jason Dean (Christian Slater), poison that same vile Heather with a kitchen cleaner cocktail as a hangover

cure, Veronica crafts a suicide note in mere seconds. It seems from that moment, JD, the son of a demolition worker whose wife killed herself in one of his explosions, is simply fulfilling Veronica's secret fantasies that are just 'too gross and icky' for her to swallow.

Nevertheless, the couple's next victims are the school jocks who have been spreading a particularly sordid rumour about Veronica's sexual partialities. Luring them to a patch of woodland behind the school perimeter at dawn, they shoot them by using what JD tells Veronica are 'Ich Luge' bullets. 'They're like tranquillisers only they break the surface of the skin enough to cause a little blood but no real damage.' But of course, he's lying. Once again, he is simply executing his devilish plot, this time to stage a 'repressed homosexual suicide pact' with artefacts surrounding the bodies to suggest much the same, and of course, another of Veronica's crafted suicide notes that announces 'a forbidden love to an uncaring and un-understanding world.'

Now with a growing suicide count, the school becomes a social phenomenon worthy of media overkill, and even spawns a hit record by a group called Big Fun singing *Teen Suicide – Don't Do It*. Reports by local television has a perverse, galvanising effect on the entire local community by bringing everyone closer in grief, and the victims more popular in death.

There is, however, a hint that things might have gone a little too far when JD announces his plan for a 'Woodstock for the Eighties' in which the entire student body will be blown up. It is the climax of the movie in which Veronica battles to stop him, and in which he provides the only genuine suicide of the film concluding with JD blowing himself up with the bomb he intended for the school.

That final scene with Veronica covered in blood, wreathed in smoke, and inhaling a cigarette is Winona's favourite shot of herself. She is the picture of absolute cool, the ultimate teenage dream, stepping out of the ultimate nightmare. And if that's not

enough, even the final dialogue is completely transcendent of the picture.

'Veronica you look like hell!'

'Yeah I just got back!'

But according to Waters, the original ending was far better. It ends with the school prom in heaven. The punch is the blue drainer liquid that Heather Chandler drank, and Martha Dumptruck is the musical entertainment. And although there were plans to shoot this ending, the powers-that-be at New World Pictures considered it too dark for the teen market place and demanded it be substituted for a new upbeat ending.

Heathers opened in March 1989 to a mixed critical reaction. Jeff Giles wrote in his review for *Rolling Stone* that *Heathers* allowed Winona to 'enter her generation's circulatory system. Teenage life was twisted, and Ryder, more than any other actor or actress, was in on the joke.'

The Nation's critic noted that '*Heathers*, a new comedy, lets you fulfil one of the core fantasies of adolescence; seeing all the popular kids in their graves.' While Roger Ebert of the *Chicago Sun-Times* observed, 'the movie is shot in bright colours and set in a featherweight high-school environment, in which dumb sight gags are allowed to coexist with the heavy stuff,' but he wasn't sure whether the film was 'a black comedy or a cynical morality play,' concluding his review by pointing out that 'teenagers will understand it best.'

But the review in *Village Voice* was the one Winona liked best. 'This is going to sound really obnoxious, but listen to what it says; "Winona Ryder plays the conflicted Veronica with deeper-than-method conviction." That's good, isn't it?' Good or bad, Winona discovered that all publicity is good publicity. Some reviews, she said, were exactly the kind to make people 'run out and see the movie.' In fact, in the USA, the film acquired such a cult following that some showings reported scenes of dialogue from the movie

being shouted out along with the on-screen action. Moans of 'Fuck me gently with a chainsaw' and 'I love my dead gay son!'

The reviews in Britain simply raved over the movie. *The Guardian* called it 'a teen movie to end all teen movies.... bites at all the conventions until real blood flows along with tears of laughter.' Another praised it as 'the blackest comedy of the year,' while others noted *Heathers* was a 'wicked, fun winner, outrageous.' The only negative comment came from *The Times* critic, Sheila Benson. 'No amount of production sheen or acting skill seems excuse enough for the film's scabrous or its unprincipled viciousness.'

All the same, *Heathers* was by no means a box office smash, its gross of a little over a million dollars ranked it a meagre 165th on the year's most successful movies listing. If that was true, and it's true that every generation gets the cult it deserves, there could be no better successor to *A Clockwork Orange* than this.

It was even turned into a stage play by students from the same high school that Winona had attended in Petaluma four years previously, and two years after the movie had been released. Sharing the same critical objection that the film had received in some quarters, the only real downside for the self-named Inappropriate Players was the fact that high school principal Frank Lynch didn't want it staged on the school campus because of the language and content in the script, so he banned it, saying the play was 'inappropriate for high school students' even though some lines had been cut from the pre-shooting script that teen director Todd (now Tawd b) Dorenfeld had laid his hands on from Script City in Hollywood.

Not only did Dorenfeld turn that script into a stage version, dismiss himself from class to run home to take a call from Daniel Waters to explain why 'some punk kid was trying to do his film on a school stage,' but he also took on the role that Christian had played in the film. 'I studied his work like one would study a snail crossing the street,' he recalls today. 'I looked closely at why he

made those Nicholson choices. I went with the kind of pop-history approach. Jack was the human that played the hero in *Cuckoo's Nest* on the screen, and that role to me was what Slater's character was trying to portray. The character, after all, when you think about it, had no personality of his own, he couldn't separate his politics from his emotions. He needed to pretend who he wanted to be. So doing the Nicholson-James Dean Hydro-Baby Teenager was perfect. It made him cool, so I did that. I did Slater.'

Despite Dorenfeld's praise, it is perhaps amusing to consider that there was a time when Michael Lehmann wasn't too sure about Christian's ability to pull off the character of JD. 'You look at him and think, this guy shouldn't be a movie star. He's got these kind of rounded cheekbones and this funny little grin on his face and those eyebrows that go up and those eyes that squint. I remember turning to our casting directors, who were women and saying, "What do you think? Are girls going to like him?" And everybody nodded their heads, and said "You bet!" '

It was a similar story for Winona. At first, she says, 'they didn't want me. It's actually on the commentary for the DVD. Dan and Michael are talking about casting me, and they say something like, "Remember how we didn't think she was pretty enough?" But when I heard that, I immediately went to some mall make-up counter and had them put make-up on me, and then I went back and convinced them to cast me. So even though *Heathers* didn't make a lot of money, I really was able to transition into a situation where people thought I could play an attractive role because of it.'

By the time the students were on the verge of surrendering one of their ambitions for the spring school production, the school's drama teacher Robert Liroff (who had believed in Dorenfeld's enthusiasm, choice, pitch and rewriting from the start) continued to do his best to schmooze the school's powers-that-be to withdraw the ban, but he got nowhere, until Raymond Jax, a professional concert, play and event producer, whose daughter Taliesyn was

playing one of the Heathers, came flying to the rescue to produce the play off campus, with Liroff's full support, and Tom Gaffey at the Phoenix Theatre in downtown Petaluma.

Then as now, Gaffey managed the Phoenix as a popular teen hangout that always welcomed teens who might have no place else to go, didn't want to go home to abusive or absent parents, or just wanted a comfortable place to spend time away from the watchful eyes of local police. With permission from Hollywood's Trans Atlantic Entertainment granted to perform the play based on the screenplay of the film, and with a telegram of encouragement and support from Winona, Michael Lehmann and Daniel Waters, indicating their well wishes for the production, and Winona's regret that her schedule would not allow her to break free to attend, the play eventually ran for three nights in June 1991.

As for the movie, critics generally wondered if young viewers could misinterpret the film's satirical content of teen cliques and suicide pacts that accompanied the murders. 'Yeah, we're getting hammered on that,' Winona sighed, but still didn't believe that the film romanticised the subject. 'We make it look sad. When kids die in our movie, everyone suddenly claims they were your best friend. What's romantic about that?'

In fact, she stoutly defends it and is convinced 'the film is obviously exaggerated, but I think it rings true.... 'Anyway, isn't that the whole concept of being a teenager? It's a time when everything in your life is exaggerated. Every motion, every event.'

Indeed it was a subject that, for Winona, struck close to home. One of her own high school classmates in Petaluma had committed suicide and already feeling disgusted with the behaviour of her school, she then and today goes to great pains to explain what happens in *Heathers* is precisely what happened in real life.

'People made fun of her. People were horrible to her. She was called everything from a freak, a witch, just a girl who dressed differently, who was kind of Goth' Then after she killed herself,

'Everybody's her best friend. Everybody talks about how wonderful and beautiful and great and artistic she was, her funeral was huge, and they gave her a spread in the yearbook, just like in *Heathers*.'

Perhaps that fact alone should have warned both Christian and Winona away from the film. 'It's not a funny subject,' they were told. 'And people won't find it funny. They'll think it's distasteful.' Interestingly enough, neither Winona nor Christian thought it was. 'I remember wanting to kill some girls in high school, but would never have dreamed of doing it,' Winona recalls. 'But it's such a difficult time in a person's life, and I think almost everyone has fantasies like that. Although the film is an exaggeration, the cliques and all the pranks in the film were like those I experienced in school. I think it's the insecurity of students that prompts them to be cruel to others. The results can be humiliating and devastating if you're not a member of one of the cliques, which I detested with a passion.'

Even her high school friend from Petaluma, Heather Bursch, was completely disturbed by it, remembers Winona, 'and we usually agree on everything.' At the same time, though, Winona also knew that 'this stuff scares people. But I think the movie's very smart. It's the first time I've done a film I could say was really important. Even if you don't like it, you have to admit it opens up a whole new can of worms.'

For Winona, making the film was a formative experience. 'I was sixteen when I made it, and going through this whole thing where I wanted to be taken seriously. I was sick of being treated like a kid, then working with these people, I was suddenly being treated as an equal, and they wanted to hear my input.' It was probably the turning point of Winona's career. The time when audiences finally realised what a fine actress she actually was.

'She can play the unsympathetic or ambivalent part, and audiences hang in there with her,' explains producer Denise Di Novi. 'I tease her that she's like a witch. Her instincts are so good,

it's almost creepy. From her first film to her last, you look at her and say, "there's a real movie star." '

That was certainly true, but Winona was still learning. One of the things she picked up was the knowledge of her sudden maturity. Before, she remembers, 'I'd sometimes try to see how lazy I could get. Tim Burton aside, my other directors had all been father figures, and all I'd have to do to get what I wanted was bat my eyes and be really cute. But with Michael, I couldn't do that, he knew what was up, and if I started to get lazy, he'd whack me into shape pretty quickly.'

But the movie had another effect on Winona. 'It taught me a lot about what I want to do with my life, my career, which is never do anything I don't feel one hundred percent about. I could probably have the perfect career if I sat down and talked to people and made decisions. I could have a road mapped out for me, and things could be very simple. But who wants that? It would mean not doing things I really wanted to do.'

Nevertheless, continues Winona, 'I wouldn't do a movie where I thought I'd influence anybody in a bad way. Having people look up to me freaks me out.' But even that, she found could be equally motivating. 'It makes me want to do a really good job, because if I do something really stupid, it could shatter somebody's image of me. So I don't have the freedom to do really stupid things, which is what I'm striving for.'

And since *Heathers* she admitted, she made more of an effort to look feminine. 'Before, I just dressed however.' She'd even go to the set dressed in her pyjamas. Now she dressed differently each day. 'It all depends on how I feel when I wake up,' she explained. 'The music I listen to. That always determines who I want to be that day.' She wasn't so keen, however, on the way photographers dressed her up like a sex bomb. 'I end up looking twenty-five,' she complained at the time. 'I think of myself as a girl, not even a

young woman. Nothing with the word "woman" in it.' Even today she admits having 'to fight not to wear make-up in photo shoots.'

Only weeks prior to *Heathers* opening, Winona and Slater went to preview screenings of the film on several US college campuses and schools. One was a promotional showing at a New York film class. It was there the couple announced they had just got married the previous week in Las Vegas. Holding hands romantically, and calling each other 'honey' throughout their appearance, they never dropped the act.

Even the less than enthusiastic audience – many of whom had already left because they were clearly disturbed by the movie's undertones – were clearly surprised by this sudden announcement, but nevertheless offered their congratulations. But the incident only encouraged Winona and Slater to contemplate further mischief. 'We talked about how we were going to do all the Hollywood marriage things' recalls Winona, 'like stage fights in restaurants, be really reclusive but then leak everything; he'd cover my face when photographers came near us, like Sean and Madonna.'

Slater, however, had an even greater surprise up his sleeve. It happened during a television talk show appearance when he actually proposed to Winona on air. For Winona, that was the end of the joke. She had now tired of it.

For Slater though, it was no joke. He actually did fall in love with Winona. He had already admitted that she was one of the main reasons he wanted to do the film in the first place. 'I loved her since *Lucas*. She was so cute, so beautiful and so natural. She was very helpful and very professional. I could tell that she and I had some type of chemistry.' Winona agreed. 'We really have a great on and off screen chemistry. He's one of the most brilliant actors I've ever worked with.'

Although Winona and Slater did become an item, it was only for two weeks. The relationship didn't actually get going until work on *Heathers* had been completed, and Winona was preparing

to join the set of her next movie. Throughout filming, and for a couple of years before that, Slater had been dating the late Kim Walker , the actress who played the lead Heather. Then they broke up. 'We never fooled around or anything during the movie,' added Winona, but 'he broke my heart. Or I thought he did at the time.'

For Slater, talking about Winona today, he hoped that certainly wasn't true. But 'she is a wild woman to work with,' he admits affectionately. 'She has a naviety, a vulnerability almost, that makes her attractive to be with and to watch.' It was, however the only time Winona and a co-star had become romantically involved, although the Hollywood gossip columns suggested otherwise.

'I can't believe the rumours,' sighed Winona despairingly. 'I'm going out with Dweezil Zappa. Alec Baldwin and I are getting married. And what's the other one? Oh, yeah,' Winona laughs, 'that the 1969 cast, Kiefer Sutherland and Robert Downey and I, are having a menage a trois affair!' And after her next movie, Winona would be faced with another one. This time, she said, 'Meg Ryan wants to kill me because Dennis Quaid and I are having an affair.' Throughout her career Winona would be linked by the press to, as she puts it, 'some fabulous guy,' but invariably it was not true, although she says, 'I wish it was, but it's not.'

It is the gossip factory that Winona hates most. The first time she heard a rumour about herself she worried what people were going to think. After all, she believed it about other people. And although she was told to ignore it, to laugh it off, she found that difficult. 'I want everyone to like me. I don't want to disappoint anyone. I hate not getting along, or being forced into a confrontation, or throwing what looks like a tantrum. The bottom line is, I'm like everyone else.' One night, Winona remembers getting a call from a friend with the latest story circulating, 'I flipped out. I hate it when you can't clear something up.' But she had a solution, 'I think I'm gonna get a cottage somewhere. Maybe New Orleans. Or I'm going to go to college, like soon.'

That was one of the elaborate plans she developed with friend Heather Bursch to escape from the hype of Hollywood. A disenchantment that began when she moved there. 'I never fitted in,' she said at the time. 'It's such a fake society. You get the feeling that everybody is scamming everybody else. You can't tell if people are nice because they like you, or because they want to use you. Nothing is genuine. Everything runs on rumour and gossip. It's really sick.'

Even in the height of her fame, she wanted to live a normal teenage life. 'I want to do the backpack thing, first drive across the United States, rent a car, and bring no money, and no clothes, and write really bad poetry,' she laughs. 'Then we want to go to Europe and do it there. We also want to go to Africa. We want to go to college together. We want to end up in Trinity in Ireland for the last two years, but for the first two years we want to go somewhere in the United States.'

They have still to find the time to do any of that, but at least it was in keeping with her dreams just as much as her next movie role would prove to be the most natural she had yet accepted, and once again demonstrated her diversity as an actress even though it would catapult her backwards by three years to play Myra Gale Brown, the thirteen year old child bride and cousin of fifties rock'n'roll legend Jerry Lee Lewis.

Great Balls of Fire! was, in fact, based on an autobiography written by Myra herself after the idea for a Jerry Lee Lewis movie had been doing the Hollywood rounds unsuccessfully for almost a decade. 'The problem with living legends, when you're trying to make a movie about one,' explained producer Adam Fields, 'is that the legend goes right on living. Jerry Lee was living his life faster than we could write it.' The solution was to retell the first three years of his career, the golden era of rock'n'roll, during which time 'The Killer' – as he was known – sold more than twenty five million records and became the most threatening claimant to Elvis Presley's

crown. It was a period that ended with the birth of his and Myra's son.

But even then, the story met with resistance. The great Dino De Laurentis complained it wasn't funny enough not realising that the film was about Jerry Lee Lewis, the musician, not Jerry Lewis, the comedian. Another studio executive handed the script back to Fields with the advice, 'Listen kid, you can't make a movie about someone who marries a thirteen year old.' But maybe that executive didn't realise the story was in fact true, and had actually taken place.

Indeed, Lewis's unorthodox marriage to Myra had earned him condemnation from the church in America, and more fatefully when he arrived in Britain for his first tour in May 1958, waiting reporters asking who his young companion was, were shocked to discover that she was his wife and also his cousin. Making matters worse was his revelation that he had already been married twice before. Lewis was booed off stage and forced to cancel thirty-four of his thirty-seven concerts. On his return to the States, he took out a five page trade ad to explain his recent divorce, in which he wrote; 'I hope that if I'm washed up as a performer, it won't be because of this bad publicity.' He also re-wed Myra in a ceremony of impeccable legality.

Even when the script finally became placed with a studio, and the movie's focus so sharply focused, there was still resistance. This time from Jerry Lee Lewis himself. He said the script wrongly depicted his love for Myra. As far as he was concerned it was 'bullshit, big-time bullshit. I don't think it was a real love affair. It was just a girl I made love to.'

He also disagreed with the wedding scene. In the movie, Lewis all but abducts Myra from school, singing as he sweeps her away in his red convertible and drives towards Mississippi to marry her. 'But Jerry, I'm only thirteen years old. Can't we just wait three or four years?' According to Lewis, it was Myra who dragged him to

the altar. 'I thought I had to live up to my obligations, and she forced my hand on it.'

On another occasion, he sent the script back with LIES scrawled all over it, and still reckons he only conceded because he was tired of having 'fooled around' with the movie for years, and furthermore, he now just 'wanted to get it done.' But in the end, Lewis prevailed, 'It's a good movie and Dennis Quaid did a good job. And so did the wonderful little girl who played Myra.'

Myra, too, was full of praise for Winona's performance. The two met when Myra was invited to attend one of the screenings of the dailies. It was where Winona, dressed in a Brady Boys T-shirt and jeans, would normally sit behind Jim McBride with her hands on his shoulders, and Dennis Quaid would slip into the chair behind her, to ease her onto his lap. Even attending journalists were quick to point out the closeness. 'Whether she can't keep her hands off the guys or they can't keep theirs off her, she and her director and her co-star remain in pretty constant physical contact whenever they're in the same room.'

But the day she watched Myra watching her, she was understandably nervous. 'We were showing her some stuff where he was picking her up from school and says "I'm gonna marry you." I looked over and she was crying, and I was so scared because I didn't know what she was crying about. I didn't know if she was crying because I was a bad actress or that it was so real. And then she turned to me, and hugged me, and said "You're a gift from God." It was probably the most amazing feeling that I've ever had in connection with acting.' Equally astonishing, noted *Premiere* magazine, was 'how precisely this young actress, this girl born in 1971, conveys the way thirteen-year-old girls looked at the boys in the '50s – whisperingly, if you will, with their mouths, but purely.'

Despite such high praise, Winona was nonetheless uncomfortable watching the finished film. 'I look about eleven years old,' she explained. But she was even more concerned about

the love making scenes with Dennis Quaid. 'My hair's back in a ponytail, and I'm wearing these Peter Pan collar things,' which simply added to her concern that people would go and see the movie and think, 'this is so perverted. Thirty-four (Quaid's age at the time) and seventeen. I was afraid that was going to take away from them watching the movie. That all they were going to think about was Winona Ryder and Dennis Quaid, not the love story.' It added an already existing ineptness to her scenes with Quaid simply because he had emerged himself so much in the shadow of the rock'n'roll legend that she never knew when he was being himself. 'He would say something to me, and I didn't know if it was him or Jerry Lee Lewis saying it.'

Neither did that make her feel any easier about filming the wedding night scene, in which, as Winona ingenuously put it, 'he's devirginising me.' Director Jim McBride acknowledged her anxiety. 'She was real nervous about the love scene for several days before shooting and indicated to me that she was very inexperienced in this area, and I had to sort of fill her in on things, verbally that is. I took it all very gently and gingerly, and tried to lead her there, but when we got to doing the scene, she leapt in with both feet and gave a very convincing performance. I'm not saying she's sexually experienced, I'm saying she's a good actress!'

All the same, Winona later admitted that when she watched the scene herself, it embarrassed and even shocked her when she realised it was going to included in the movie. It's really scary because it is like the deflowering of Myra. 'She starts out sort of meek and demure, and then she starts to get into it and starts to, like lose control, and there's music, and she starts to really move and stuff, and he stops her and says "Where'd you learn to move like that?" And I say, "It's the music," and get right back into it, and he gets out of bed and storms away, leaving me thinking I did something wrong. It goes through a whole range, from being a sort

of game to being painful to feeling really good, and then he freaks out, and I start to cry.'

Not only that, Winona continues, but 'the face I chose is really revealing. I couldn't believe it was me. It looks really weird to me. Dennis is so big, and I'm so little, I don't look a day over thirteen except when I take my shirt off, and I have this 1950s bullet bra on. I was just going by what I thought it would feel like. I watch other people's love scenes, everybody's so sexy, everyone tries to be really subtle. But Jerry and Myra, as weird as it was, I think they really were in love with each other, and I really wanted that to come across. I wanted to come across like, when love comes on so strong, there is no right or wrong.'

Still, she simply adored the character she played. 'I loved that role,' she told *Rolling Stone* two years later. 'Myra Lewis was probably the furthest you could get from the real me. But the things I associated with her was her strength, her honesty, and her love for Jerry Lee Lewis.'

Although it is not evident in her performance, much of Winona's time shooting the movie was plagued by ill health. It was the first onslaught of the physical and emotional exhaustion that would affect the next five years of her life. It started when filming on location in London she was felled by a particularly virulent flu.

'It was awful,' shudders Winona. 'I couldn't sleep or eat or anything. I was on these penicillin-type drugs. Finally they brought a doctor in to give me a shot, and even he was freaked out. He thought the whole film depended on me surviving. He had this horse needle, and he was so nervous that he kept missing the veins on my arms. So finally he just jerked it out of my arm, and without even telling me, gave me a shot in the butt!' It was, she said, 'my only vivid memory of London.'

Matters worsened however when the crew returned to Memphis. One night, Winona remembers, 'I was kind of delirious, and I remember doing the weirdest thing... you know when you're sick,

and you have a fever? And you pick up an orange or a grapefruit, and they're comforting because they're cold, so you put them on your face? John Doe (who played Winona's father in the movie) brought over a bunch of grapefruits for vitamin C and stuff. So I put the grapefruits all over, like surrounding me in the bed. And I just laid there and tried to sleep.'

Panic set in, and with it, came a chronic insomnia that was destined to plague Winona for the next five years of her life. 'The digital clock was going 3.30! 4.30! 5.30! I stayed up the whole night,' and when daylight broke, Winona remembers, 'it was just the saddest thing to me. I thought I was going to die or something. And from that night on, because I knew it (insomnia) could happen, it did happen.'

Talking about it some years later, she wondered why she ever told the story. 'Hey,' she exclaimed, 'maybe the grapefruits gave me insomnia for five years.' More likely though was the fact that she had spent most of her adolescent years on movie sets, and in hotel rooms and pining for Petaluma. She would frequently reminisce about home and missing her family, by all accounts, sweet, funny, and infinitely gentle people.

'My mom and dad are very different and very much in love,' admits Winona fondly. 'Mom is very sentimental and sensitive, and I've never met a single person who doesn't love her. She is completely non-judgemental. Dad is very intellectual and loving, and he's so proud of me, it's funny, he uses Ryder himself sometimes. He says, 'I want to let people know I'm related to you!' He has a clipping service and scrapbooks, and follows things I don't even follow. He knows every magazine and newspaper that's ever mentioned me.'

Despite Winona being ill during the filming, she still remembers *Great Balls of Fire!* as a fun shoot. She had certainly enjoyed the time she spent with the musicians at the legendary Sun Studios

at 706 Union Avenue in Memphis where both Jerry Lee and Elvis made their first records.

The label had been founded by Sam Phillips in 1952 as the Memphis Recording Service. But before establishing the Sun label itself, Phillips leased his recordings of Howlin' Wolf, B.B. King, Little Junior Parker, and Bobby Blue to various other labels that included among others, the legendary Chess Records. Both the Sun offices and the single recording studio were then located in the small building that had previously housed a radiator shop until moving to Madison Avenue, still the present day home of Sam Phillips' Recording Service from where he launched the Phillips International label. As for Sun Records, Shelby Singleton bought the label from Phillips in 1969, and moved out to Nashville leaving the original Sun building to be sold onto a plumbing company, and later to an auto-parts store before being restored by Grayline Tours after Elvis' untimely death in 1977, and to this day remains an historic landmark even though the studio opens operatively at night.

Winona especially liked hanging out with Mojo Nixon, who played Jerry Lee's drummer, and John Doe of the legendary Los Angeles punk band 'X'. It was Doe's rocker demeanour that impressed Winona enough to ask him for guitar lessons. He obliged as did Nixon with Winona's request to appear in his next music video for a song called *Debbie Gibson Is Pregnant With My Two-Headed Love Child*. She played Debbie Gibson wrestling a Tiffany lookalike in a giant tub of jelly. The role for Winona was the ultimate 'teen dream.'

Great Balls of Fire! was released in June 1989 to a strangely bemused critical reaction, although praise for Winona's performance once again won her the attention of the critics. *Newsweek* raved, 'Winona Ryder again proves herself the most gifted and endearing actress around. She plays off Quaid's manic romantic assault with breathtaking spontaneity, her fresh, wide-eyed face running the

scale of adolescent emotions. From glazed puppy love to pop-eyed bewilderment.'

Much the same as everyone else said, that 'Ms Ryder was fabulous.' Even the fatal box office performance of the movie at US theatres couldn't tarnish her reputation. In fact, she was the one redeeming feature of the film which, in the end, only grossed thirteen million dollars, behind some seventy other films released that year that fared much better.

Some critics, however, were swift to accuse the film of overlooking some historical facts surrounding Myra's book. One was the traumatic life she suffered the year before she was swept off her feet by Lewis. She had been raped by a neighbour, and in her own, adult opinion, she considered it relative of her marriage to Lewis because at the time she didn't think anyone else would want her. But the movie omitted any reference to it, but instead, portrayed Myra as a carefree innocent simply swept along with the excitement of Lewis, and the whirlwind of rock'n'roll. The movie's only suggestion that Myra may have been sexually experienced is when he consummates the marriage by accusing her that she 'sure don't move like a virgin.' But the comment is never explained.

Although *Great Balls of Fire!* remained reasonably faithful to the historical content of The Killer's early career choosing the legend as it's focal point, there were, as with most musical biopics, some factual content changed to suit the movie, and although purists and rock'n'roll historians may argue, overall the legend was depicted much as it happened.

For the premiere, Winona would be wowing the paparazzi by squeezing herself into a tight white Giorgio di Sant Angelo lycra mini dress with plunging neckline. She was, in fact, the first to do so. Winona, of course, would through the years, distinguish herself from the rest of young Hollywood by daring to create a look that would be both elegant and cutting edge. She did so by not falling victim to trends of the moment, but instead by sticking with the

looks that suited her. Winona's delicate features, noted *Movieline*, give her a waifishly romantic quality that allows her to wear the vintage styles of the twenties and forties she adores, better than anyone else.

Most times, in fact, she would be ahead of the hard-core fashionists. Winona, after all, would be the first to resurrect the Audrey Hepburn gamine look long before the fashion magazines christened it the next big thing. But probably the truest statement of her approach to style would be at the 1994 Academy Awards when everyone voted her Best Dressed at the Oscars. Ever since then, she would have a permanent place among the ten best-dressed actresses in Hollywood.

But it wasn't only the paparazzi that noticed Winona. Johnny Depp, the dark-eyed hero of television's *21 Jump Street* was also in town for the premiere.

Winona Forever

'Every move I made was being documented. If I drove down the street in my car, people stared. If I went out to eat, it was written about the next day. Everyone knew where I had been. It was, like, everyone knew my schedule. Everyone I met was in the industry. And even if they were nice and genuine, I'd think that maybe it was because they wanted to use me for something.'

It was a bright Sunday morning in Los Angeles when *Rolling Stone* caught up with Winona for an interview in May 1989, just weeks before the opening of *Great Balls of Fire!* She was cooking pancakes in the kitchen of her cheerful, desert-toned apartment while dancing around to a Buddy Holly CD. 'We need something more inspiring,' she told journalist David Handleman, replacing Holly with AC/DC's *Hell's Bells*, but after a few chords, she decides that's not right either, and switches to Fairground Attraction instead, singing along, 'It's got to be-e-e-e-per-fect!'

'I like their songs,' she confessed. 'They're romantic but not depressing.' Nevertheless she still prefers fifties music. 'It leaves more to the imagination.' She had, of course, just completed a movie about one of its most controversial legends.

It was at the premiere of that same movie where Johnny Depp spotted Winona, it was where they first met. Well, sort of. Or rather, its where their eyes connected. They were in the lobby of New York's Ziegfeld Theater, and according to both, it was love at first sight. 'I was getting a coke,' remembers Winona, but Depp was more precise. 'It was a classic glance,' he said, 'like the zoom lenses in *West Side Story*, and everything else gets foggy.' Winona, on the other hand, doesn't remember it being a long moment, but one that was suspended. The pair weren't introduced properly, however, until a couple of months later when a mutual friend,

Josh Richman, brought them together in Depp's hotel room at the Chateau Marmont. 'I thought maybe he would be a real jerk,' she confessed, 'but he was really, really shy.'

Depp was a Hollywood outsider seen by most as a modern rebel in the mould of James Dean. Born John Christopher Depp II in Owensboro, Kentucky, on 9 June 1963, he initially pursued a rock career with a band called The Kids. But that was before he moved over into Hollywood to pursue a relentlessly uncommercial series of films and oddball parts that resulted in a career that was as bright as Winona's. He debuted in *A Nightmare on Elm Street* in which he was swallowed up by a bed, and followed it with minor roles in *Private Resort* and *Platoon* before landing the role that would take his career to new heights of fame with a reported staggering ten thousand fan letters a month. *21 Jump Street* was the most popular television show in America at the time, and Johnny Depp was its star. The premier male teen idol, the ultimate symbol of cool.

From that point of view, Depp and Winona shared much in common. They were both the biggest stars of their generation. The rising TV idol and the teen starlet. It was a movie match made in heaven. But they shared much more than fame. Depp had read the Beat poets that Winona grew up with, loved to collect the first editions of their work, often visited her father's book store, and understood the counterculture that had surrounded her childhood. And not least, they had a mutual obsession for *The Mission* soundtrack, Jack Kerouac, and Salinger's *Catcher in the Rye*.

With such bonding qualities, it was no surprise that once Richman had introduced them to each, there would be an instant connection. There was, and almost before Winona knew what was happening, she was arranging to see Depp again. Their first date was at Timothy Leary's house. Depp was ecstatic. 'When I met Winona and we fell in love, it was absolutely like nothing before. We hung out the whole day... and night, and we've been hanging out ever since. I love her more than anything in the whole world.'

As Winona admitted later, 'I never really had a boyfriend before.' At seventeen, she hadn't really contemplated, or even thought about a serious relationship. The only seemingly close call had been her two week fling with Christian Slater. And that she said was 'too weird,' reasoning that 'when you're really good friends with somebody, it's hard when you try to make something work. It's bogus. It should just happen naturally.' She was not, by her own admittance, a veteran of relationships.

'It wasn't like I was after Johnny or anything,' she confided. 'I'd heard horror stories about what happens when you dive in real quick.' But she underestimated the strength of her own emotions. Five months after meeting each other, they were engaged, and a month after that, they were living together, even if it was in a succession of hotels and rented apartments. Their relationship was quickly taken up by the tabloids and the teen magazines. Winona Ryder and Johnny Depp. The gossip columns couldn't go wrong. The fact that Depp was twenty six, Winona, seventeen, and they were getting engaged was headline news.

In fact, the press couldn't resist writing about Depp's habit of getting engaged. His previous engagements to *Twin Peaks* star Sherilyn Fenn, and Jennifer Grey of *Dirty Dancing* didn't seem to worry Winona in the slightest, or if it did, she shrugged it off. 'People assume it bothers me that's he's been engaged before,' she vowed, 'but it really doesn't. We have a connection on a deeper level. We have the same colouring, but we're from very different backgrounds, so we're interested in each other all the time.'

The tabloids nevertheless hounded the couple from the moment the relationship went public. And in Manhattan there was even a brief craze for car bumper stickers that demanded HONK IF YOU'VE NEVER BEEN ENGAGED TO JOHNNY DEPP. It was during this time that Depp developed his hatred for the press. Most actors have a love-hate relationship with journalists. Although most are willing to be accommodating with film publicity, when

their private lives are put under the microscope, most celebrities object to the intrusion. Even when things are stable, being asked the same question ten thousand times is understandably irritating. It was this aspect that annoyed Depp more than any other. He particularly remembers one occasion when he was 'in the John of some bar, and some stranger came up to me, and said, "So are you and Winona still together?" In the urinal for Christ's sake!'

Winona, too, found the pressure of Hollywood's ravenous paparazzi pack and the constant media exposure of their relationship both tedious and tiresome. So much, in fact, that she became inwardly protective of the situation, and would in the future keep a tight check on her press profile, never allowing matters to snowball out of control as they had done in this period. She rightfully considered that the world had no right to intrude on her private life.

'I don't like discussing my relationship with Johnny with the press. It's nobody's business. Nobody knows anything about it, not even my friends know what my relationship is like. I don't even know it.'

Depp, however, was so involved with the relationship that he felt the need to set the record straight. 'There's been nothing throughout my twenty seven years that's comparable to the feeling I have with Winona. It's like this weird bounding atom or something. You can think something is the real thing, but it's different when you feel it. The truth is very powerful. Now I know. Whatever I've been through before, it hasn't been this long. It wasn't like, "Hi, nice to meet you! Here's a ring." '

He even confirmed the permanence of his attachment to Winona by having WINONA FOREVER tattooed in a double banner scrolling on his right bicep only inches above the Indian chief head commemoration of his Cherokee heritage to match the BETTY SUE tribute to his mother on his left, which for some seemed a rather extreme way to express the seriousness of his

intentions to Winona. For Depp, it was simply an eradicable mark of his commitment to her. 'Believe me, it's not something I took lightly.'

Still, Winona herself must have been thrilled, even if, as she waited at Sunset Strip Tattoo, she freely admits, 'I was sort of in shock.' Besides, she continues, 'I'd never seen anyone get a tattoo before so I was petty squeamish, I guess.' Repeatedly removing Depp's bandage to stare at the engraving afterwards, 'I kept thinking it was going to wash off or something. I couldn't believe it was real. I mean it's a big thing because it's so permanent.'

For Depp, the relationship was the closest he came to getting married. Certainly that is how Winona favoured it. 'I've got the feeling that this is right. But I don't want to do it just so I can say I did it. I want to have, like, a honeymoon, and the whole shebang. We're going to get married as soon as we have time, and we're not working.' Winona's father was equally enthusiastic. He himself entertained no doubts whatsoever. If anything his instincts screamed approval. 'He thinks, Marry him!' said Winona. Most evident from the times when she and Depp spent weekends at Winona's family home in Petaluma away from their New York loft. Once there, she remembers, they were completely pampered. 'They really love him a lot and even bring me and Johnny breakfast in bed. They're so cool.'

Not so cool, however, were the work schedules that kept the couple apart for the first few months of their relationship. Depp was in Vancouver on the set of *21 Jump Street* while Winona was shooting her next role in Jim Abraham's *Welcome Home Roxy Carmichael* in Clyde, Ohio. And although work for both would prove to be an aching separation, it would also provide a welcome rest from the daily harassment of the popular press.

Winona had been attached to *Welcome Home Roxy Carmichael* for at least two years, and in that time she had accumulated a crateful of items that she thought her character, Dinky Bossetti,

might need. Things such as circus posters, and back issues of National Geographical even though they were unlikely to be used on screen.

She had even visited the massive Rose Bowl flee market in Pasadena looking for a book bag. Scrutinising an old doctor's satchel, and shifting it from hand to hand, considering its weight, she put it back on the stall holder's table. No, Winona decides, 'she needs a backpack. This is too uncomfortable to carry, and Dinky's a very practical girl.' It was typical of her method of getting into character.

But she no longer felt a connection with it. She did when she first read the script, but she was fourteen then. Now Winona knew she was too old for the part. 'It was the first time a movie had been made just for me, so I couldn't say no.' On top of that, she complained that she had completely misread the feeling of the story to the point she hoped people wouldn't even go and see it.

Nevertheless her portrayal of Dinky was, as Roger Ebert said in his review, 'the one small treasure' of the movie. Her performance, he continued was 'perceptive and particular.' That was certainly true, but the film was, all the same, hammered by the critics on its US release in October 1990. But it was a different story in Britain.

Although highly praised as a 'darkly comic drama of dream and expectations,' and one that was 'touching and amusing while dealing with ideas seldom touched on in American cinema,' the film sadly was swallowed up amongst the surge of bigger movies on release at the time. It was nonetheless a film Winona should be proud of, if only for her precise portrayal of a troubled teenager. Her feelings of disappointment may have been misplaced.

Winona's character, Dinky Bossetti is the fifteen year old adopted daughter of carpet salesman, Les Bossetti (Graham Beckel), and his domineering wife, Rochelle (Francis Fisher). She knows nothing of her real parentage, but as her hometown of Clyde, Ohio begins preparing for the return of Roxy Carmichael, the home-town girl

made good, rich and famous, Dinky begins to construct a past for herself that might explain her own attitudes and peculiarities.

Dinky, or Stinky, as her schoolmates rechristen her, dresses entirely in black, has painted her bedroom the same colour barricading it with an array of locks and chains, spends much of her time on the riverbank in the ark she has constructed from an abandoned houseboat with the menagerie of animals she's collected, and her ideal family vacation would be spent working on the 'Alaska Pipeline.'

That return of Roxy's to dedicate a Cosmetology and Drama Center dominates much of the story as does Dinky's conviction that she is the baby daughter that Roxy bore and abandoned at the hospital fifteen years before. But how ordinary, or heroic, was Roxy, or indeed what is she is famous for. It is a question that Dinky asks Roxy's ex-boyfriend, Denton (Jeff Daniels). 'She was in a song,' he replies, but when Dinky can no longer disguise her incredulity, the only reply he can muster is: 'Do you know how hard it is to get in a song.' Even so, Dinky believes that Roxy was possessed with other peculiarities, many of which surface in Dinky's own personality in the days leading up to Roxy's return, which when the day finally arrives, does nothing more than devastate the myth of popularising the most ordinary of heroes.

Directly after completing *Welcome Home Roxy Carmichael*, Winona travelled to Boston to join the set of her next movie, *Mermaids*. She had read the book by Patty Dann long before she saw the movie script. 'It touches different people in different ways,' remarked Winona of the story's appeal. 'Some people think it's about mother and daughter relationships. Other people think it's about what happens when you don't have a father.' For Winona, it was about being a teenager, jumping from one obsession to another, and 'not being able to figure out who you really are, and what you really think.'

Winona was to play Charlotte, the teenage daughter of Mrs Flax (Cher). It was a part Winona instinctively knew she wanted. If nothing else she could at least relate to her inconsistencies more than she could Dinky Bossetti's. By her own admittance, Winona was just as erratic. 'Every day I'm in a different mood,' she said, but nevertheless, playing a fifteen-year-old teenager still proved challenging. 'It's hard to erase knowledge about life so you have to give yourself a lobotomy.' But continued Winona, 'If I'm there in my head, what happens to my body just happens. I have no control.'

By the time she arrived in Boston, and having had no time off at all in between films, she was exhausted, and still not sleeping well. But she didn't let it show. Even when she did find a break in her schedule, she filled it with Depp, and when she couldn't do that she worked, worked, worked. She appeared in a fifteen minute question and answer AIDS documentary being made by her mother's video production company, and starred in Mojo Nixon's *Debbie Gibson* video, and when she wasn't doing that, she even found time to pose for *Spy* magazine's Christmas cover decked out in a Santa Claus costume, commenting on the recent explosion of interest in the constitutional status of flag burning.

Winona reasoned away her voracious appetite for work by pleading 'since I was in demand at the time, I couldn't refuse.' But her first day on the *Mermaids* set was not as simple to justify. In fact, the production was one of total chaos. When filming began the previous autumn, Swedish director, Lasse Hallstrom of 1985's *My Life As A Dog* was directing the movie. He had assembled the original cast that included Britain's Emily Lloyd of *Wish You Were Here* fame in the pivotal role of Cher's eldest daughter, Charlotte. But when Hallstrom announced he wanted to revise the script to include Charlotte's younger sister, Kate (Christina Ricci), commit suicide, Cher fiercely opposed the idea. It was, she complained, too far-fetched for words. She also knew that cinema audiences

wouldn't sit still for such a storyline. After all, *Mermaids* was a feel-good movie. And there was no way on earth she was going to do anything else to the contrary.

Hallstrom exited the production taking Lloyd with him, and although industry rumour suggested she was dismissed and later sued the production, Winona was recruited to replace her, with Muppet maestro Frank Oz taking over the directional seat. But even then, there was conflict. Oz didn't understand the picture either. He began treating the movie as if it were Chekhov, turning the family drama into a Greek tragedy by laying stress on the tragic aspects against the comedic ones. Another problem apparently was the fact that Oz worked too slowly threatening to take the film badly over schedule.

Shooting was already well under way when Oz also quit the set and another industry rumour was swift to credit Cher and Winona with the coup, a rumour that Patrick Palmer, *Mermaids* line producer, supported. 'Winona led to Frank's leaving as much as Cher did. I was surprised she articulated things so well. The adult side of her is very clear, with very strong opinions. Like Cher, she's very calculating in that she knows what is good for her, and does what is best for herself in the long run.'

Even visiting journalists to the *Mermaids* set were quick to point out that with their similar dark hair and eyes, Cher and Winona made a striking and credible mother-daughter pair, and if the rumours were true, they also shared a similar flair for getting their own way.

But the first time Winona met Cher, she was understandably wary. Nonetheless Winona didn't have any preconceived ideas about her co-star. 'I thought maybe she was going to be intimidating,' but as soon as they met, they found they were instantly compatible. 'We just struck up an instant friendship,' remembers Winona. 'We connected real well, and I think that comes through in the film.' But it also came from, as Cher points out, 'the same acting style.

There's sparseness to it. She prepares very little. She just goes out and does.'

In the years following her break-up with her late husband, Sonny Bono, killed in a tragic 1998 skiing accident, Cher had established herself among America's top female rockers, and was now carving out a similar career in Hollywood, and having already won critical acclaim for *Silkwood, Mask, The Witches of Eastwick,* and an Oscar for her performance in *Moonstruck,* no one doubted that *Mermaids* would help her gain even more momentum.

Nevertheless, there were moments in Cher's career when a lot of people told her she couldn't be a singer, or a television star, and certainly not an actress. They even said she could not have a hit album in the nineties. But each time, her determination proved her doomsayers wrong. Much the same as Winona had done, when rejecting the advice of her agency, she filmed *Heathers.*

Winona simply found Cher delightful. A bond that was further cemented when Cher shot a video for her 1990 British chart topper, *The Shoop Shoop Song,* and closing theme song from the *Mermaids* soundtrack, for which she insisted Winona and Christina Ricci appear alongside her, decked out in wigs and pink polka-dot outfits reminiscent of the film's period. Cher later raved, 'We were like sisters. We lived together, hung out a lot and got a lot of strength from each other.'

The arrival of *Mermaids* third director Richard Benjamin improved things immensely. Having been an actor himself, Benjamin had an immediate sympathy with actors requirements. But he was forced to introduce longer days into the filming schedule. At least twelve to fourteen hours each day. For Winona that would prove to be arduous on top of her already declining ill health. She was still battling against insomnia, and combined with wandering around the set in Charlotte's summer dresses during Boston's coldest ever winter, Winona was a flu victim just waiting to happen.

She had suffered bronchial and sinus infections since she was a child, but she had never experienced anything quite like this. Nevertheless she struggled on untreated and unrested until her condition worsened, and not surprisingly, developed into an upper-respiratory infection that was so severe it halted production for an entire week while Winona struggled to regain her health.

'I was really sick, and I couldn't get better because I was so cold all the time.' But she consoled herself with two hundred packets of instant Japanese noodles that Depp sent her, and a tape of the Minneapolis band, the Replacements.

'My favourite band of all time is the Replacements,' she once swore. 'If I were to have a hero or a personal god, it would be Peter Westerberg.' The Replacements vocalist had already lent his name to the high school in *Heathers*; now throughout the making of *Mermaids*, one Replacements song dominated Winona's listening, *Sixteen Blue*. 'To me the song is about inconsistency. It's about thinking you are crazy – that's how you feel when you're sixteen.' Later, once she was well enough to resume work, if any single outside influence helped her get inside Charlotte's head, then it was *Sixteen Blue*.

Johnny Depp visited Winona on the set as often as he could throughout the *Mermaids* shoot and through his own filming commitments on his fourth, and last season of *21 Jump Street*. It was where they would constantly fall into an embrace after each take and stand hugging wordlessly until he relinquishes her for the next take. But he could clearly see that Winona was not well. Those long sleepless nights, he observed, were finally taking their toll on her. His weekend treks cross country to Boston started with the last flight out of Vancouver every Friday, and the last one back on Sunday. His only comfort was knowing that Winona had Cher to fall back on.

'Noni and I had some catastrophic days, and we cried a lot,' remember Cher. 'Both of us were insecure being told that our

instincts weren't on target. Noni was battling insomnia and chewing her nails up to her elbow. If I wasn't so strong, and she so trusting, we would never have gotten through it.'

It was a strength and trust that guided Winona, still exhausted, through the final part of filming and the voice-overs she was required to provide for the narrative structure of the movie. It was Cher, says Winona, who got her through that. She taught her how to relax and generally kept her from, 'you know, freaking out.'

For all its troubles Winona still loved *Mermaids*. 'I really wanted to get into performing with what I would term a family drama, although it's a pretty strange family. It's a film I like a lot because it shows the inconsistencies of being an adolescent, and their sudden changes of mood.'

Winona also loved the role for being the 'epitome of inconsistence teen angst.' In one scene, when looking for Charlotte after she takes her car, Mrs Flax tells lover Lou Landsky (Bob Hoskins), 'I'm her mother, if something bothers her, I'm the last person she's going to talk to. She's a teenager for Christ's sake, I'm amazed she even talks at all.' Winona's point exactly. 'You stop communicating because you can't articulate what you're feeling. You assume your parents can read your mind. You're confused, they're confused. It's a party of confusion.'

It was that exaggerated fickleness of behaviour and mood in Charlotte to which Winona related in the role. 'One day she'll be obsessed with Catholicism, but the next day she'll be obsessed with Joe the gardener. And the next day she'll want to be an American Indian. I had really been going through stuff like that. I would think, I'm going crazy! I don't know what I want. I don't know who I am!' It is afterall, Winona agreed, what made both the melodramatic and comedic centrepiece of *Mermaids*.

The movie is essentially a romantic comedy that opens with Mrs Flax breaking up with dating her boss, and going straight home to pack up her belongings and her children, Charlotte and Kate,

and pin pointing a map to decide their next destination. It has happened eighteen times before, observes Charlotte. Every time Mrs Flax breaks up with one of her boyfriends.

The family, this time, ends up in Eastport, Massachusetts. A small sleepy town whose only eligible bachelor is shoe salesman named Lou Landsky, a short, fat, balding man who quickly becomes hopelessly devoted to Mrs Flax. Charlotte in the meantime has found a love of her own in the form of the neighbouring convent. But her fascination with Roman Catholicism and her religious calling to become a nun are soon challenged when she meets Joe Peretti (Michael Schoeffling), the handyman who works at the convent. He also drives the school bus. 'Please God,' pleads Charlotte, 'don't let me fall in love and want to do disgusting things.' She even finds herself wishing he was unbuttoning her dress as he tells her about his long dead mother dying in the house she now lives. Shocked at her sinful shame, she's convinced she's 'going to burn in hell for sure.'

Her flames of guilt and lust are only cooled when for the first time she and Joe make love in the convent belfry of all places, while little Kate, falls into the river, narrowly saved from drowning by the nuns in the convent. The climax of the story though, and Winona's finest in the movie is the one in which Charlotte struggles to prevent her mother from moving once word of her liaison with a much older man has spread through the community with scornfully fateful results, and one that ends indignantly for Charlotte at the same time as she begins to understand the instincts that motivate her mother.

'This is not about him, this is about me, okay. That's over. He is gone. Maybe your life works for you, but it doesn't work for me, and I want to stay and finish high school.'

'Great Start' screams Mrs Flax. 'What's your major – town tramp?'

'No mum, the town already has one.'

It was a scene Cher was unlikely to forget filming. After a couple of run-throughs, the cameras shot the take, but Winona didn't pull back from the slap as she had in rehearsal. 'When I connected,' remembers Cher, 'I thought I was going to pass out, because we'd done it three or four times, but the slap you're seeing, she didn't pull back, and I caught her right on the side of the face.'

Winona however, had done that on purpose. Otherwise it would, she feared, 'just look like I snapped my head, and I wasn't hit, so it worked that way.' But it also allowed Winona the freedom to create the performance she wanted. A testament to the dedication of her acting, something she had begun to learn in her childhood at the impromptu groups her mother ran in Elk. She made the unbelievable believable.

She didn't feel quite so dedicated, however, to the final sequence bopping around the kitchen set to Jimmy Soul's *You Wanna Be Happy.* 'I've always been a little bit uncomfortable with dancing,' Winona told an Oprah Winfrey audience at Aspen. 'I guess I was a little nervous, but it was a lot of fun, a lot of energy, and I don't know how many takes, wasn't that many though. It was the last day of shooting which was great, so we had the whole movie behind us, so we were really excited.'

Cher confirmed, it was pretty lose, to the same audience. 'And also, it came pretty much out of nowhere. We didn't really decide to do that until very close to the end of the movie, so it was really fresh, and we really didn't know what we were doing, and the moves were loose so we had a pretty easy time of it.'

But the most uncomfortable scene for Winona was the sexual sequence in the belfry. 'Let's face it,' she said, 'sexuality is such private thing. Only people in this business have to actually perform it, but luckily, it's just work, and you don't really – well, there's no insertion involved. Thank God.'

Nevertheless, *Mermaids* was the second time she lost her virginity on screen. 'Yes,' she remarked, 'I've gotten to share that

moment with the world twice,' but she still found it embarrassing. 'When I see myself on screen kissing somebody, or trying to seduce somebody, or thinking about those things, I get really nervous, and I just want to crawl under the seat.' She was even more surprised when a couple of friends told her she was really sexy in *Mermaids*. She didn't think so. For Winona, it was 'the most unsexy thing I've ever done.'

She continues. 'I've never done anything deliberately sexy. I'm relatively shy about that stuff. At the same time it's exciting. But I'm really grateful that I haven't made myself on the basis of being sexy. With a lot of actresses, that's them. That's what they are, that's what they're famous for, that's what they've sold themselves as. Maybe I've done a couple of bad movies, but I never exploited myself.'

The critical reaction to *Mermaids* was mixed. *The New York Times* called it 'a smooth, unexceptional entertainment about coming of age in a world where truly bad things happen only on television,' but nevertheless found the movie 'enchanting and funny.' *Variety* thought the film was 'caught between worlds, oscillating between broad comic strokes and tired familiar melodrama.' But most felt Winona was the true star. Roger Ebert added, 'In another of her alienated roles, she generates real charisma.'

Even with such high praise, and a Golden Globe Best Supporting Actress nomination for her performance, Winona was rapidly tiring of playing the alienated teenager, and no matter how much charisma she generated, she wanted to leave those roles behind. She came upon the solution, however, sooner than she thought.

In less than a day after finishing *Mermaids*, Winona was on a flight to Rome to join the set of Francis Ford Coppola's *The Godfather Part III*. Coppola knew that he had 'a wonderful actress in Winona.' But what he didn't know, or expect, was that she would get sick. Neither for that matter did Winona.

Coppola had a reputation around Hollywood for being a larger-than-life film maker in the Orson Welles tradition. He was arguably the key American director of the seventies for consistency, innovation and sheer breadth of vision. Martin Scorsese, Robert Altman, and Steven Speilberg were probably his only serious rivals, but now, at the dawn of the nineties, he was thought to be all but washed up. Either that or he was deliberately keeping a low profile after the low-budget, but lavishly produced old-style Hollywood musical, *One For The Heart*, bankrupted his independent production company, Zoetrope, in 1982.

Inspired by an apprenticeship with Roger Corman, Coppola made his feature debut with a B movie shocker called *Dementia 13* in 1963, and followed it with a handful of other low-key, but admired pictures. The most notable of these being the feminist road movie, *The Rain People*. In that same period, he also turned his attention to scripting, *Reflections In A Golden Eye*, *The Great Gatsby*, and the Oscar winning *Patton* among them. He also turned to producing, and came up with the classic American Graffiti, part of which, interestingly enough, was filmed in Winona's hometown of Petaluma. Although *Graffiti was* among the most successful of Coppola's recent offerings, none would be as popular as when he directed his Vietnam odyssey, *Apocalypse Now*, or his Oscar winning *Godfather* epics *Parts I* and *II*. Individually and collectively, they were the redefining of the gangster movie, just as *The Exorcist* and *The Omen* had redefined horror. A run of movies followed with *The Outsiders*, *Rumble Fish*, *Tucker* and *Peggy Sue Got Married*. An impressive resume, but apparently it had it's drawbacks. Whereas those latter films all scored at the box-office, they weren't exactly blockbusters. And neither was the Coppola name alone strong enough to sell movies anymore. It was probably for that reason as much as anything else that Coppola decided to break with tradition and return to the *Godfather* series after fifteen years. Even though

he had once vowed, 'it would be a joke, a farce. Abbot and Costello meet the Godfather.'

Nevertheless, Coppola receded his own words, and commenced filming late in 1989 for a Christmas release the following year. With a forty five million dollar budget, Coppola assembled his cast. As before they were excellent choices. Al Pacino, Robert Duvall, and Diane Keaton all returned to the roles they had made famous, or by which they had been made famous. Andia Garcia and Eli Wallach joined with substantial roles. And playing Corleone's daughter Mary would be Winona.

Winona however was still exhausted. Most evident from the moment she and Depp stepped off the plane in Rome. Her fever was running at a hundred and four, her lungs were killing her, and her ears were piercing in agony from the flight. More worrying though was her condition days later when there was still no improvement. Her ears were still ringing in pain, and her lung infection made every breath an agonising chore. Nevertheless, and right on schedule, she turned up for work. But then she collapsed in her hotel room.

Depp immediately summoned the production team doctor, who promptly declared Winona too sick to work, and to sick even to fly home. After a few days, however, she did fly home to Petaluma recalling that the only thing that got her through the flight was the thought of her mom's soup and getting into her own bed. 'I was seventeen years old, and when you haven't been home for a year, and you've been working the whole time, and you're really sick, you just have to be home.' No different to what any of us would do suffering similar conditions. But when you are Winona Ryder, any symptom of bad health is seen as nothing more than seriously delaying the production of a major motion picture. It was the one area of affliction she had so proudly avoided throughout her teenage years on set. And there was no shortage of adults who wanted to make her painfully aware of that.

In fact, as she lay in bed at home and recovered, she was getting threats of her career being over, of getting sued, and of throwing away the opportunity to star in a true American classic. Even her agent warned Michael Horowitz, now firmly placed with Cindy as his daughter's manager, that if Winona didn't do the movie, she might as well give up acting there and then. Winona later retorted by departing the agency the moment she could. But the advice was the same everywhere.

The press, of course, were just as bad, swiftly attributing other reasons for her departure from the *Godfather* set in Rome. Stories of all descriptions circulated around Hollywood. From a nervous breakdown, an eating disorder, and a drug addiction, to being pregnant, and running off with Johnny Depp. Some even suggested, it was so she could join the *Edward Scissorhands* set with Depp in Florida, despite the fact that Winona had already agreed to appear in the film long before Depp was cast in the title role. And even though the shooting schedules of both films would overlap, Winona would overcome that problem when she got to it.

Equally, she quickly dismissed the suggestions that Depp was influencing her to drop out of the Coppola movie. Instead she credited him as the one stabilising force who got her through the troubles that sprang from her ill health. 'He was just taking care of me, ordering room service and sticking his fingers down my throat, helping me to throw up.'

But what Winona couldn't understand, however, was all the commotion. 'I was sick and exhausted. That's what happened.' But on her return home, and for months to come, Winona became equally sick and exhausted at having to defend herself. 'The truth is so simple. It's amazing how people want things to be as complicated and nasty as possible.' But how many more times would she have to defend her decision? 'I think maybe some people are waiting for me to fuck up because I hadn't really fucked up yet.' All the same, she continued to explain time after time after time, I had nothing

left in my system. I was a wreck in every sense of the word, and I just needed to rest and do nothing.'

Sure, she continues, 'it's disappointing, devastating, in fact. I wish it didn't happen, but it did. Obviously I would have loved to work with those wonderful actors and a great director. But it wasn't a choice. It wasn't like, "Well, I'm not feeling well today, maybe I won't do this movie." The doctor was there, and he said, "You have an upper respiratory infection. You can't do it." My leaving the movie was a disappointment to everyone. Especially me.'

But Winona was not the only cast member to leave the movie. Robert Duvall had quit the set after a row over money, and Paramount instructed Coppola to simply write out his character from the story. The same however could not be done with Winona's part of Mary Corleone. But Coppola already had a solution for that by casting his daughter, Sophia in the role. It was a move that he considered a good one, and although critics didn't agree, Sophia performed the role admirably, or as her father pointed out, with 'a good heart, really good innocence and sincerity.' Winona agreed. 'I think she did a wonderful job. I really like her a lot.'

Nonetheless Winona was 'devastated at losing such a role but the choice was made for me, my body just couldn't do it.' But at the same time she was also thankful for the kindness in which Coppola treated her even after her departure. All she could do was hope that she may have the opportunity to work with him again in the future. It was finally realised nearly two years later when she began the process that put *Bram Stoker's Dracula* together.

In the meantime though, all she could do was stay in bed and recuperate on a regime of her mother's chicken soup, herbal tea and reflect on her relationship with Johnny Depp. She did that as well. 'He is an amazing person whom I have an enormous amount of respect for, and very deep feelings for.' It was no less emanating for Depp. 'He swells in her presence,' observed Bill Zehme when he caught up with the couple for a January 1991 *Rolling Stone* feature.

'When they hug, they hug fiercely in focused silence, their squeeze keeps re-grouping. They seem lost in each other. She smokes his cigarettes and she is not a smoker.' Evidence enough that Winona and Depp were not, as she pointed out, 'a possessive, weird little Hollywood promenade.'

Idol Essence

'I can't imagine anything better than to work with someone you love because then you're never separated from them. You get to go to work together and go home together. It's a real blessing.'

By 1989, Tim Burton, formerly an animator with Walt Disney had established himself as the hottest director in Hollywood. He had reached this enviable position with the success of *Beetlejuice*, and the first *Batman* movie, his most recent project. But now, he wanted to make a movie that he had long cherished since childhood, but Warner Brothers, the film company who bankrolled his last three movies were strangely less than receptive to the idea of his tale about a manmade man with scissors for hands.

Strange because *Beetlejuice* had turned around seventy three million dollars at the box office, and had undeniably proved Burton's ability to strike profitable chords with cinema audiences. Warners, however wanted a *Batman* sequel in its stead. Burton did not, he shrugged and simply defected across town to Twentieth Century Fox who ended up with a movie that would gross a respectable fifty four million dollars.

Edward Scissorhands had haunted Tim Burton since he was a child, the image created in his sketch of a boy with a shock of wild, but out of control black straggly hair, and deadly scissor blades in place of fingers. It was also an image reminiscent of the classic German children's story, *Struwelpeiter*. Finally in pre-production on *Beetlejuice*, Burton commissioned novelist Caroline Thompson to write a screenplay. 'I had read her book, *First Born*, which was about an abortion that came back to life. It was good. Close to the feeling I wanted for *Edward Scissorhands.*'

Burton had the image of this character, explained Thompson about her unusual scripting assignment. 'He said he didn't know

what to do with it, but the minute he described it, and said the name *Edward Scissorhands*, I knew what to do. It was Tim who came up with the image of the guy with the hedge clipper hands and I came up with everything that had to do with them. It was the perfect joining of our talents.'

Originally the idea was to produce *Edward Scissorhands* as a musical comedy. Thompson even wrote a song, *I Can't Handle It*, but the idea was scrapped in a subsequent revision. Although most of the script remained remarkably similar to the early drafts, it was still a variation of Burton's obsession with the *Frankenstein* theme.

Edward is the unfinished creation of his inventor (Vincent Price), who doubles up as his father in echoes of Disney's *Pinnocchio*. But before Edward is completed and given proper hands, the inventor dies. Sometime later, Edward is discovered by dedicated Avon Lady, Peg Boggs (Dianne West) making an out of the way call to the inventor's castle. She discovers Edward with 'those hands', and takes him home to live with her family in a weird, off-the-wall pastel coloured vision of suburbia. There he becomes an object of fascination, the source of fantasy, gossip, resentment, adoration, and lust for the neighbours.

But for Edward, his affection is Kim (Winona), the cheerleader daughter of his hostess, who in turn, provokes her jock boyfriend (Anthony Michael Hall) into a succession of bullying outrages. Although Edward wins over the community at first with his elaborate hedge trimming sculptures, and outlandish hairdressing skills, the town eventually turn against him, hunts him down, and drive him back to his castle in a sequence reminiscent of countless Frankenstein movies. The difference is that this time the monster survives.

The decision to cast Johnny Depp in the title role was indeed, an instinctive one. Although initially Burton went along with the studio's request to consider Tom Cruise for the part, he impulsively knew that the *Top Gunn* star was not one to capture the bizarre

character of Edward. Besides, Burton was adamant. He wanted Johnny Depp.

Casting Winona for Kim Boggs was equally instinctive. As instinctive, in fact, as her acceptance. Not only did it offer her the chance to work with Burton again, but also with Denise Di Novi, her producer from *Heathers*, and now head of Tim Burton's production company. And although it was a bonus for Winona to have Depp on board, it was still a nerve-wracking one as far as she was concerned.

'Working with Johnny turned out to be really great, but I was scared and nervous about it. I mean, if there's one person that I want to impress with my acting it's him. So there was a lot of insecurity the first couple of days, but it turned out to be a really motivating situation.'

Neither did it worry Burton that his two stars were in a relationship. He knew Winona too well, and his instincts screamed approval of Depp. 'I'm not a counsellor and had no intention of guessing how long their relationship might last, so I decided not to think about it.' Indeed, once filming was over, Burton confirmed, 'I don't think their relationship affected the movie in a negative way. Perhaps it might have if it had been a different kind of movie, something that was tapping more into some positive or negative side of their relationship.' But they were, he observed, 'very professional and didn't bring any weird stuff to the set.' But he was also aware of the pitfalls of casting them together.

'They could have split up in mid-shoot, but it never happened, and in retrospect, their relationship helped the core romance more than it hindered.' Depp couldn't agree more. 'The fact that we were together on the set, and in love, only fuelled what was going on between the characters of Edward and Kim.'

One of Burton's primary reasons for casting Winona was that 'she always responds to this kind of dark material.' But it was sheer mischievousness that prompted him to put her in a blonde

wig and give her the role of Kim. 'I thought the idea of Winona as a cheerleader was very funny. I used to laugh every day when I saw her walk on the set wearing this little cheerleader outfit and a Hayley Mills-type blonde wig. She looked like Bambi.' But the role was, confirmed Burton, probably her most challenging.

'It wasn't Shakespeare or Joan of Arc,' continued Burton, 'but a definite stretch for someone who instinctively moves closer to the dark than the light, and although Winona felt awkward and uncomfortable in her clothes, she still managed to demonstrate real power and total believability. That's what I counted on, just like in *Beetlejuice*. I needed someone to ground the movie so it wouldn't spring off into the stratosphere.'

'Tricky too,' he observed, 'because she plays a suburban youth who doesn't have very much of an edge. I think she might even say it's probably the most difficult thing she's ever done because he did not relate to her character.' Winona agreed. 'It really was a difficult part because it was a kind of girl I've seen but never known. She sort of starts out like the girls who used to throw Cheetos at me in high school.'

Winona, of course, was simply thrilled to be working once again alongside Burton. 'His ambition is very humble, very internal. Most people have to compromise certain things to get it on screen. He does his exact vision and doesn't change a thing.' Besides, Burton also spoke the same language as Winona. And they were both on the same wavelength. 'Did you ever meet somebody who you can just talk to? That's how I feel about Tim Burton. We have the same sensibility, and we think the same things are funny.'

Depp himself affirmed Burton's enthusiasm over Winona's role. 'It would have been easier to hate her character because of the negative way she treated Edward at first. Winona walked a fine line. She played it so that the audience knows that hers was the only honest reaction – that everyone else was treating him like a toy.'

Again, Winona agreed, but had no reservations about Depp's ability to play the part. 'He plays it like a little boy. You don't feel sorry for him, he just plays it with the honesty of someone who doesn't know how to put on a face, You know, how little kids can blurt the truth? That's what he does.'

All the same, she continues, it was a courageous role. 'A lot of actors were afraid of the part of Edward because it was so vulnerable, and he doesn't have a gun, and doesn't have a girl. Johnny went for it. That takes a lot for an actor, especially a male actor to do.'

Nonetheless *Edward Scissorhands* fascinated the media on its release in December 1990. Not only as a movie, but equally with the real-life relationship of its stars, and several reviewers picked up on their chemistry. 'What could be cartoonish becomes, with Ryder, a moving and plausible love story,' wrote Judith Newman in *Mirabella*. But that however didn't overshadow what many critics believed was Burton's best film. 'A haunting yet magical fairytale touching the hearts of all those who watch, regardless of age, gender or race.'

Whatever Winona and Depp thought of the attention paid to their on-screen romance in *Edward Scissorhands*, it was the media perception of their off-camera relationship that caused the most concern. Winona admitted that the continual hounding of the tabloid press hurt. It was, she remembers 'horrible and certainly took its toll on our relationship. Every day we heard that we were either cheating on each other or we were broken up when we weren't. It was like this constant mosquito buzzing around us.'

Rumours that Winona had been stepping out with a succession of other young stars were constant, and although she and Depp ignored the tattle, refusing even to dignify the tales with a response, the stories still rattled on with even wilder accusations of Winona and Depp sleeping with their co-stars, and rowing furiously. Even the public view of the relationship was one of Winona and Depp

not being together anymore, and if they were, then it was already troubled.

The papers, Winona cursed, 'were always trying to put me with other people. I mean, I work with actors, and I know them, and sometimes I might have dinner with them, but that's the end of it, and Johnny does the same thing with actresses. I guess part of it is that they want to get a reaction, and they also want to start a scandal, an affair, or whatever.'

Depp, on the other hand, apparently didn't seem quite so blameless. He made no secret of his past liasons. Even close friends testified that they weren't all so much in the past. It just added fuel to the fire. One of those liaisons, it was said, was Tally Chanel, whom he met at the premiere of Bruce Willis' *Die Hard 2* in July 1990. The B movie actress confirmed how she helped Depp out of his limo. 'Our eyes locked, and he asked me to marry him,' she said. But Depp had also confessed his attraction to Patty Hearst as 'a sort of crush' when they worked together on the set of John Waters' *Cry Baby*.

But then again, Depp had asked Waters, also a mail-order minister, to marry him and Winona in Las Vegas. Her refusal to go along with the scheme prompted another flood of stories. This time about jilted grooms and unrepentant brides. And matters were made worse when the couple finally gave in and answered questions about their private life that did nothing more than move reporters to dig even deeper.

'To get off a plane after you've worked all day and flown six hours to have fifty photographers trip you and call you a whore to get a response is repulsive,' complained Winona. 'If I'm in a limousine, I'm afraid to talk to the person I'm with because of the driver. Even in a restaurant people eavesdrop on you.' But she also acknowledged that youth and a kind heart did not keep her out of the supermarket tabloids.

Even Tim Burton was stunned at the posse of paparazzi that were at an airport one time after he, Depp and Winona flew back from Florida. 'It was one of the most horrible things I've ever seen in my life,' he remembers. 'I'm sort of a believer that if you're in the public eye you've got to accept a certain amount of that. But I've never seen anything so hostile.'

It was no wonder then that Winona and Depp moved their base to Manhattan for a while, even though they still continued to travel back and forth to the West Coast. There at least, they could turn their back on Hollywood's unrelenting paparazzi and tabloid press. But even then, they didn't throw wild parties. Neither did they go to the New York nightclubs, besides, according to Depp, he didn't even know where they were. Instead, they walked, wandered, frolicked, rented movies and went home. Just like any other couple.

'We're both young, and I think that we should be making the most of our relationship at this stage,' said Winona at the time. 'I'm one of those people who believe that the teenage years are the most wonderful years of your life.'

But for Winona, they were largely spent in front of movie cameras or at worst, answering and dodging questions about her personal life. She also knew that her teenage years were almost over. As she turned nineteen in October 1990, she was reminded of the resolution she made back at the end of *Mermaids*. She wanted movie parts 'that aren't about adolescent angst.' But Hollywood had heard that tune before from a dozen or so other child stars, who suddenly realise they are ageing, tried to change course before it was too late, and even the few that did make movies into maturity, their careers were never the same. But Winona was not discouraged, if anything it only cemented her determination.

'You learn to repress a lot, oddly enough, when you are an actress, because you express so much,' said Winona. 'Especially when you're a teenage actress, you get confused. You don't express

yourself in your own life. I was trying to have this life I wasn't comfortable having, and trying to be this person that I was reading I was.'

Once she turned nineteen, Winona remembers, 'I read a disgusting article called something like HOLLYWOOD'S HIDDEN BREASTS. It was all about actresses who you wouldn't think had breasts but did. It was the first time I read something that referred to me in that way, and I felt very violated. I thought, they don't think of me as a child actress anymore.' But maybe she didn't either.

Although the article didn't reach any conclusion that Winona herself hadn't visited already, she also knew that it had, all the same, tapped into some of her own insecurities at the time. Another was her indecision of fleeing California to live full time in New York having spent so much time flitting between East and West Coasts. It was the city from where her father came, and where her grandparents still lived. But, she admits, it didn't work. 'I couldn't deal with the fact that if I got hungry at night, I couldn't go anywhere because of the crime factor.' Six weeks later, she would simply shrug and move back to California settling into her new home in the canyons north of Beverly Hills.

Neither did she think a friend's suggestion that she contact the acclaimed cult director Jim Jarmusch to talk about working together would work. In his eyes, she thought, 'I might be some sort of Farrah Fawcett. Him a well-known independent filmmaker, and me, a Hollywood actress. I was a little ashamed at the time.' She remained uncertain about the whole idea. Even after a lunch date was arranged she continued along her course of self-doubt. But much to her astonishment, Winona discovered, he was as much a fan of hers, as she was of his. In fact, she couldn't get over the fact that 'we each wanted to work with the other.' She was equally surprised when he handed her the script of his latest movie.

Los Angeles / New York / Paris / Rome / Helenski centred on five individuals who take simultaneous taxi rides in the five cities of the working title. There was a role for Winona she might like playing opposite Gena Rowlands. The only snag was the part had been written for a male actor. Jarmusch told Winona that he was prepared to change it if she accepted the part. Winona accepted.

In an engaging series of shaggy-dog stories, expertly told, Winona's part was set in Los Angeles where a top Hollywood casting agent (Gena Rowlands) takes a taxi driven by Corky (Winona), a fast-talking, gum-chewing, chain-smoking cabbie whose big ambition in life is to be a mechanic. For Corky driving is simply one more step that needs to be made before her goal is attained.

Maybe it Corky's flippancy that intrigues the agent. Even when she mentions the night blindness that makes driving after dark such a chore, for instance, Corky blurts back, 'Is that something that happens to you when you get old?' Or maybe it's the sheer passion in which she curses out at a careless fellow motorist, 'Try driving school you fucking nimrod!' Or maybe it's the eccentric view she musters to describe guys, 'Can't live with them can't shoot them.'

Whatever the fascination, there is something about Corky's manner that appeals to the agent, for when the journey ends and an enormous tip has changed hands, the agent offers Corky a part in a movie, but she turns it down. 'I'm a cab driver, this is what I do.' But everyone, the agent persists wants to be a movie star. 'Nah, I want to be a mechanic.' And it is that brief exchange that establishes the film's theme. How something as simple as a cab ride can alter one's perception of life through unexpected opportunity.

Winona's segment was shot quickly in two weeks with no more than Jarmusch's regular crew of nine people. Winona admits, 'The first couple of days, I was incapable of saying what is was like to be in the presence of Gena Rowlands. I'm an absolute fanatic

about the films of John Cassavetes, and she's my favourite actress. I couldn't believe she was sitting behind me in the taxi!'

'Most of our dialogue takes place while we look at each other in the rear view mirror. She was pretty, funny, sweet, polite. Everything you'd expect from a woman like her.' Winona's only regret however was that 'I was too intimidated to discuss Cassavetes with her.'

With its original working title changed to the snappier *Night On Earth*, the movie opened to fair reviews in October 1991, and is, even today, perhaps Winona's least seen movie, but in Britain, it was an entirely different story. There the press simply raved about it, with Winona's own performance, as usual, strong and tentative.

Night on Earth was to be Winona's last movie with ICM, the agency she had switched to after the *Godfather III* debacle, and to whom she would later return in December 1997. But for the time being and once filming was completed she signed on with Creative Artists Management (CAA). Upon doing so, she asked to see every script they had on hand. After *Edward Scissorhands*, apart from *Night On Earth* she didn't work for almost two years, simply because the scripts being sent to her, were in her view 'crappy.' None would allow her to grow up.

From now on, Winona didn't want anybody else deciding which scripts should or shouldn't be sent to her. 'I don't care if it's one of those random, floating-around scripts that doesn't have anyone attached to it, I want to see everything,' she demanded. CAA handed over fifty scripts to her, one of which was *Dracula: The Untold Story*, adapted by Jim Hart directly from Bram Stoker's 1897 novel.

Adult Roles

*'I wanted to encourage Winona to emerge as a young leading lady because I think she has both the incredible beauty and the talent of a young Vivien Leigh. And she's also so bright that as an actress, she's very capable.' – **Francis Ford Coppola, Director***

Winona had read, and enjoyed Bram Stoker's *Dracula* in junior high, but Jim Hart's screenplay, she thought, was something else. What she liked most about it, as she did with the novel, was the narration written like the chapters of a private journal, just like the ones she herself had kept since childhood, and just like Stoker's original book, 'I thought that made for a cool adventure film, a sort of intellectual thriller.'

She also wanted to turn it into a feature film. Wilshire Court Productions had originally commissioned the script for the cable channel USA network, with Michael Apted slated to direct. Then when the possibility of a cinematic project arose, Jim Hart began shopping his screenplay around the Hollywood studios, but strangely without success. One producer, Hart remembers, even asked asked, 'Why do a remake of *Dracula*? It's been done a hundred times. Everybody knows the story.'

The fact that the tale had been done to death was certainly true. but it was equally true to say, that no one had ever done the book. Winona too felt determined that Hart's screenplay should be turned into a movie. She liked the script immensely, and wanted to find a director for it. She knew there was only one. Francis Ford Coppola. She considered him perfect for the project. It was also perfect that she was meeting with him in a few days-time.

'When Winona gave me the script,' recalls Coppola, he asked, 'Well, is it the real Bram Stoker's *Dracula*? And she said "Yeah yeah yeah," and when I read it, the first scenes are Vlad the Impaler, and

I said, "Oh, this is real!" ' Historically, Vlad the Impaler was the medieval Rumanian King whose lust for human blood, although spilled in the decidedly unsupernatural field of battle, gave rise to much of the Dracula legend, and is, in fact, a principle figure in Stoker's original tale. 'I'm amazed watching other Dracula films,' admitted Coppola, 'how much they held back from what had been written or implied.'

Hart's screenplay, said Coppola, was closer to Stoker's novel than anything done before. Hart agreed. 'Dracula's terror and fear is not only physical, it's also erotic, it means you're in a fever, you're sweating, you're aroused. It's sexual.' The difference between book and script was the original depicted a horror show of female sexuality run amok, while Hart's version told the tale of a young woman's sexual and romantic awakening.

'Winona read my screenplay,' said Hart gratefully, 'and asked Francis for his reaction to the script. She was interested in the role of Mina, and valued his opinion. Coppola's opinion was that Winona absolutely should play Jonathan Harker's bride to be, and the object of Dracula's long lost love. And by the way, could he direct the film?'

To this day, however, Winona plays down her part in bringing the movie to the screen. 'Everyone's saying that, like, I found the script, and I gave it to Francis, and he decided to do it, and therefore I put it all together. But all I did was find the script. I gave it to him, and he said he'd do it. But I didn't have anything to do with anything else. I wasn't behind the scenes.'

Besides, continues Winona, 'Francis and I liked the same things about the script. It was very romantic and sensual and epic, not really a vampire story.' It was, she confirms, 'more about the man Dracula, the warrior, the prince. He is unlike any other man. He's mysterious and very sexual, and attractive in a dangerous way.' It precisely summed up the heart of Bram Stoker's original novel, and it seemed only appropriate that the author's name should be affixed

to the title of this latest adaption. But that was not the only reason. Another studio, Universal, already owned the rights to the Dracula name. The addition of Bram Stoker would simply avoid confusion and any copyright infringements.

Even though Winona and Coppola were now firmly committed to the idea of filming *Bram Stoker's Dracula*, Hollywood was not entirely convinced that another retelling of the classic horror story was either needed or required. There was even talk at the time of Winona starring as a female Jesus in *The Second Greatest Story Ever Told*. Although it may have sounded preposterous, her colleagues at CAA admitted that it seemed more feasible than another *Dracula* retelling. After all, how many more times could the story be told.

All the same, Winona and Coppola continued with their persistence. Not only that, vampires were back in vogue. Novelist Ann Rice was approaching the fourth instalment of her bestselling *Vampire Chronicles*, and some half dozen other movies were already either in, or approaching production, everything ranging from *Buffy The Vampire Slayer* to an adaption of Rice's *Interview With The Vampire*. Whatever else, vampires were hot.

The search for an actor to play the title role once Coppola went public with his plans set off a deluge of Hollywood's rising young actors rushing for the part. Daniel Day-Lewis was one of the first mentioned to be the most ideal choice, but he was already committed to *The Last of the Mohicans*. Andy Garcia was another. He approached Coppola but was reluctant about the love scenes. And there were others, such as Armande Asante, Gabriel Byrne, Viggo Mortensen, Antonio Banderas, and Gary Oldman, all of whom flew out to an audition camp set up at Coppola's estate in California's Napa Valley. His final choice, however, from the cream of names was Oldman, an unconventional choice to many maybe, but nevertheless, one that proved to be right. Sure, no one would ever replace Bela Lugosi or Christopher Lee as the Kings of the Counts, but Oldman came close.

Winona screen-tested alongside Oldman, and the pair hit it off immediately. For the role of Jonathan Harker, Coppola wanted an Errol Flynn type. Someone who could effortlessly set young hormones racing. Keanu Reeves, the much-hyped star of *Bill and Ted's Excellent Adventure*, seemed the most appropriate choice. Anthony Hopkins as the vampire slayer, Dr Van Helsing, certainly was. An actor who, Coppola insisted, could command respect from the other cast members. British unknown Sadie Frost was recruited to play the part of Mina's best friend, the unfortunate Lucy Westerna, over such contenders as Ione Skye and Juliette Lewis, while Cary Elwes, Richard E Grant, and Bill Campbell played her suitors. Tom Waits was cast as the lunatic madman, and dedicated Dracula disciple, Renfield.

Critical objections to Winona cast as Mina were in circulation long before filming even got under way and growing insistently louder as the film approached release. Nobody could quite picture her decked out in period costume being pursued by the very real horrors of Count Dracula. A far cry, some would say, from the comic pursuits of *Beetlejuice* and *Edward Scissorhands*. Nor could they imagine Winona's distinctive Midwest accent wrapped round the vowels of a young English miss.

Winona herself may not have shared the doubts of her critics, but she openly admitted that the role was the most difficult she had taken on. 'I had to tackle a lot of those awful Victorian manners,' she recalls. 'I read a lot of books on turn of the century etiquette and watched a lot of period movies, like *A Room With A View*, anything with Maggie Smith.'

But she also knew that she couldn't rely on what she had done in the past. 'There couldn't be any eye rolling or sighing.' From that point of view, Winona was probably most thankful to Coppola for introducing Greta Seacat, a drama coach, recruited to work with both Winona and Sadie Frost. She would teach them both how

to reach deep inside themselves and extract emotions most people might never truly experience.

'She opened a lot of doors inside me that I didn't know existed,' confessed Winona. 'I had always gone on my instinct, but for this, you couldn't phone in anything. Even when it's a reaction shot, or if it's one word, or if you're walking down the street, you have to be completely in character.'

But Seacat had also been brought into the production to help Coppola feel more comfortable discussing sexuality with the female cast. 'I've never been very good at that, asking girls to take their clothes off. So I very much wanted Greta, who's a woman I feel very comfortable with, to be my go-between, to help me ask these girls to perform in erotic ways.'

In retrospect, Winona's fascination with Dracula's long-lost love, Mina, should not have been surprising – it has since proven characteristic of her favourite kind of role. 'She's very independent for her time,' Winona notes enthusiastically. 'She has strength and intelligence.' But as the reincarnated wife of Vlad the Impaler, 'her connection with Dracula is uncontrollable.'

Winona, however, took pains to ensure that the erotic connection was not so uncontrollable that she would completely abandon herself to passion. In one scene, for example, when Mina tears wildly at her bodice as she writhes in the vampire's embrace, her clothing remains firmly adhered to her body. But for another, cut from the campfire sequence of the final movie, the script demanded she seductively pulls open her corset to induce Van Helsing (Hopkins) into caressing the nipple of her exposed breast. But with her face far-off camera, the moment is never more than insinuated it is Winona.

Besides 'I won't do nudity' she repeated. It was even written in her contract to prove it. But if she was breaking her own cardinal rule to appear semi-nude, she had her reasons. 'When you go through the whole process of becoming a vampire, you try to get

everything off you. You become very animalistic, and an animal wouldn't want to be in a corset. That's why I was pulling on my clothing. There was a lot of footage, which they didn't use, where I wasn't doing that. It looks now as if that is all I was doing, when there were maybe two moments that I did.'

Obviously, continues Winona, 'exposing yourself, just in general, is difficult. But when you're working with people like Francis and Michael Ballhaus (the cinematographer) and our incredible camera crew, it's a lot easier than working with real strangers. Everybody was protective; there was no gawking. It wasn't an atmosphere where you felt unsafe. It was very respectful.'

Winona did, however, agree with Seacat that Coppola wouldn't know how to say something to her that he would probably know how to say to someone like Al Pacino. 'He would talk to Greta about it,' remembers Winona, 'and Greta would tell me what source to tap into, or what preparation. It was the whole method thing that I never really studied.'

Although she worked with Seacat throughout the movie, it was Coppola who directed her. 'He always encouraged experimentation,' she remembered. One method that clearly didn't please Winona was the one reported in *Premiere* magazine about Coppola apparently goading her through a scene by shouting a barrage of abuse and insults at her off camera.

It was during the filming of the vampire wedding sequence, one of the most dramatic in the movie, when Jonathan Harker, Dr Van Helsing, and their companions burst in to discover Mina sucking blood from the pierced breast of the vampire, and for which Winona was required to capture Mina's self-hatred and revulsion at her unleashed sexual passion by throwing herself on the bed and break down crying. But despite the urgings of Seacat and Coppola, and the pressures of the cameras rolling with cast and crew all around, Winona worked her way through the first couple of takes hiding her face with her hand, not reaching the pitch

of emotion Coppola desired, so discreetly he called on Reeves, Winona's friend and co-star standing off camera and off mike, to insult and shame Mina/Winona as the cameras rolled again, and almost unexpectedly, Coppola himself joined in, yelling at her, 'You whore! You fucking whore! You! Look at you! Look at yourself! Your own husband's looking at you!'

It was, continued *Premiere*, 'Just the push Ryder needs. She shrieks, collapsing onto the bed. Over and over again, Coppola makes her heave and sob, refusing to cut as she does the scene, six, seven, eight times. "No more!" she says finally.' Only then, did Coppola gather Winona in his arms. 'I'm sorry, I'm so sorry,' he whispered apologetically, 'I don't mean it.' But today, Coppola barely remembers the incident. For him, such theatrics seemed daily fare on the shoot.

On screen, of course, the scene lives up to all the drama that went into creating it. But according to Coppola that was the whole point. 'I always try to disrupt the actor,' he explained. 'Try it this way, try it that way. The more I do to them, the more I'm enabling them to enrich themselves, so when they do it, it's going to be really truthful.' The point, he adds, is to 'capture something that is happening rather than something that's pre-planned. It gets pretty crazy, but they like it.'

Winona, however, did not. It was, she told *Empire* magazine some years later, 'completely ridiculous, and didn't work at all. And yeah, it was very upsetting. But it was the wrong kind of emotion for what he wanted. He's very experimental, I guess, and I certainly didn't appreciate it. Not to disrespect him. I think he's done some amazing work, but his methods didn't work on me. I just get pissed off when somebody screams at me. I don't cry, I just glare. And I certainly didn't appreciate it.'

It was something she reinforced when *Rolling Stone* caught up with her for a March 1994 interview. 'I would never have bad-mouthed the movie at the time. Luckily now, I don't need to be

Francis Coppola's favourite actress to have a good career. Now I know I can have my opinion and still be respected. But before, I was scared, because he was just so intimidating. I thought if I spoke out, people would think I was insane.'

All the same, she continued, 'I think that he's a wonderful director and he's made some masterpieces, but I learnt a lot on that set about what I'm not capable of tolerating.' She also spoke of the film not being one she enjoyed watching. 'I don't like my role any more than the stylised look overall. I was persuaded that it would be a sort of Merchant-Ivory *Dracula*. My costumes weren't realistic, and I had too much make-up, so I felt artificial, like a prop.' Everything that Winona disliked. Even when she heard that a sequel was being planned, her response was equally disbelieving. 'There's a sequel?' she asked. 'Really? Ha!' She was even more amused when she learned that neither she nor Gary Oldman were to be involved in it. If anything, she was most probably thankful.

But not all of Winona's problems were entirely due to Coppola's techniques, however. 'I couldn't relax and appreciate what was going on,' admits Winona, 'because that was also the phase where I chose to play the part of the young tortured artist. I was the only one responsible for that. I had personal reasons for being unhappy during filming.' Besides, she continues, 'the filming itself placed a lot of pressure not just on Francis shoulders. But also on the group, on Gary and Keanu. On everyone in fact.' Not least, Winona herself.

In one scene, for instant, she was required to sit in the centre of a ring of fire constructed by Hopkins as Van Helsing to ward off the undead brides of Dracula. But no one on the set knew that Winona has had a fear of fire all her life, and it says a great deal that even while the scene was being shot, her terror remained bottled up inside her. Only Hopkins, it seems, who was trapped in the circle with her, sensed what she was going through. He was doing the whole performance, Winona recalls, 'and I was crying, but

Anthony was very protective, every time they cut, he would lift me up and hold me.' And in another scene, cut from the final print, the script called for a prone Winona to be completely submerged in blood. Equally alarming, no doubt, as the underwater filming she would endure years later on the *Alien Resurrection* set, but less the training or practical guidance.

She also balked at the method of filming all the rehearsals on video. 'To me, rehearsals are a training exercise, a work in progress.' Neither was she captivated with Coppola's bonding week of assembling the cast for rehearsals and relaxation at the director's estate in Napa Valley at the ranch-winery he calls Camp Coppola. 'We are looking for very deep emotional relationships and resonances in these characters,' Coppola noted in his journal. 'Make Gary, Winona and Keanu make very personal connections with these themes.'

But that was one of the difficulties paramount among Winona's troubles. Her shifting relationship with Gary Oldman. It started out as a genuine bond of friendship, but quickly deteriorated. 'We hung out before the movie in rehearsals and stuff,' she explains, 'but it wasn't the same after we started shooting. I really don't know why. Maybe it's his way of working, but I felt there was a danger.'

Coppola noticed the change too. 'They got along, and then one day they didn't. Absolutely didn't get along. None of us were privy to what happened.' But it forced some adjustments. There were literally times when Winona could barely stand to be acting opposite Oldman. According to Coppola, 'I had to say to her, okay, play this scene and make believe it's me instead of Gary, make believe it's whoever.'

Part of the conflict may well have been their different acting styles. For Winona, Mina was a role that required Seacat to help her extract the necessary emotions, while Oldman could hardly refrain from playing Dracula twenty four hours a day. For him, the

role was a lifestyle that he needed to live as long as Coppola wanted it.

Neither did it help that Winona nicknamed Oldman the King of Pain. 'He's a very emotional actor,' she observed, 'whereas with me, you have to go inside a little bit. Being emotionally on the brim can be very beneficial and also very destructive. If you're doing something where you don't want to be that emotional, it's like they spill over anyway. I'm not saying that happened a lot, but in rehearsals it did. He was very emotionally on edge. It wasn't like we hated each other, it's just that we both did our own thing.'

Equally damaging, no doubt, was the talk of Winona's romantic involvement with Oldman that was nothing more than the usual press rumour. Matters worsened however when the couple, spotted shopping at Tower Records, encouraged even more speculation. Although Winona was completely incensed by the stories, insiders simply blamed the high profile and erotic setting of the movie.

Nonetheless, the Dracula shoot rolled on. Still suffering from insomnia, and still enduring the attention of the tabloid press, Winona admits going through much of the movie feeling 'tired, tense and not very happy.' As with the making of *Mermaids* when sleepless nights threatened her health, Winona simply continued as if everything was fine, when indeed, nothing could be further from the truth. 'I was being watched all the time,' she said of the years that constant work, and 'dealing with who people want you to be' finally took their toll.

Finally, during a break in filming, Winona visited a doctor who diagnosed her condition as 'anticipatory anxiety' and 'anticipatory nostalgia,' whatever that is. Winona didn't know either. But 'I don't think I have that,' she said. All the same, the doctor assured her she was suffering from nothing more than the normal symptoms of an identity crisis. Normal, that is, when you considered the side effects of one. Indeed, others may have termed it nervous breakdown, and many, doubtless, would have preferred one. But for Winona, she

simply went along with the specialist's advice, took the prescription for the sleeping pills and was told not to worry. She could, he said, 'literally eat them like candy.' She did that as well. After all, it was just what the doctor ordered. She also slept.

But as if to prove that when it rains it pours, Winona received another setback just as she approached her twentieth birthday. At the same time though, she also knew that she had come upon one of those times that occur for most people sooner or later, when suddenly everything that can go wrong, does go wrong. From that point of view, Winona was no different. The loss of her next movie project even proved the point, all the more since it would have reunited her with Tim Burton for his adaption of Valerie Martin's spellbinding novel *Mary Reilly*. It was the marvellous retelling of Robert Louis Stevenson's classic tale of *Dr Jekyll and Mr Hyde* told through the eyes of a servant girl in the doctor's household.

It was no surprise that Winona wanted to link up with Burton again. As she herself explains, 'with Tim Burton, my policy was simple. I was ready to do whatever he wanted! If I could, I wouldn't work with anyone except the same people every time.' Nor was it surprising that Burton wanted to cast Winona in the title role. It was as if it had been created specifically for her.

'What happened, was the studio wanted to push it.' condemned Burton. 'Whereas before I could take my time to decide about things, in Hollywood, you get shoved into this whole commercial thing. They want the movie.' The last straw came when the studio told him they had another five directors who were interested in the project, insinuating that if he didn't get started, one of the others would. Although they probably just wanted to hurry him up, they chased him off instead. 'Well, if you've got five other people that want to do it, maybe you should have them do it' Burton retorted. But looking back, he also reasons, 'basically they speeded me out of the project, because they saw it in a certain way.' And Burton saw it in another. 'They saw it with Julia Roberts replacing Winona, and

once Stephen Frears had taken over as director, that is what they got.'

All the same, Winona was disappointed. 'I'm sure people assume I hate Julia Roberts because she's really hot and gets to do whatever she wants, workwise. But I like Julia. I know her a little bit, and I think she's a really cool person. I think she's talented, and I'd rather be losing parts to her than to some idiot.' Still the loss probably hurt, especially as it meant she wouldn't be working with the director she thought was 'the best on the planet.'

As work on *Bram Stoker's Dracula* neared completion, Winona decided to sit back and allow herself some time off to take stock of her life. She needed to get things into perspective. But more importantly she wanted to sort out her true feelings for fiancé Johnny Depp. After all, the pair rarely saw each other any more, and although they kept up appearances when they went out, they didn't go anywhere together that much. It was apparent they had began to drift apart. They may have shared the same house, but they didn't share the same life. It was just the beginning of what would be a painful end.

Not so painful would be Winona's decision to move again. Despite her earlier reservations of living in New York City, she began shopping for a new place there, and by late summer 1992, she found one. It was a pied-a-terre whose eventual decorative refurbishment by actor and friend Kevin Haley won her a lavish spread in *Architectural Digest* magazine. Haley was also responsible for the decor at the 1920's Beverly Hills house she purchased around the same time. The place had been completely modernised when she came across it, to the point, Winona couldn't even stand to stay there alone. 'It was creepy.'

Haley restored the house to it's original Mediterranean style, then furnished it around a nineteenth-century Czechoslovakian chandelier that epitomised old-style Hollywood glamours. The New York apartment on the other hand took it's tone from a grand

1940's French table with it's wrought-iron base decorated with musical notes. Lacquered panels adorned with musical instruments were set up in the living room around a similarly decorated parchment covered bar.

Winona was thrilled. 'In my work, I'm often physically uncomfortable, wearing tight corsets or standing around in the freezing cold so it's important to have a place to retreat to.' Her only complaint, she joked, were her neighbours. 'All the famous models live here,' she remarked of her new home. 'I feel like a fucking midget freak.'

She moved into the New York apartment in October, just before *Bram Stoker's Dracula* was released. The critics hated the film, and so did the studio. Coppola wasn't crazy about it either. He'd already spent the months of August and September doing reshoots and recutting the movie no less than thirty-seven times, and it had become far less radical than Coppola had even hoped for.

'The one thing the movie lacks is headlong narrative energy and coherence,' wrote Roger Ebert in one of the more moderate reviews. 'There is no story we can follow well enough to care about. There is a chronology of events as the characters travel back and forth from London to Transylvania, and rendezvous in bedrooms and graveyards. But Coppola seems more concerned with spectacle and set-pieces than with storytelling. The movie is particularly operatic in the way it prefers climaxes to continuity.' Overall though, Ebert enjoyed the movie, 'simply for the way it looked and felt.' He finally called it 'an exercise in feverish excess,' and noted that Winona, Oldman, and Hopkins 'pant with eagerness.'

Sometimes though, it doesn't seem to matter what the critics reckon. The cinema-going public is perfectly capable of making up it's own mind. And that's certainly what happened with *Bram Stoker's Dracula*. In America the movie enjoyed both the biggest box-office opening in the lifetime of Columbia Pictures, and the widest non-summertime release in Hollywood history.

It was a similar story in Britain, where Winona was already consistently ranked among the top ten box-office stars of the decade. Although the critics in the UK were generally kinder to the movie, studio executives remained on edge as its January 1993 release date approached. They didn't have to worry. One of the country's most respected critics, James Cameron-Wilson, was completely bowled over by the film, describing it as 'A fresh, exhilarating look at a very familiar story.'

British audiences, in fact, flocked to over three hundred cinemas in the first three days, placing the movie seventh in the country's box-office listings and effortlessly rolling it into the same company as the more predictable blockbusters of the year that included *Basic Instinct*, *The Bodyguard*, and Tim Burton's sequel *Batman Returns* among others.

From there Dracula fever swept across Europe, and three months after its British release, the film had grossed two hundred million worldwide. From that point of view alone, it was Winona's most successful movie so far, and one that spun off everything from a Winona Ryder Dracula pinball machine to a series of almost unrecognisable action figures.

With all the hype of *Bram Stoker's Dracula* still going on, Winona slipped almost unnoticed from one great director to another. Compared to the to the nightmare of working with Francis Ford Coppola, filming with Martin Scorsese on *The Age of Innocence* promised to be both delightful and enlightening.

Scorsese was regarded as one of the most innovative and exciting directors whose career won him international recognition with his display for earthy realism and imagination. Everything from *Raging Bull* to *The Last Temptation of Christ*, and from *Mean Streets* to *Cape Fear* proved he could make popular mainstream movies. Even his earlier work as montage supervisor on MGM's 1972 documentary *Elvis on Tour* carried that same hallmark of originality

Nevertheless, some considered him an odd choice for the screen adaptation of Edith Wharton's *The Age of Innocence*, but it was, admitted Scorsese, the 'exquisite romantic pain' that attracted him to the project. Besides, it had been one of his dearest fantasy projects ever since a friend, and movie reviewer Jay Cocks handed him a copy of the novel and told him, 'when you do that romantic piece, this one is for you.'

Winona, too, had no reservations about accepting the pivotal part of May Welland. She was in her trailer on the *Dracula* set the day Scorsese called to offer her the part, and according to Winona, she flipped out with excitement. Winona had read the novel in junior high for her final report in English, and even then, she had identified with its potential for the screen. 'I always knew that it would make a great movie,' she said thrilled. 'When I was doing acting workshops, I got it into my head that I could perform the lead role of May Welland in the movie. So isn't it fucking weird that six years later, Martin Scorsese calls me up on the phone and asks me to do the film.' Afterwards, she simply raved about how the whole thing had been exhilarating from beginning to end.

Even though Scorsese was firmly committed to the idea of filming *The Age of Innocence*, Hollywood's powers-that-be remained wary about making a love story dating back seventy five years. Scorsese, however, was not discouraged. From Twentieth Century Fox where the project originated, he simply passed it through Universal before ending up at Columbia with a movie that would eventually gross a respectable thirty-two million dollars at the American box office.

According to producer Barbara DeFina the movie cost much the same in production. A surprising, but moderate budget when you consider the thousands of exquisite costumes, elaborate production design and dedication to period accuracy. Winona, too, was equally surprised. 'My engagement ring alone must have been worth hundreds of thousands of dollars.'

The novel and the movie, observed Roger Ebert in his review, 'took place in the elegant milieu of the oldest and richest families in New York City. Marriages are like treaties between nations, their purpose not merely to cement romance or produce children, but to provide for the orderly transmission of wealth between the generations. Anything that threatens this sedate process is hated. It is not thought proper for men and women to place their own selfish desires above the needs of their class. People do indeed marry for love, but the practice is frowned upon as vulgar and dangerous.'

It was that theme that was the centrepiece of the film. How Newland Archer (Daniel Day-Lewis) cares for, and eventually marries, May Welland (Winona), but is truly in love with her cousin, the Countess Ellen Olenska (Michelle Pfeiffer), a woman of dubious reputation. It was in reality, a portrait, or more so, a study, of New York aristocracy during the 1870's.

'I had to pinch myself to believe I was working with Michelle Pfeiffer and Daniel Day-Lewis', Winona said thrilled. Although on first meeting Pfeiffer, 'I thought she didn't like me.' Maybe that had something to do with the difficult time Winona was going through. But no, 'she really took me under her wing, and took care of me. It took a while to get to know her, but I respect that. It's now one of the most trusted friendships I have. She's incredibly loyal and honest.' It was certainly a welcome change from the actresses clamouring to be Winona's best pal. 'I've had actresses I don't even know call me and say "we're both famous, let's hang out." '

But Pfeiffer was equally captivated with Winona. 'We just acted like such girls,' she later revealed. 'The two of us would look at each other and burst into giggles.' The pair would sing and dance and run high-spiritedly across the set. Even Daniel Day-Lewis made a point of simply hiding himself away when they got going, although he later recalled, 'Winona did a wonderful rendition of *I'm Just A Girl Who Can't Say No* (from *Oklahoma*). That was a performance I wouldn't have missed for the world.'

Indeed, there were several reviewers who picked up on the chemistry between Winona and Day-Lewis suggesting their relationship was not just confined to the screen following the movie's September 1993 release. And while the Hollywood grapevine continued to insist as much, Winona simply let the speculation drift over her head.

'She is very, very determined,' added Richard E Grant, her friend and co-star from *Bram Stoker's Dracula*. 'Around the set she giggles like someone who has just come out of high school. But when the camera rolls, she doesn't screw around.'

Winona herself was also thoroughly enamoured with Scorsese, particularly when he invited the cast to his home to watch films in his private screening room. 'Martin is the best,' she exclaimed. 'If I start talking with him, I can't be stopped! He's so brilliant.'

It was certainly different compared with the never ending nightmare of *Bram Stoker's Dracula*. Even when Winona was asked to compare the difference of working with Scorsese to her time with Coppola, she was quick to reply, 'They're both gentlemen, but Francis provided this crazy atmosphere, people running around and chasing each other, which was perfect for the movie. Marty was more subtle and delicate. He's a genius. I feel silly saying that, because it's so obvious, but he and Coppola are amazing teachers. I've learnt more about film from them than I would in any sort of film school.'

Yet it could have turned out to be so different. Winona was still taking sleeping pills to combat her insomnia, hardly thinking anything of it. After all, the doctor had told her she could eat them like candy. Then one night, she forgot and lay awake in the dark for hours. At that moment she realised she may have become dependent on them for sleep. 'When I realised I needed them, I stopped taking them.'

She also turned to Michelle Pfeiffer for advice who told her to 'flush them down the toilet.' She did, and although the sleepless

nights returned, Winona knew it was worth it. 'I was in better form, more relaxed, and the experience was great.' Maybe that had something to do with the role of May Welland, a young but rigidly conventional woman. It is probably true to say that it was the most challenging and subtle part Winona had ever undertaken. She was someone who refused to acknowledge defeat, or even to accept that there's a conflict. She knows that her fiance is in love with another woman, but she also knows that in his own way, Newland is just as much a conformist as she is. So what if he pledges undying love to the Countess and dreams of fleeing with her to a world away from high society? May knows that, and accepts it, but she's also knows that he'll never do it.

That was that aspect of May that intrigued Scorsese most of all. His favourite scene, he admits, and 'one of the reasons that I wanted to make the film,' is when Newland tells May that he has to travel to Washington to attend a Supreme Court hearing, but in reality, he intends to visit the Countess, who also lives in the capital. No sooner has he told his yarn than they learn the Countess is herself on her way back to New York and that Newland is expected to collect her from the railroad station.

'I'm sorry' asks May, 'but how can you go pick up Ellen when you have to go to Washington this afternoon?'

'Oh, that's been postponed.'

But May knows otherwise. And Newland, suddenly realising this, overcomes his story by telling May that the case is still being heard. It's just that he doesn't have to go.

'So then it's not postponed,' replies May.

'No. It's not postponed, But my trip is.'

'They both now he has lied,' explained Scorsese, 'but neither actually admits it.' It was perfect for capturing how the facade of respectability and deceit can remain thoroughly intact when manoeuvred with diplomacy.

It was also an aspect of the role that Winona herself found intriguing. 'It's funny,' she recalled, but 'Marty's mother came up to me after she saw the movie, and said, "You handled it like a lady, I would have beat the hell out of him." I suppose I would have done too.'

Nonetheless, it was not an easy role for which to prepare. As much as Mina in *Bram Stoker's Dracula*, the character of May, naive yet determined, demanded that Winona bond not only emotionally but also physically and intellectually with her character.

'Unlike most of his films, Martin Scorsese's adaptation of *The Age of Innocence* will have impeccable manners,' warned *Premiere* magazine as production continued. An on-set etiquette expert, Lily Lodge was recruited to consult with the cast when filming commenced just outside New York in the picturesque town of Troy on 26 March 1992. Winona was thankful for her help. She said she consulted with Lodge on the tiniest of detail. 'Wait! Could I touch my face,' she'd ask. 'You have to ask those things because they might mean something. To put your hand on your hip could mean, "I want to screw your brains out." ' Lodge nodded her agreement. 'That would be a no-no. It would mean you were a harlot.'

Winona even tried to put weight on for the film to surpass the hundred or so pounds that she has weighed ever since adolescence, but she couldn't. It was her only disappointment of the entire shoot, but one that she knew didn't matter.

What did matter was her sheer enthusiasm for Scorsese. And that was so exuberant, it simply spilled over into her performance. 'It was the first time I ever felt proud of myself as an actress,' she confessed, and her pride was indeed justified. Evident from her diary entry at the time. 'I feel like it's okay to be who I am. It's okay to be a fucking movie star. It's okay to live in a nice house.'

It was a far cry from another entry she made some years before when on a flight back to Los Angeles from London she was apparently feeling less than enthralled with it all. But then again,

she admits, she'd had half a beer and was already feeling tipsy, so perhaps it should be no surprise what she wrote. 'I wish I wasn't doing what I was doing. No that's wrong. I like what I'm doing – I just don't like parts of it. Classic, huh? This sounds so classic, actors bitching and moaning about wanting to be like everybody else. But if they were, they'd just want to be movie stars. I can live how I want. That's that. No one put this wall up. No one else knelt down around me and laid the bricks. I did it myself.'

Nevertheless, it probably had something to do with Winona feeling almost ashamed of being an actress at the time. 'I felt like it was a shallow occupation.' Even when she went to see bands with friends from school, she remembers how 'people would be watching every move I made. They'd be judging me. "Look at her shoes! I bet those cost four hundred dollars!" That affected me because I grew up with no money.'

According to one reviewer, Jack Kroll of *Newsweek*, May was the film's most difficult role, but Winona made her 'a poignant blend of sweetness and cunning.' And Vincent Canby in the *New York Times* singled Winona out as 'wonderful... a sweet young thing who's hard as nails as much out of ignorance as of self-interest.'

Martin Scorsese also shared in this wave of enthusiasm for Winona's contribution to *The Age of Innocence*. 'I think she's reacting to being part of a labour of love. We had a very good time. Winona has a good sense of humour, and her energy is boundless. She'd be jumping up and down, but when you said, "Action," she froze into position. All that energy was behind her eyes, and it was fascinating.'

The Age of Innocence is a beautiful movie, and it was no surprise when it received a fistful of award nominations. In the end, though, it won just one Oscar. Beaten down by the likes of *Philadelphia*, *Schindler's List* and *The Piano*, in the other categories, *The Age of Innocence* became Winona's second successive movie to win Best Costume Design. More importantly, it earned Winona her first

ever Academy Award nomination, for Best Supporting Actress. A clear favourite in many people's eyes, Winona lost out to Anna Paquin, Holly Hunter's co-star in *The Piano*, but at the 1994 Golden Globes ceremony however, Winona would sweep the same category.

'It such a great honour,' said Winona backstage. 'I mean I've never won anything in my life, except for a spelling bee when I was in fifth grade. It gives me so much hope and joy, because those were always the movies that I loved, that I felt weird for loving. Because everyone else, especially my generation, never really got what period pieces were all about, and things that weren't contemporary, they just didn't pay much attention to. So the fact that this movie just did so well and reached a lot of people, it was so timeless, you know, it's like, these emotions can exist is any century.'

It was also an evening of triumph, the like of which she had never imagined. And it wasn't over when the ceremony closed. When she returned to her home in Coldwater Canyon that night, she found her entire family, godfather Timothy Leary included, ready to throw a celebratory party. 'It was really cool, because they've always been so anti-establishment, and then when I won this award that's aired on TV and everything, and they were so excited about it.'

They were excited about it because Winona had remained true to herself. She was a great actress, they knew, but they also knew that many other great actors and actresses, caught up in the momentum of success, had sacrificed everything that made them great in the first place just to earn more money, win acclaim, or accept more awards. Winona had avoided those traps.

'This friend of mine said something really wonderful after the Golden Globes,' she remembers. Bono, the U2 vocalist, was right behind her when she was walking in, and Winona recalls how 'you have to walk through zillions of news cameras and talk to each of them. So I was talking to them, and afterward Bono said, "I am

so baffled by this whole evening. You do this thing where you are completely yourself, but you're not revealing your heart and your soul."

And then, she continues, 'we talked for a couple of hours about interviews, about all the times we've been screwed, and the times it's been great, and I was saying how hard it is, because like everybody else, I'm totally insecure and I want the interviewer to like me, and I want to be cool and say the right thing and I try to be honest about that. But there are also things I don't want to talk about.'

Second Love

'It was a really good thing that Johnny and I split up, for both of us. We'd drifted apart for a long time before the press found out it had ended. It was painful, but it wasn't that bad, you know.'

Winona's next movie project was set in a world that was also changing, but one that was very much out of control. *The House of the Spirits* was a tale described by its publicists as 'Every passion.... every obsession.... caught in the fire of revolution.' Winona's own revolution was both personal and public, although she would have probably preferred a more private one.

All the same, Winona was excited. She could hardly believe she had been chosen to play Blanca Trueba in *The House of the Spirits*. 'I was really flattered because I replaced the director's wife (Pernilla August), who got pregnant and couldn't do it.' That did not however stop Winona from asking for some time to consider the offer of the part in Billie August's adaption of Isabelle Allende's acclaimed novel, in which a saga of a family's rise to power and its fall is played out against a background of political upheaval in Chile. Winona's uncertainty over whether or not to accept the role was understandable. Still feeling exhausted after *The Age of Innocence*, she knew only too well the consequences of pushing herself too hard.

'I was desperately unhappy,' she remembers of the time. 'I couldn't sleep. There was so much drama in my life, and I didn't have time for the little things that make life fun and make me happy.' Neither did it improve matters that the character she would be playing had her own set of difficulties with which to contend. Being abused by a father, losing a mother, bearing a child out of wedlock, believing a lover dead, and experiencing imprisonment and torture, were all elements of the role.

137

But Winona knew that she didn't really have any choice. How could she possibly reject such a challenging part, or the chance to work with such a phenomenal cast of Jeremy Irons, Glenn Close, and Meryl Streep. Or indeed the chance of working on a movie that echoed elements of her own interest in the human rights charity, Amnesty International. Winona left for the set in Portugal shortly after the Academy Awards ceremony. Her first diary entry of the trip reads, 'Lisbon. Yikes. Weirdness.' But by her own admittance, she felt slightly out of her league, and was immediately assailed by self-doubt. 'It's hard to forget that you're working with Meryl Streep. I was very intimidated until I met everyone. They were so kind,' remembers Winona, but once 'you see someone, and you see they're human, it goes away.' It also helped that her mother accompanied her.

But Winona needn't have worried. Streep was immediately impressed by Winona's work method, of the way she does it all in close-up. 'The camera really does love her. It can't seem to get enough of what she holds in her eyes.' It was for many, and still is, that double charm of the true movie star. The charisma that draws emotion from the viewer and the technique to express its nuances. It's a method, observed journalist Richard Corliss, that's both 'more direct, from her eyes to your heart. Grand old movie style, and more subtle than the high voltage "I scream in your face" style favoured by most young actors. They are heavy metal. Winona is unplugged.'

Bille August too, proved to be an ally Winona would value. Best known for directing Ingmar Bergman's autobiographical *Best Intentions*, he was, Winona said, 'really nice, sensitive and considerate towards the actors.' She could still remember the time August postponed filming a scene for a week because of rain, unaware that it meant Winona was intending to return home that same day. 'Normally that wouldn't bother me,' she explained, 'but I really wanted to get back home. I spoke with Bille, without

demanding, and he took the trouble to change the shooting schedule. No other director has ever done that for me.'

There were a number of reasons why Winona wanted to return home. 'I was going through a really strange time in my life,' she reveals, and although, 'in a weird way, it was therapeutic.' there were times, 'when I wasn't sure if I could make it through.' One of those times was during the latter stages of filming, when her character Blanca's relationship with a known extremist (Antonio Banderas) leads to her arrest and interrogation. Taken from the Trueba family home, and driven blindfolded to military headquarters, she is put under the charge of Colonel Garcia (Vincent Gallo), who unbeknown to Blanca, is her half-brother. Under the pretence of interrogation, Garcia vengefully extracts from Blanca the recompense for the frustration he has felt over his illegitimacy.

Even though, as Allende herself would point out, 'they are only a suggestion of what happens to people,' Winona shudders at the memory of performing the ensuing scenes of torture. Ones that she now finds almost unbearable to watch.

'It was very difficult,' Winona recalls hesitantly. 'I hate to say it, but I don't know if I could do it again. It's very violating, even though you're acting, to be handled in that way. Because you have to make yourself receptive, so it turns into... well, it's not pretend any more. To make it look real you have to open up, and there are a couple of things you can't fake. When someone picks you up by the hair, when you're being dragged through the street... you can't fake it. To a certain degree you have to get hit.'

The hardest thing was being blindfolded and handcuffed. 'You don't know where the hit is coming from, and you don't know when. Thank God for Vincent Gallo. He is a friend of mine, and we were just hugging after every take. Everyone was so wonderful and supportive and would have done anything, but I was covered with marks and bruises, my shoulder got kind of dislocated. Luckily it was the last thing we shot.'

But she also remembers looking at the bruises in make-up and recognising that her battered physical state reflected something more internal. 'I realised because of the rough year I'd had, that seeing myself that way was how I felt inside.' Shortly before she left for Portugal, Winona was shattered to discover that two school friends had been killed in a freak accident. And that another friend, a guy she had a crush on as a child, had just been diagnosed with AIDS. It was no wonder she was feeling too troubled to confront whatever was troubling her. Cutting herself off from everything except her work and her private agony, she looked for ways to relieve herself from the depression that had apparently dogged her for some time. No less than any of us would who find ourselves facing problems.

'I tried to be an alcoholic for two weeks,' she would smile later, remembering the nights she spent alone in her hotel room for a couple of weeks making Screwdriver cocktails from the minibar, smoking cigarettes and playing Tom Waits doleful album, *Nighthawks at the Diner* on the stereo over and over again. But the night she fell asleep with a burning cigarette between her fingers and waking to find the room in flames simply terrified her. The incident was enough to frighten her from returning to the minibar again. Besides she knew that alcohol was no solution. From that moment, she admitted, 'I haven't been back, and I wouldn't ever want to return.'

Even so, Winona was still struggling with her problems over sleeping, and wondered how on earth she would make it through the seemingly ever restless nights. 'I was so worried about it that I couldn't fall asleep. I had this digital clock, and every time I barely opened my eyes I saw these huge red numbers saying 3.30AM. Okay, I have two and half hours before I have to get up.' Eventually she consulted a sleep therapist who told her to ditch the digital clock, and anything else in her life that was bothering her. She knew exactly what he meant. Her life with Johnny Depp had been

heading towards its end for some time, or at least, signs of it were certainly evident.

'But the insomnia was really a symptom of something else,' admitted Winona of her psychological and emotional state that had all the symptoms of some kind of identity crisis. 'If you spend your most crucial adolescent years being watched by millions of people, being told what's good and what's bad, you have no sense of who you are. I was so used to people telling me who I was. I was Winona! I was precocious! I was adorable! I was sexy! These labels were being slapped on me, and I didn't have any life outside of it, except when I went back to Petaluma.'

Even more damaging was the fact that 'I would just see myself in magazines and I would think that's what I am. I'm this, I'm that, I'm Johnny Depp's girlfriend. Neither did it help, she remembers, driving around in the middle of the night, unable to sleep, lonely and depressed, to discover her picture on the cover of *Rolling Stone* at a newstand. 'Winona Ryder' it said, 'The Luckiest Girl In The World.' But she continues, 'I didn't feel like the luckiest girl in the world. I felt like I didn't know who I was.'

For the time being though, she returned to New York determined to deal with what she had promised herself. To finally bring her relationship with Depp to a close. It had after all, brought her nothing but misery and drama over the last year.

Perhaps that determination came through in her performances, though any suggestion of it seemed to alarm Winona. Ever since her early days of drama training, she'd been told to express her anger, her depression, and her pain in her performances, but some things, she felt, were too private. Some emotions and feelings were perhaps only safely expressed to someone highly professional, or someone very close. But certainly not to an acting coach. 'I decided, I don't care if someone says 'You're going to win every award in the world for that performance, but you could only have done it because you

were going through stuff. I'd still go back and want to be really happy, and be bad in the movie.'

But even then, it still worried her. Maybe the pain and turmoil she was going through in her personal life had spilled over into her performances. Maybe too it was what spurred her on, and maybe it was the reason she was so good. But that shouldn't have been a concern. She was good because she was blessed with talent. And once she came to realise that she also realised that she could be just as good an actress, 'in fact, I think a better actress being a happy person. Not having all that drama in my life. Not acting like I'm forty and divorced five times. You don't have to be miserable to be a good actress.'

True to her resolve, she broke up with Depp, and the end of their romance was dutifully reported in the press. *People Weekly* wrote, 'Ryder's representative confirms, after months of press speculation, that Ryder and Depp are a couple no more. The two young movie stars have called off their engagement and gone their separate ways.' And although her diary entry at the time revealed that she was feeling 'fragile, a little confused, heartachy, and a little tired,' Winona was also able to sleep again. And as for Depp, 'He's a special guy,' said Winona later. I was just really young. I don't know what his excuse is, but that's mine.'

Depp on the other hand believed his relationship with Winona slowly unravelled over time. The pressure of their film careers taking its final toll. In June 1993, he announced publicly, 'We split up a month ago. When you're with someone, and you love them, it's never easy to cut the string – to sever the connection. But, with us, it just came to seem the natural thing to do – a natural progression – just something that had to happen. I wouldn't say that our splitting wasn't exactly a devastating experience for either of us, really. We're still friends. We still talk. And everything's fine, very amicable, very nice.'

But whatever Depp may have said in public, behind the scenes he was said to be devastated. A friend confided anonymously to *People* magazine that 'he was so desperately in love with Winona, that when they broke up, he wouldn't admit that it was over for the longest time.'

Winona and Depp had started out their life together by being open with the press in the hope that it would satisfy their demand for celebrity news and gossip and finally leave the couple alone. That did not happen. 'It's very hard to have a personal life in Hollywood,' Depp revealed at the time, explaining that the decision to be open as they were was, in fact, a mistake.

'I thought it would destroy the curiosity monster. Instead, it fed it. I had nothing but bad luck after talking about this stuff. It became such a public thing. Everyone felt like they were part of it, or owned part of it, or that they'd somehow got the right to ask me about her. I hated it.'

Although Winona filed away her engagement ring along with her other memories, for Depp, the visible tokens of his love for Winona were going to prove more difficult and more painful to dispose of. His WINONA FOREVER tattoo became the object of much press speculation, and the butt end of many a comedian's joke over the next year, but Depp finally acknowledged that he was going to have it removed, letter by letter. One journalist caught it shortly after the treatment began. 'At the moment it reads WINO FOREVER.'

When asked, Winona felt there was little to be done about the tattoo. 'What do you want me to say? It's like, "It's there, oh well." If I hated him, I'd probably say something. If I was still in love with him, I would probably say something poignant. He's a great guy, but I don't really think about it.'

People Weekly however was quick to note that Winona did not remain alone for long. 'We hear from other sources that Ryder is now seeing David Pirner, lead singer of the rock group, Soul

Asylum. Pirner apparently left his girlfriend of eleven years to be with Ryder.'

In fact Winona had fallen in love with Pirner's band long before she had fallen for him. Soul Asylum's recently released *Grave Dancers Union* had been among her constant musical companions during the filming of *The House of the Spirits*. 'I'd been listening to them a lot in Europe.' Their music, acknowledged Winona, was 'the one thing that helped me through that movie'. Just as listening to *Sixteen Blue*, the Replacements song about teenage loneliness got her through *Mermaids*.

And like the Replacements, still Winona's 'all-time favourite band', Soul Asylum also hailed from Minneapolis. They had been around for years, and gigging just as long, and had only recently moved from cult heroes to platinum sellers. It was almost on a whim that Winona decided to attend the taping of their MTV *Unplugged* performance. Afterwards she was introduced to Pirner but was very surprised when she met him. 'I thought he had red hair,' she laughed. 'The pictures on the CDs are very small.'

Two weeks after that first meeting, back at her home in Los Angeles, Winona discovered that the band where due in town, and invited Pirner round for a mushroom pizza. 'Our schedules didn't really allow picnics at the beach. But it was still very romantic,' she revealed. 'We were talking so much, the pizza got cold. I wanted to fry it, and he said, "That's impossible," because he thought after being in a band for seven years, he knew every trick for heating up pizza. But I totally fried it. It was like a montage sequence.

They met up with each other again in New Orleans in June, and recalls Winona, she had the greatest time ever. 'I was completely removed from being Winona Ryder, the actress. I was just this girl in corduroy shorts and a really dirty T-shirt, with just a credit card.' Playing pool with Pirner and his friends was a whole new experience. 'I'd lived in this weird shell of paranoia for so long, and then it just cracked open. At first, the onlookers would be going,

"Ooh, you were in *Beetlejuice*," and five minutes later they'd be like "Your turn." '

For a moment, she confessed, 'I could picture myself in a moment of total bliss saying, "Oh, let's get married right now!" I mean, I wouldn't do it, and the institution of marriage is something I question for people my age. But I thought, God, if the press had seen me in New Orleans, they could've made it into anything. I don't know what Julia Roberts did in marrying Lyle Lovett after a two week courtship, but it could've been like that. I think whatever you want to do in your life is just fine, as long as you want to do it, and you're not doing it for effect or attention.'

Although Winona wasn't shouting her business from the Hollywood hilltops, it was obviously apparent that she felt much more comfortable talking about her relationship with Pirner than she ever did discussing Depp. It was, she said, 'a nice thing that's evolving. Our relationship is different than any I've ever had. It's more casual, more of a friendship. What I'm basically saying is that it's not full of drama, which is really nice,' Besides, she continued, 'Dave is only like my second boyfriend.' But she also put it down to her own newly-discovered self confidence, and to a frank, disdainful lack of interest in the latest rumours and stories that the tabloids continued to concoct about her.

'I think I let myself be hurt by what they said about me, like I'm having an affair with so and so, I'm pregnant, I'm a drug addict – they've said everything under the sun. But it no longer bothers me, mostly because I don't deal with the kind of people I used to deal with. There was a part of me that wanted to know, and so there used to be people who would call me up and tell me what they'd heard, people I was working with, make-up artists or whatever. But I don't want that anymore. I hear things about me and sometimes think, "Oh really?" and it does not even penetrate.

'Even when Johnny says something about me in the press, it's like I look at him the way you look at someone you used to

know, and you say, "Oh, him," and it's not this big dramatic thing. And, God, I'm very happy that I'm not with an actor.' But, as one journalist would point out, and perhaps to aid her never-ending quest to be gracious, Winona never makes an unkind remark about Depp on or off the record, doesn't read his press and didn't go to see him in *Benny And Joon* or *What's Eating Gilbert Grape*.

For a time, though, Pirner was all she talked about. Some however remained uncertain of how their relationship would pan out. 'They are still discovering each other,' confided one friend. 'And right now it looks pretty intense because Noni is pretty intense. I'm just not sure that given their different temperaments and lifestyles, Dave will be a permanent fixture in her life. Part of his allure is his outlaw status. It appeals to the deeply conservative side of her.'

Although elsewhere other friends revealed that Winona and Pirner had much in common, the ubiquitous Hollywood insiders considered they were simply light years away from each other. Richard Corliss writing in *Time* magazine described them 'more George and Gracie than Sid and Nancy.'

But when journalist Jeff Giles caught up with the couple for a March 1994 feature in *Rolling Stone*, they were sharing the cooking and taking turns to wash the dishes. At first, wrote Giles, 'they appear so different as to cancel each other out. She drinks root beer, he drinks red wine. She wants to know if she should cut the chicken; he says, "Oh, just tear a leg off." Both are curious and well read and both are unaccustomed to sleeping at night, and both can think sideways. In person, they have a sweet and easy chemistry. When one of them talks, the other stops, looks and listens. And when Winona goes to the kitchen, she pauses, puts her arms around his neck, like a headlock, only nicer.'

Even when asked to explain her appeal as an actress, she laughs and asks Pirner, 'What's my appeal Dave?' to which his ready reply of 'Your appeal is that you don't know what your appeal is' was

probably spot on target. But even more obvious to Pirner was how unspoiled she remains. Once he remembers, I heard Winona on the phone telling somebody that she didn't get into this for the money. What an absurd thing to have to say when acting was all you wanted to do since you were thirteen.'

Although Winona was as protective as she could be about her new relationship, she also knew just how pestilent the influence of the tabloid press could be. In October 1993 for instance, Winona appeared on the cover of *Vogue* in a pose that clearly illustrated the outline of her ample breasts more so than any photo shoot had before. 'My older brother (Jubal) went in to buy it. The girl at the counter said, "Winona Ryder had a boob job," and it was like, "No, she didn't," and the girl goes, "Yes she did. Look at her tits." My brother got in this fight with this girl. It got really ugly.

'You know, I have a chest, and people assume it's not real because I'm small,' continues Winona. 'People who are catty think that if someone has an attractive feature, it can't be real.' The suggestion of having undergone plastic surgery leaves Winona just as cold. 'I'm way too chicken to go under the knife. The thought of someone touching your breasts with something metal is too horrifying even to think about!'

Winona was also enjoying the freedom of being between movies as she read the scripts that came in, aware of what roles she was looking for, and of those that might be suitable. One she adored was that of Amy in Joel Coen's *The Hudsucker Proxy*, and her failure to land the part was for Winona, the one huge devastation of her career. Even more disappointing was the fact that 'I was up for it, read a bunch of times, and got close, I think.' Not only that, it was the first time Winona had lost out on a role she really wanted. In the end, it went to Jennifer Jason Leigh recent star of *Single White Female*. Still the loss hurt. 'It took me a long time to get over because I felt I really would have been great in that part, but it's like

one of those things you think about it and you cringe, but you get over it.'

Not that she would have long to brood. Her would be screen father from *The Godfather Part III*, Al Pacino, was beginning work on what he termed 'a personal documentary' about Shakespeare's most complicated work, *Richard III*. In *Looking For Richard*, Pacino wanted Winona to play Lady Anne. He knew only too well that Winona was one of the few actresses young enough for the part, and one of the few with the ability to perform Shakespeare, and understand the scene she would be playing. He also knew she was perfect for the role. For Winona, the two weeks of filming proved to be everything she believed acting should be. Informal, relaxed, and above all, entertaining.

She would be appearing alongside her *Beetlejuice* and *Great Balls of Fire* co-star, Alec Baldwin, who was to play Clarence. 'We're getting forty dollars a day and all the doughnuts we can eat,' laughed Baldwin. Kevin Spacey was recruited to play Buckingham, with Estelle Parsons as Margaret, Aidan Quinn as Richmond, and Harris Yulin as King Edward.

Pacino's vision was certainly different. He described *Looking For Richard* as a combination of scenes from the play mixed with documentary footage about Shakespeare's all pervading impact – the way in which 'everyone from Sir John Gielgud to kids in New York's Hell's Kitchen are affected by the Bard's words.'

Long after Winona and the other actors had gone home, Pacino continued to work, filming interviews with a cast that ranged from construction workers through to truck drivers and onto his own peers – James Earl Jones, Rosemary Harris, Kevin Kline, and Derek Jacobi. 'By juxtaposing the day-by-day life of ordinary people with the actors and their characters in the play,' explained Pacino, 'we attempted to create a kind of cosmic mosaic showing Shakespeare in a way that has not been seen before.'

For some time, the press would refer to Pacino's project as nothing more than an extravagant home movie. But two years later, in October 1995, Fox Searchlight, the speciality division of Twentieth Century Fox, acquired the worldwide rights to *Looking For Richard* in a deal estimated to be worth about three million dollars. Following its premiere screening at both the Sundance Film Festival, and its international debut at Cannes, the movie was finally scheduled for a late spring 1996 release in America, and in Britain for early 1997, only weeks before *The Crucible.*

'Pacino has made an informative, engrossing and hugely enjoyable movie that stands as a work of pure entertainment, almost as powerful as its inspiration' wrote *Empire* magazine in their review of the film in February 1997. *Rolling Stone* were equally complimentary, calling it 'a great adventure and outrageous fun,' while Godfrey Cheshire writing in *Variety* noted that *Looking For Richard* was 'high spirited and infectiously energetic.' And one of Britain's most respected film critics, Barry Norman said much the same in his recommendation for the movie, observing that 'Winona Ryder made a gorgeous Lady Anne.'

Just as she was wrapping up her work on *Looking For Richard*, Winona's next role came in the form of a script she immediately fell in love with. Her agent thought it was just perfect for her, or at least, it would make a change. Helen Childress's *Reality Bites* was a movie Winona could wear jeans in. 'I'm so sick of wearing corsets and big hoopy skirts,' admitted Winona. She knew it was time 'to wear jeans and look normal' again.

There were however a lot of people around Winona who disagreed with her judgement. Although Ben Stiller was well respected, this was his first major feature as a director. For Winona, it was the chance to 'act my age for once'. Nevertheless, she can remember what most folk told her. 'You just did a Scorsese movie! You can't do this young first-time director project.' But Winona was adamant. 'Why am I so concerned with being older? I have

149

plenty of time for that.' Besides, she continued, 'a lot of people my age have come up to me and said, "why don't you do a movie about us?"'

For some reason, Winona explained, 'people think it's less serious to do a movie with young people.' She also had a lot of friends in college with whom she grew up with back in Petaluma who were saying much the same thing. 'Movies don't show what we're like. Certainly a lot of them are offended by that "fuckable woman" image. And these aren't critics or intellectuals. These are regular kids who just go to the movies every other weekend.' Winona believed that *Reality Bites* was a movie for them.

But was it a movie for her? Her only concern though, after all the costumes, accents, and high drama of *Bram Stoker's Dracula*, *The Age of Innocence* and *The House of the Spirits* was that *Reality Bites* with its contemporary romantic comedy appeal of four friends, newly graduated, whose attempts to survive in the real world in Houston, Texas, might tempt her to slip back into the adorable mannerisms that had been her signature ever since the beginning of her career. 'I don't want to turn into Winona Ryder being cute. Everyone assumes that doing a movie like this is so easy, but it's actually really hard. If I had been trying to just be appealing. I would be over now. That's never been my agenda.'

But Denise Di Novi, producer of both *Heathers* and *Edward Scissorhands* considered *Reality Bites* was 'the first film where you really see how adorable Winona is. She's the most charming, funny, sweet person.' Critics too agreed. One wrote that Winona, as the bad-tempered Lelaina was 'so charming and adorable that she even makes you love her scuzzy grunge-waif haircut, which makes her look like an acorn that just woke up.'

For Winona though, the appeal of *Reality Bites* was simple to understand. It was, she said, 'a fun film, and nice because I didn't really have to rack my brains. I enjoyed being on the set.' There were however, some aspects she didn't relish. One was the scene

where Lelaina and her friends indulge in a nostalgic singalong. 'I really hate my singing voice,' she confessed, 'so this was a big deal.' But even then, it was not as bad as she had anticipated. 'I sang Conjunction Junction from those seventies educational cartoons and you don't have to sound like Whitney (Houston) to sing that!'

Another was the scene where Lelaina and friends begin dancing in the aisles of a gas station convenience store to the Knack's seventies hit *My Sharona*. Doing that, she confessed, 'was probably the most fearful moment of my film career, like okay, I've just gotta let loose and be a geek.' Even more alarming, said Winona, was the fact that 'a couple of people I know who saw it didn't know we were kidding, and that really scared me, like, what if people think that I dance like that.'

And if that wasn't enough, there was another downside. Well, as far as Winona was concerned there was. That of the so-called generational references. Most of which were completely alien to Winona. 'I was born in the seventies, and so my generation were really the eighties,' she confessed. 'And also, I didn't have a television when I was growing up, so all those TV references and the seventies culture retro went over my head. I had to ask the other cast members what they were, and watched episodes and stuff like that, which was kind of gruelling.'

She did however, enjoy her time in-between takes on location in Houston. Sitting in her trailer, eating junk food, drinking Coca Cola, and talking about David Pirner, for whom she managed to wrangle a minute one line cameo playing one of Vickie's one night stands. But that was more to do with missing each other than anything else. Indeed, Winona was as surprised as Pirner that it even ended up in the movie. 'We were shooting so much at that point on video tape that we thought most of it would just end up in the trash.' All the same, she smiled, 'it was fun, and just a good excuse to hang out together'

In the end though, her co-star Janeane Garafalo who played Vickie, had to tell Winona to shut up about him. 'I just couldn't take it anymore. She definitely exceeded her Pirner limit.' But he was, she admitted, like Winona, charms most everyone, 'and is really funny and cute and sweet. I have a crush on him.'

Pirner was no less attentive of Winona. He'd always call her when their work commitments kept them apart. And on one occasion, Winona recalls, 'he called me and said he'd gone into a truck stop in Oklahoma City to play pinball, and after he started he realised he was playing the Winona Ryder Dracula pinball machine. He said, "I couldn't tell if it made my day, or ruined my game." '

For the time being though Winona focused on her role of Lelaina Pearce, of which *Reality Bites* was essentially her story. She is interning for a time at a local television station as a gofer on someone's nightmarish vision of local breakfast television. The host hates her and blocks her possible full time recruitment by the station. Lelaina overhears him and takes revenge in dramatic style by substituting his cue cards for a wide range of embarrassing confessions along the lines of 'I like little girls' and 'I'm a self-righteous prick.'

She is promptly given her marching orders, but she's confident she won't be out of work for long – so confident in fact that she even turns down an opening at the Gap. Not only is she rejected for every job in her field, but also loses out in interviews for the most menial tasks.

Unemployed and unemployable, Lelaina sinks into self depression not helped by her refusal to do anything more than lie around smoking and spending hours on the phone to the Psychic Hotline. It takes a four hundred dollar phone bill to shock her back to reality, and to catch the gradual return of her ambitious streak.

For Lelaina, that means making a video documentary about her friends: Vickie, Troy (Ethan Hawke), and Sammy (Steve Zahn),

who like Lelaina, are facing some hard facts about life after college, and mapping out their own offbeat survival guide.

Into this self contained world bursts Michael (Ben Stiller), a yuppie cable channel producer who meets Lelaina after his car smashes into hers. Smooth talking, smart, monied and successful, he wins Lelaina's heart only to lose it again when he adapts her documentary for cable television. 'She has been labouring over this documentary for a long time.' explained Winona of her character, 'and does not want to see it commercialised.'

In one scene leading up to that moment in which Lelaina's name is called over the intercom of the diner where she and Vickie are brooding over coffee, Winona's facial expression, as *Premiere's* Tom Shone points out in his review of the film, 'registers a quick roll of embarrassment, curiosity, and flattered incredulity which is quite the most relaxed bit of acting I've seen all year.'

By the time *Reality Bites* came out onto the screens, it was being hyped, as another critic put it, a 'Generation X' movie. 'I try to avoid labels,' explained Winona. 'If you label something "Generation X", it sounds as if other generations aren't going to identify.' Nevertheless she hoped the movie would have a timeless appeal. 'The dilemmas my character faces are the dilemmas lots of girls have faced, no matter what era they lived in.'

The script however turned out to be very different from the finished film. 'Most of us,' admitted Winona, 'were feeling as if what was happening to my character's documentary was also happening to the movie.' Even the production company, Universal, recalled Winona was 'a lot more liberal than I expected them to be. I don't think studio heads quite get the joke about the Gap, for instance, but they left it in the movie.'

Very nearly though, the reference didn't end up in the film at all. The idea to use the Gap clothing store as a congenial tone essential to the movie's sense of realism was about to be surrendered when Winona came flying to the rescue. 'We needed permission to use

the Gap name,' explained Stiller, and although he did his best to persuade the company to agree, he got nowhere. 'Then we had this idea,' remembers Stiller, 'why not let Winona give it a shot.' She had already appeared in a Gap poster campaign, and just may have the flack to pull it off. She did, and immediately, Stiller laughed, 'it was anything you want, Winona.'

Nevertheless Winona felt she ruined the movie overall. 'I can no longer make small movies with a first time director because once I'm attached the movie changes.' *Reality Bites*, she thought, certainly did. She even accused the film of having been slicked up into a 'music video vehicle' to take advantage of her star billing. But Tom Shone was more complimentary. It was, he noted, a movie that had the 'sense to slap Ryder in sneakers and give her a little romantic entanglement to chain smoke over.'

Winona though recognised that the film was doomed to be a period piece. 'The success of the film lies in the fact that what happens between the actors is current. It will probably be quite dated in five or six years.' Some however thought it may be dated long before that.

A Film for Polly

'She was from my home town, my school. It was horrible. Now there's a foundation. I'm on the board and I try to help. I love kids and if I'm in a position where I can have some positive effect, I take it.'

Thirty days before Halloween night in October 1993, a large dark bearded stranger crept through Polly Klaas's bedroom doorway while her mother, Eve, and younger sister, Annie Nichol, slept soundly in the next room. Wielding a knife, he bound, gagged and tied pillow cases over the heads of her two friends, Kate and Gillian, who, both sleeping over for a slumber party, were like Polly, just twelve years old, realised there was every reason on earth to be scared. The intruder told them not to move until they had counted to a thousand, then he picked Polly up and slung her neatly under one arm, and carried her off into the night.

It took twenty minutes for Kate to squirm and wriggle herself free before she could run straight to Eve's room to wake her up. 'I was in a state of total disbelief,' Eve Nichol told reporters. 'Then I heard Gillian crying. She said, "It's true. He was here. He took Polly." ' Annie didn't even wake up.

News spread through Petaluma within hours of the abduction, soon reaching other cities in the suburbs of California. Neighbours called to offer help as organised searches and vigils got under way. School children drew cards and made banners demanding to 'Let Polly Go!' and draped them over the main downtown street in Petaluma Boulevard. Across the state, mothers, grandfathers, school children and teenagers joined in the search. It was, one Petaluma resident described, 'a movement of the people.'

Indeed, 'She's still a little girl, who is afraid of the dark and afraid of being alone,' sobbed her father, Marc Klaas. Whenever she went to sleep she always insisted the hall light remain switched on

as well as the shell-shaped nitelight in her bedroom. It was no more than any other child, younger or older, would want to lessen their fear of darkness. Polly in that respect was no different.

She was, added Eve, a bookish child who enjoyed practising the clarinet, playing with her sister Annie and Kitten Milo and visiting her dad. The night before her abduction, she had her first ever babysitting job for a neighbour, and was, friends recall, always bright and happy. Shy but talented, Eve remembers a few days before her abduction how she came home from school with stories of another Petaluma Junior High student who her history teacher had said was 'so shy, she never even raised her hand in class, but who went on to be a famous movie star.' That student was, of course, Winona Ryder. 'Polly was so excited,' Eve continued. 'She told me her greatest dream was to meet Winona.' And for a short while, it looked like she might get that opportunity.

A volunteer command centre was set up in Petaluma to co-ordinate the thousands of residents from the surrounding community responding to the largest manhunt in American history. They answered countrywide calls, read thousands of letters and searched for Polly. A mass distribution of two billion images of Polly were sent worldwide. Flyers were displayed in shop windows, laundrettes, schools and bars, and relayed in their millions to television stations, libraries and public buildings. Everywhere Americans looked, the image of Polly Klaas, 'America's Child,' the beautiful girl with the warm brown eyes, shown smiling, stared out at them.

Among the hundreds of selfless volunteers who abandoned their normal daily routines was Joanne Gardner, one of the key helpers manning the phones when a call came through from Winona. 'She was in a hotel lobby in Los Angeles sobbing,' remembers Gardner. 'She said, "This is my town. This is my junior high. What can I do? Do you need money?" ' Then they talked for an hour and a half.

'Winona had an awful lot of experience because she'd had some horrible experiences of her own,' Gardner told the media. Memories of the stalker who had plagued Winona's teenage years was still a subject she felt uncomfortable discussing, but nevertheless, she told Gardner about them and offered to put the family in touch with some people she knew.

'She had some psychologists that she knew,' Gardner confirmed. 'She had some FBI people that she knew. She astonished me with her grasp of the situation.' They were people who had helped Winona through her own ordeal. An ordeal that although she had been advised not to discuss publicly, was reported to be one of a most serious nature. As we discovered in an earlier chapter, he was a man who knew where she lived, knew her routine and knew everything about her. Polly's kidnapper, it emerged later, was thought to have operated much the same way as Winona's stalker, of targeting and watching, spending time in Petaluma before planning and executing his crime.

Flying up to Petaluma, and making her way to Polly's home, just two blocks away from where she once lived, Winona hurled herself into the case by joining the teams scouring the surrounding countryside, manning the information hotline at the volunteer center, and pledging the entire two hundred thousand dollar reward that was offered for Polly's safe return.

David Pirner, too, threw himself into the search. Like Winona, he had an understanding of what Polly's family were going through. Only three months earlier, Soul Asylum's latest single *Runaway Train* had stormed the MTV airwaves with a hard-hitting video, dealing with runaway children that used pictures of real-life cases in the hope that the missing kids might see it, and realise somebody cared about them. Since then, there had been a swarm of sightings and even more importantly, reconciliation.

Winona also spoke with the pupils at Petaluma Junior High, the school she herself attended, encouraging them to keep faith

for Polly's safe return. 'I'm here to support all of you,' she told the five hundred who gathered in the campus quad to hear her talk. 'It really is a tragedy but Polly seems really smart. Everything I've heard about her is, she's smart, so maybe she can outsmart some people out there.' Afterwards Winona was simply grateful that she had been able to boost their spirits in the midst of a tragic situation, evident from the chants of 'Thanks Winona' and 'We love you.' One boy even ran up and gave her a hug. Still, Winona's greatest wish was for Polly to come home safely so she could just 'meet her, give her a hug, and see that she was okay.'

'She single-handedly put the story back on the front pages.' Polly's father recalled with gratitude. 'She was trying very, very hard to get Polly back.' They were, he added, 'both from the same city, and I think she recognised something in Polly that was in herself.'

Winona though was just pleased she could help, pleased too that she had both the money, and the media allure to keep the Polly Klaas case in the press. But there were those sceptics, at least initially, that assumed she had only become involved for the sake of publicity. Winona herself worried about that too, but was swift to brush such accusations aside.

'That is something people keep asking me about, talking to me like it's an actor getting politically involved in something. I don't think that was the case. To me, it isn't an issue at all. I've never been involved with anything like that.'

Joanne Gardner too, balked at such a suggestion. 'This is not, "Let's go open a shopping mall" kind of stuff. This is "life in the balance" kind of stuff.' It wasn't, Winona felt, really a cause. 'It was an outrage, and it's outrageous that more people aren't outraged. When something happens to a child, the world should stand still.'

The press however didn't seem to share her view. 'They were refusing to write about it unless I did interviews,' condemned Winona, 'which was kind of sick.' Nevertheless, she went along with their demands, simply to keep Polly in the public eye. For

Winona it was a few minutes of inconvenience. For Polly and her family it was their entire future.

For the foundation, already established in Polly's name by members of the Petaluma community to raise funds and maintain interest in her disappearance, it was a dedication, which had by late October, with Winona on the first Board of Directors, also directed its efforts to assist other families and communities in similar situations, who were suffering the same ordeals over a tragedy of a missing child, and even more importantly, to prevent such tragedies even occurring.

But tragically, that hope for Polly was cut short two months after her disappearance, when on 4 December, Polly was not found alive, but murdered. It followed the arrest of Richard Allen Davis, a state paroled and convicted criminal with a long history of crime and drug abuse, who had directed police to a disused timber yard at Cloverdale, fifty miles north of Petaluma, where Polly was found under some planks of wood. America froze with outrage at the same time they demanded changes for legislation in crime prevention.

Winona attended Polly's memorial service just before Christmas in Petaluma barely able to contain her grief or her anger. A lot of people shared her rage. Two years later, in October 1995, as Davis prepared to come to trial, his defence were so concerned about finding a non-prejudicial jury that it took weeks to even agree on a venue for the hearing.

And just a few weeks after Polly's memorial service, Winona's own childhood fear of kidnapping, probably reawakened by Polly's death, returned to haunt her. She was on the street in New York when a passing drunk suddenly grabbed out shouting her name. He was most likely quite harmless, and offered no real threat, but the incident was enough to intimidate Winona that she immediately returned home. Not surprising when you consider that Winona, not much bigger than a girl herself, had once been the attention of a stalker. That alone was threat enough.

Still, Winona did her best to shrug off such intimidation, but some years later, another similar incident of an over zealous admirer drew up equal concern. She was at a neighbourhood bar in San Francisco celebrating New Year's Eve, when, as she herself explains, 'a guy came up, grabbed me, and started to kiss me. I freaked out, and my brother pulled him off me.' What was so strange, Winona continued, was 'he felt that since he'd grown up watching me on screen, he thought he could do that. I think he was drunk, but it really shook me up.'

But Winona's real concern was for children, and nowhere is it better expressed than with her involvement in the Polly Klaas case. She even persuaded Universal Pictures to turn the February 1994 Los Angeles premiere of her film *Reality Bites* into a benefit for the Polly Klaas Foundation. 'I try to talk about it as much as I can because I don't want people to forget just because it's over.'

In fact, it was tragically ironic that just six months before Polly's disappearance, Winona had been talking to the National Center for Missing and Exploited Children. She was 'trying to figure out something I could do, mostly for runaways. And then this happened next door.' Indeed Winona's consideration for children is always in evidence. Even on film sets, she is said to be acutely sensitive to youngsters, and often speaks out with brutal honesty about Hollywood and it's damaging effects on young performers. Indeed, it is a subject she is more than qualified to discuss.

But perhaps nobody quite realised just how much Polly continued to prey on Winona's mind, or how indeed the tragedy had affected her until she announced that she was to participate in an adaptation of one of her favourite books, even though it would knowingly contradict her own belief that all great literature was sacred and should never be touched by Hollywood. There were however exceptions. Louisa May Alcott's *Little Women,* Winona knew, would make a fitting tribute to the memory of Polly.

'I just thought it was really appropriate because it was Polly's favourite book.' In fact, Polly's copy, a red bound children's edition with a schoolgirl's handwriting scrawled inside – THIS BOOK BELONGS TO POLLY KLAAS – is one of Winona's most cherished possessions today, and she was determined that the film would be dedicated to Polly.

Even today the book is read by virtually every schoolgirl in Western Europe and the United States. *Little Women's* four free spirited March sisters, beautiful Meg, impetuous Jo, fragile Beth, and romantic Amy, plus their caring mother, Marmee and the largely absent father were in fact modelled on Louisa May Alcott's own family. Set in nineteenth century New England during the Civil War, the story follows the four sisters turbulent romances and lasting friendships in the enchanting years between adolescence and adulthood, encompassed by the love of their caring Marmee who in turn unwraps a gift of humour and heartfelt emotions in morals and responsibilities which, of course, do nothing more than exile the girls from their own social echelons of society, only to be further complicated with discrimination of politics and poverty. It is also that which is the centrepiece of *Little Women.*

There had already been two best loved movies as well as a less critically acclaimed one made for television. And even at the time a remake was being considered, not one studio in Hollywood was interested in committing themselves to yet another version.

Everybody was scared of making *Little Women,* remembers Winona. No one, they said, is going to go and see it. 'It won't make money, and blah blah blah. I don't think it would have been made at Columbia unless I said yes, or unless Julia Roberts wanted to do it.' Certainly, agreed Mark Canton, then chairman of Columbia Tristar. 'It only became a reality because of Winona's participation.' She is one of the very few actresses around whom a studio can build a production observed *Life* magazine. 'And the only one of her generation.'

The idea of making a fourth version had come from Amy Pascal, then an executive vice-president of production at Columbia, and one of her friends, screenwriter Robin Swicord. The two women had discussed the project ever since the early eighties, and their passion for making a film of the book a decade later remained unabated. Both knew that Alcott's story had as much resonance in the nineties as it did in the 1870's.

Pascal's first choice of producer was Winona's old ally, Denise Di Novi. She in turn called Winona as soon as she was offered the project. They, too, had talked of their love for the book on the set of *Heathers*. As soon as Winona answered the phone, Di Novi recalls, 'I said, "You won't believe this, but we can do *Little Women!*" And of course she jumped and said she'd love to do it.' She would be playing Jo March, the novel's aspiring writer heroine.

Apart from the connection with Polly Klaas, there were other reasons for Winona's enthusiasm about the film. She had read the book when she was twelve, loved it, and was still very passionate about the story. Besides, her parents had written about Alcott in two of their books. One, *Shaman Woman, Mainline Lady*, Winona explained was 'about famous women writers who were under the influence of drugs when they wrote their masterpieces. Louisa May Alcott had contracted a disease while she was a nurse in the Civil War and was given morphine. She became addicted and was on it when she *Little Women*. ' And there was also the film script Michael and Cindy had been working on for years about Alcott's relationship with New York critic and short-story writer, Fitz Hugh Ludlow, whose library Michael now owned.

With such strong links to the novel, Winona could be relied upon to make *Little Women* work. Outside her own professional circles though, she was considered an odd choice for the part. 'One of fiction's few pointedly unbeautiful heroines – prickly, awkward, and anti-social' was how one critic described the character of Jo

March. A far cry from any role Winona had played in the past, but Di Novi was not concerned.

'I found *Little Women* a very comforting book as a kid,' she explained, 'because Jo wasn't like all those other girl heroines, really pretty and popular and everything. I didn't feel inadequate when I read about Jo. Winona is actually more like Jo in real life than any other character she's played. Winona may be little, but her personality is big.'

Winona herself leapt into the role. She learned to knit and taught herself needlework, darning, and pen-and-ink calligraphy, as well as receiving instruction on the intricate nineteenth-century social customs and etiquette required of ladies of that era. On set, she vowed she would wear hardly any make-up, and 'with my hair pulled back in braid, I look very plain.' And for enthusiasts of June Allyson's portrayal of the same character in Mervynle Roy's 1949 version, she also had the same slightly overlapping teeth for which she was still grateful to Allyson for their continued presence.

But Winona was also keen to make the film for another reason. It had 'something to say about developing character, developing your mind, and helping others. It's not just about how to be hip or how to be cool.' More importantly, it had something to convey to people her age and audiences of her generation. It was 'something that speaks to them.' She even decided that if her name could persuade Hollywood to make films like that, then 'great!' But equally enthralling for Winona was the overall feminist tone as much as the individualism of the characters, and that, she said, was another 'something' she could relate to with Robin Swicord's nineties screenplay.

Among the many highlights she adored was the scene when following a minor family tiff, the youngest sister, Amy, burns the manuscript Jo has spent months slaving over, Jo returns home to discover her precious book already turning to ashes. She flies at Amy, screaming her hatred, and even after she has been pulled

away by her mother, her fury still blazes as brightly as her novel. 'You're dead! You're nothing!'

Far less enchanting for Winona was the scene when she turns down Laurie's perfectly good marriage proposal. 'I really haven't forgiven myself for that whole thing,' she told *Empire* magazine. She can even remember asking Christian Bale to do 'something obnoxious so that people won't hate me so much for not choosing you.'

She also took great pains to find a suitable director, passing over a number of well-established names before finally approaching the Australian director Gillian Armstrong. As soon as she and Di Novi met her, they knew their search was at an end. Much the same as David Seltzer had done casting Winona for *Lucas*. She too, instinctively knew, she had to look no further.

Born in Sydney and raised in Melbourne, Australia, Armstrong's career had been irrevocably challenged ever since primary school, she dedicated herself to writing and putting on plays. But pursuing an interest in costume and theatre design, she enrolled in the film department of an art school, later working as an art director and documentarian before moving into directing in 1975.

She first grabbed the Australian public's attention with *Smokes and Lollies*, a documentary study of three fourteen year old girls, and the first in a trilogy of documentaries that traced the same three women's lives. By the time the third, *Bingo, Bridesmaids and Braces* was released in 1988, she was already making her mark in feature films that had begun ten years before with a debut as Australia's first ever female director for the much acclaimed *My Brilliant Career*.

That was, Winona recalled, 'one of my mother's favourite films when I was growing up.' She even admits to having seen it herself at least a hundred times. 'So I kept saying we've got to get Gillian to direct.' And although Armstrong was enthusiastic about the project, she was initially reluctant to take it on.

But Winona practically begged her. 'I bombarded her with compliments, so she couldn't even speak. I talked about how great she was, visually and emotionally. That her films had substance, and she got great performances out of actresses. I just talked her into it, thank God.' But even after Armstrong had agreed to do it, even after meeting Winona and realising, 'I found a face that I was desperate to capture on film,' it still required a lot of determination on her part to actually go ahead.

The last time Armstrong had worked in Hollywood on *Fires Within* in 1991, the experience had been a disaster. Ignoring her protests, MGM had completely recut the movie to the point that Armstrong herself felt completely divorced from it. Then when the movie was finally released, it was suffocated with a limited distribution.

Discussing the debacle on the set during the making of *Little Women*, Armstrong philosophically sighed. 'It's the old Hollywood story. It's part of the game. They put up the money, and then they tell the director who's made them a hundred million dollar success that she doesn't have the final cut. It's luck of the draw, really.' This time though, to avoid any similar disasters, Armstrong insisted she would edit the footage on her own at home in Australia.

'We were very excited when we first met Gillian,' Di Novi said. 'She had a reverence for the book, an immediate understanding of what made the book important and also what made it fun. She saw depth and meaning, and knew how to balance all the aspects, not making it too serious or too silly a film, not making it a message movie or pure fluff. Gillian found the perfect blend to make it entertaining.'

Winona confirmed Di Novi's excitement. 'As soon as we started, I believed in Gillian. She's got a real point of view. I think *Little Women* is going to be a classic movie because it's really heavy and really intelligent, and in a way, it's a real art movie, too. It'll appeal to the people who drink cappuccinos in the lobby.'

Slowly the cast began to take shape around the core of Winona. Looking for an actress to portray the March family's mother, Marmee, Di Novi decided she wanted someone, 'earthy and warm and sensual.' Who better than Susan Sarandon. Like Winona, Sarandon could identify with an aspect of the Alcott family, not the commune aspect, but the religious and ethical one. Sarandon had, after all, grown up in a strict Catholic family, the eldest of nine, and as a child aspired to a career as a saint. For the rest, Trini Alvardo, who played Diane Keaton's daughter in Armstrong's *Mrs Soffel*, became Meg, Kirsten Dunst and Sammantha Mathis respectively played the young and oldest Amy, and Claire Danes, spotted by Winona on a bootleg copy of the *My So Called Life* television pilot was chosen for the role of Beth. It all seemed an excellent mix. 'Within ten minutes of their first lunch together, there was instantaneous chemistry,' Di Novi recalls. 'Everyone just clicked. They started teasing each other, goofing around and acting silly, just like real sisters.' Gillian Armstrong confirmed Di Novi's impression, observing how Winona was 'warm and generous to all the girls in the movie, and that was fantastic because it set a tone. They really did become like sisters.' Even visiting journalists to the set would agree, watching charmed as Winona looked out for the younger actresses, keeping them amused with impromptu activities like Take A Bow, a sort of Simon Says and Charades like game.

Four Words! Winona signals. First word! Movie! She twinkles flirtatiously and bats her eyelashes, laces her fingers and rests her chin on them like a Precious Moments figurine. She poses for a moment, then suddenly extends her arms and starts sashaying around.

'Shy!' squeaks Eva, the nine-year old daughter of Susan Sarandon, watching Winona's every move. Wrong

'Dancer!' Wrong.

'Pretty,' guesses Sarandon. More, bigger, Winona signs.

'Beautiful!' Sarandon cries, getting involved. Close, so close, but shorter.

'Beauty?' Sarandon guesses.

'Beauty and the Beast!' Eva yells, ecstatic. Yes!

It was typical of the lighthearted interludes on the set in Victoria, British Columbia, where shooting commenced on 18 April 1994. One of the several locations on Vancouver Island. Scottish coal-baron Robert Dunsmuir's century old Craigdarroch Castle was another commandeered for several scenes, while the streets of Victoria itself were transformed into New York's Greenwich Village of the 1860's. Tons of dirt were shipped in and spread around the streets to camouflage the modern roads and sidewalks as modern day electric street lights and signs were removed, and horse-drawn carriages were brought in as well as more than a hundred and fifty period costumed extras, while the exterior of the Royal Roads Military College was used in depictions of France and Switzerland.

Winona herself found the transformation awesome. 'I really do romanticise about the nineteenth century,' she confessed. 'I mean, I go, "Ooh, they made their own bread, they ride in those carriages." Though I'm sure medicinally and scientifically it was a drag, there was more emphasis on the importance of relationships between a family. You didn't move out when you were sixteen. You communicated with people on a much more real level.'

It was an era, nonetheless, that disciplined caution, especially around the house. 'The prop people warned us to be really careful when we carried candles around,' Winona recalled. 'One night while we were shooting, we heard this scream. Claire (Danes) had carried her candle too close to her head, and whoosh! her wig went up in flames.' The crew accustomed to girly high spirits on the set thought Danes' screams were just another outbreak of horseplay and ignored them until Winona herself leapt on top of the actress, forgetting her own fear of fire, and beat out the flames with her

bare hands. It was, Winona laughed later, 'like an episode from Rescue 911.'

Little Women was released for Christmas 1994 in America, a lavish production that fulfilled all the criteria for a seasonal movie and rapidly became both a critical and box-office smash hit. It worked well out of season as well. 'The film of the week, and of the year so far,' raved London's *Independent's* Quentin Curtis when the movie opened in Britain in March 1995. His was only one of many acclaimed reviews.

And for Winona, there was the additional acclaim from her peers with a second Academy Award nomination in as many years. For the 1995 Oscar ceremony, she was nominated for Best Actress. 'I really didn't expect to come back so soon,' smiled Winona proudly at the nominees luncheon, 'but it's great. It's absolutely an incredible feeling.'

But she was equally surprised at the positive reaction the film received from male audiences. 'Well, men did see it actually, but nobody ever talks about that. The men saw it, and they couldn't believe they liked it, and a lot of men didn't admit going to it. But the only thing I've heard is that it's just got an incredible reaction from all ages and both sexes, and I think more men saw it than people think.'

'In these times,' continued Winona, 'when everything's so hip, this movie is so pure. It's beautiful. It's inspiring. It's about people, it's about individuals, it's about women's rights, it's a great love story, all the things we label corny, but they're really not.' It was, she continued, the kind of movie 'that makes you want to call your mom.'

An American Superstar

'She's really authentic, and audiences respond to that. I think her authenticity allows her to give us an insight into life's human condition, and that's what we like to watch' – **Laura Ziskin, President, Fox 2000**

Winona's next role, Finn Dodd, in Jocelyn Moorhouse's *How To Make An American Quilt* was a movie based on Whitney Otto's 1991 bestselling novel. A Berkeley graduate student adrift in her mid-twenties, Finn is battling a thesis on the rituals of women's handiwork in tribal cultures and her imminent marriage proposal to her live-in boyfriend, a carpenter named Sam (Dermot Mulroney). Overwhelmed by both, she flees to the small California town of Grasse where she grew up to ask her grandmother Hy (Ellen Burstyn) and great aunt Glady Jo (Anne Bancroft) whether she should go ahead with the matrimonials. There she discovers they have already made up their minds as their quilting circle gather to make Finn's wedding gift, they talk and reminisce, each one bringing a life experience to Finn's future, now even more assailed with doubt after flirting and consummating a fling with Leon (Jonathan Schaech), she spars her decision whether to marry a lover or to marry a friend.

The movie was a sort of object lesson in the joys or at least the solace of remaining conventional. How a person's heart rarely makes the wrong choice, but sometimes that decision isn't the right one after all. In fact, it was that theme which was the centrepiece of *How To Make An American Quilt* and beautifully concluded in Winona's voice over that sets the final scene. 'You have to choose your combination carefully. The right choices will enhance your quilt, the wrong choice will dull the colours, hide their original

meaning. There are no rules you can follow. You have to go by instinct, and you have to be brave.'

Many critics compared the movie to *The Joy Luck Club*, a similarly constructed film about a group of multi-generational females tackling universal issues. Although that one didn't quite have the remarkable group of actresses that was assembled for *American Quilt*. For director Jocelyn Moorhouse making the film was a very emotional experience. 'I admired all these women for quite a long time. It was like a wish list from the golden age of American cinema.' Winona couldn't agree more. 'For the first few weeks I literally could hardly speak. When you're surrounded by these women, who are like national treasurers, it's better than any acting class. I tried hard not to stare or eavesdrop. It's been a beautiful, enlightening experience for me.'

Apparently the feeling was mutual. Winona's 'such an amazing creature,' observed Ellen Burstyn. 'Jocelyn said she's like a rose, and that is what she's like. You can't help but admire her delicacy and beauty, and she's so bright and funny and dear.' Claire Danes, her friend from the *Little Women* set was equally gratuitous. 'She's not guarded when she works. There's no veil there, so people feel close to the character she plays.'

Such a premise of mutual respect among the actresses was nonetheless to the movie's benefit during filming, even though there were times the admiration was equally amusing. Maya Angelou, who played Anna, the senior quilter, recalls the day Alfre Woodard, one of the younger characters, Marianna, and Winona breathlessly remarked, 'Our friends ask us, "What is it like to be working with such icons?" The elder actresses were so simply amused by it all that every time they were given directions by Moorhouse, they laughed, 'Are you speaking to me, or are you speaking to an icon?'

Winona was the first cast when that process began in the spring of 1994. 'I really loved the character of Finn,' she said at the time. 'I seemed to get attracted to characters who are really confused,

probably because I'm really confused most of the time, but I thought it was a great way of showing someone who's trying figure out what to do with their life. The script was just very subtle and beautiful. I immediately connected with it, and I wanted to be part of it.'

The practical similarities to *Little Women* were many. Once again, the director was Australian, only this time, one making her Hollywood debut. In fact, Moorhouse was recruited after producers Sarah Pillsbury and Midge Sanford had caught her first film, 1992's *Proof.* And once again, Winona was working alongside a crew that was primarily female in virtually all the major creative roles. 'I walked into the rehearsal,' Anne Bancroft smiled, 'and it was the first time in my career where there were no men in the room. I thought I'd died and gone to heaven.'

So did Dermot Mulroney. But for different reasons. 'By the time they were casting the role of Sam, they had a list the length of your arm of America's greatest actresses. So I get there for my first day of filming, and I'm getting kissed by Ellen Burstyn and Anne Bancroft and Jean Simmons and Winona Ryder.' That was, he remembers, 'a banner day.'

Filming of *How To Make An American Quilt* commenced in October 1994 for release exactly one year later in America. The film's first outing in Britain was a month later at the London Film Festival, but nationally not until the following summer. Almost everywhere, the movie was greeted with a mixed critical reaction. *Entertainment Weekly* and Britain's *Film Review* called it 'a five-hankie weepie,' while *Flicks* described it as 'a touching drama,' noting it was 'essentially a film by women, about women, for women, it has an edge that takes it well beyond the conventional women's picture.' Others said that 'if it pulled the same audiences as *The Joy Luck Club*, it's a hit.' And Jonathan Ross, writing in *News of the World*, thought it 'excellent.' There were, of course, a batch of conflicting and generally more negative reviews, but overall the

171

film opened strongly and was still figuring in the US Top Ten a month after it's release. And even though it was not considered a major hit, it still managed to take over twenty three million at the box office.

The movie was however completely overlooked by both the Grammy and Oscar committees, even though Winona would have considerable presence at both. Her beautiful reading for the audio book of Anne Frank's *Diary of a Young Girl* earned her a best Spoken Performance nomination at the Grammy's, and little over a month later she appeared on stage at the Academy Award ceremony to introduce Bruce Springsteen's performance of *Dead Man Walking* from the film of the same name. But of *How To Make An American Quilt*, there was no mention.

In fact, it was Winona's appearance at the Oscars without David Pirner that more or less confirmed what the Hollywood gossip columns had been insisting for weeks – that she and Pirner had broken up. Within the week *USA Today* confirmed it, and so did Winona's spokeswoman, who said the two weren't dating now but 'remain very close and very good friends.'

Although no explanations were offered, insiders simply blamed the career conflicts that kept the couple separated for so much of the time. Neither apparently was she in a hurry to let anyone else into her life. Although she would attend the premiere of *Sgt Bilko* with British actor Richard E Grant, who had worked alongside Winona in both *Bram Stoker's Dracula* and *The Age of Innocence,* it was never suggested that the couple were anything more than just friends.

Indeed, it would be late 1996 before Winona was again publicly linked to anyone. Stories of a romance with *X Files* star David Duchovny swiftly swept through the tabloids compounded no doubt by Duchovny talking about Winona with passing journalists. 'She has everything. A gorgeous face, sharp mind, and best of all, a sense of adventure.' Winona however was not so enthusiastic as

Duchovny. After all, they were nothing more than just friends, and Winona was quick to reinforce that when she talked with *American Vogue.* 'Somehow the rumour got started and it was like a hurricane hit. I just wanted to nip it in the bud,' she said. 'We're just good friends who've casually dated, and we went out a few times, but that's all there is. I'm not involved with anyone. Period.' For the moment, confirmed Winona, 'I'm currently happy just spending a lot time with myself.'

Even a reunion with Pirner was speculated upon when the couple were supposedly spotted canoodling in an Los Angeles park sometime after they had ended their three-year relationship. The fact that it was rock star Erik Erlanson pictured with Winona didn't seem to matter. But then again, it wasn't the first time there was talk of a reconciliation between Winona and Pirner. The pair were reported in the US press to be 'cozy,' playing house for two weeks in Essex, Massachusetts during the making of *The Crucible,* and their attendance together at the Manhattan premiere of the same movie only added fuel to the fire.

There were also rumours in circulation of dating, two-timing and being in love with the playboy son of retailing billionaire Mohammed Al Fayed, Dodi Fayed, who at the time was being romantically linked to Diana, Princess of Wales. Winona, of course, didn't have much to say on the subject. What after all could she say about someone she never met, and had never even heard of? Besides, 'I would remember somebody named Dodi.' But when Dodi, the boyfriend Winona never knew was tragically killed with Princess Diana at his side in a car accident in Paris, people started to call Winona asking for comments. All she could do was express her regrets and point out that she and Fayed had never met.

Nevertheless the stories continued. One that appeared in some tabloids in Britain reported that she was secretly dating Jay Kay, the Jamiroquai vocalist. The pair had apparently 'been spotted out on romantic evenings canoodling at London's trendy Met bar.'

Winona however was quick to deny any romantic involvement with Kay, and for that matter, the several other musicians that she was linked with. Evan Dando of The Lemonheads, former Nirvana drummer Dave Grohl, and Stephan Jenkins of Third Eye Blind. But according to Winona, 'I've been linked with people I haven't even met. If I was literally in the same room with a guy, it was in the papers the next day, but none of the rumours are true.'

Nevertheless, there was still a buzz in the gossip columns that she still only dated rock musicians. She herself remained incredulous on the subject. 'That is the most ridiculous thing. I'm a girl. I like boys. I was with a musician for four years, so I guess I got a certain stigma that I dated rock stars.' But it wasn't the only occasion. A reporter for American teen magazine *Sassy* once asked some alternative rockers if they would go out with her, explaining, 'It's my theory that boys start bands so they can get famous enough to attract Winona Ryder.' Asked whether the comments concerned her, Winona smiled serenly, and replied, 'Why can't we all just get along?'

According to one young actress, 'Noni is a very nice person, but it has to have been hard for her because she's never had a normal life. Like when somebody suggests something ordinary like "Let's have a barbecue," she gets kind of excited because for her that's something really exotic. If it wasn't for having a cool family, she'd probably have gone crazy by now.'

From *How To Make An American Quilt*, Winona moved directly into shooting *Boys*, a movie that she calls 'a very weird kind of *Snow White*'. Or at least, that's 'the first thing you think of.' Adapted from the short story, *Twenty Minutes* by the gifted James Salter, the film opens with a promising air of mystery as a cop (John C Reilly) calls on Patty Vare (Winona) at her Maryland home to ask about a car stolen the night before, and about the disappearance of Bud Valentine (Skeet Ulrich), a hot pitcher for Pittsburgh. A nervous Patty claims ignorance and hops on her horse for an afternoon ride.

When the horse rears and she's knocked unconscious, Patty's found by John Baker Jnr (Lukas Haas), a senior at the tie-and-jacket Sherwood School for Boys.

Instantly enchanted by Patty's beauty, Baker is equally captivated by her sense of mystery, and soon learns that she is on the run. But from whom and why remains unknown. Determined nonetheless to shield her from her pursuers, the independent Baker breaks school rules and shelters her in his dorm room.

As mutual attraction turns to romance, a door is opened for each of them. For Baker, it reveals a glimpse of what adulthood can be, and for Patty, a doorway back to a time of innocence and purity. 'She's almost a kid, and he's almost a man,' explained Winona. 'They're both at a kind of crossroads, and they just happen to fall into each other.'

But *Rolling Stone* was not convinced. 'The film lacks the dangerous edge of Salter's haunting story,' wrote Peter Travers in his review of the film. 'Flashbacks to Patty's night with Bud don't resonate with the terror of a life thrown out of balance. The happy ending is a miscalculation. It's fine for *Snow White* to go out with a smile and a song, but Patty Vare needed to lie down with darkness.'

The Los Angeles Times agreed. 'Not only disappointing but numbing,' complained critic John Anderson after watching the movie. 'You're left wondering what in God's name is going on... and we can't for a moment buy the love affair between Baker and Patty.' Not surprising with just seven years separating Haas from Winona, who herself looked several years younger than her actual age at the time. Nevertheless, continued Travers, they 'make adorable flirts, but the fuss the film tries to stir about the kid and the older woman doesn't fly since Ryder, at twenty-four, still looks like jailbait no matter how much she smears Patty with lipstick and badass attitude.' That is probably true. But at the same time, Winona, as Anderson put it, 'seems to get more beautiful with

175

every picture, she looks good even when she's supposed to have a hangover.'

Another reviewer went even further in his aversion to the movie, suggesting the film would have been far better if the script had been abandoned altogether and simply replaced with scenes of the dramas that had reportedly been going on behind the cameras.

Indeed, one nearly halted production altogether. Winona had been crazy about the *Boys* script when it was first presented to her. 'I had a bizarre reaction to it. It was almost like reading a diary. The dialogue and the emotional pacing seemed so personal. It was a terrific story that seemed to happen in real time, not movie time.' The role also offered Winona something else. The chance to play a complicated, grown-up character. 'She's a kind of lost person. Most characters that I read are one or the other. Either good or evil. Patty is doing destructive things, but she doesn't know why she's doing them.' It was what attracted Winona to the part in the first place, but a late script revision that introduced a sex scene adding nothing to the plot, but an entire difference to the film's box-office appeal, would leave Winona less than enthusiastic.

'There's an obligation to commercialise something when you have a movie star in it,' she complained, as memories of *Reality Bites* returned to haunt her, 'I don't blame anyone but myself,' she admitted, but was determined that no way on earth would she do this version. She told the producers and walked off the set.

'She cannot be seduced,' confirmed Denise Di Novi. 'Ninety percent get persuaded by people around them, 'You have to do this part, work with this director,' but you can have fifty people in a room telling Winona what to do, and if she doesn't want to do it, forget it.'

'All this strategy has nothing to do with creativity or art or acting or any of those things,' said Winona once. 'It has to do with money and power and box office and positioning,' areas of her career that she felt no interest in whatsoever.

Neither, continued Di Novi, can she be swayed by popular opinion, pressure or manipulation. 'I think that's why she's so successful. She really has a backbone and makes decisions based on the right criteria. She doesn't do things because she thinks it's good for her career or she'll make money.'

Still, when *Life* magazine caught up with Winona for a December 1994 interview, she was staring at a blank calendar. 'I have lots of time. I have just dropped out of this movie.' It took several weeks and one crucial telephone call from Winona to Stacy Cochran, the writer and director, before she returned to the set of *Boys*. With differences resolved, and script restored, Winona was pleased. 'The only reason it worked out is because of the conversation. I'm really happy about that.' She would not however be so happy with the completed movie.

'It was terrible,' she complained. 'I thought it would be this small, quirky, weird little love story, but sometimes you know early on, uh-oh, this is going to be a real stinker. I tried to pull out, but they were going to sue me for like, every dollar I'd make for the rest of my life.'

But even then filming was not without its difficulties. Locations had to be carefully selected due mostly to Winona's hectic schedule. Maryland was ultimately chosen for a number of scenes, and St John's College in Annapolis was commandeered for the ones depicting the Sherwood Boarding School for Boys. The meadow in which Winona as Patty is thrown from her horse was situated in the horse country just north of Baltimore. But according to Robert Elswit, the director of photography, filming could not have been smoother. Besides, 'how can you go wrong shooting Winona Ryder. The camera just loves her.'

As much as Winona was the first choice for the role of Patty Vare, so was Lukas Haas for John Baker Jnr. His past credits included such pics as *Leap of Faith*, *Music Box*, *Rambling Rose*, and, more notably, his role as Samuel Lapp in *Witness* opposite Harrison

Ford. Winona was delighted. 'He really is a tremendous actor, and I think people are going to be blown away by how self assured and strong he is. He's not the kid from *Witness* anymore.'

There was, confirmed producer Peter Frankfurt, 'a really nice connection between the two. They liked each other very much, and there is a sympathetic quality that comes across in their performances.' It was an observation that Winona also shared. 'There's definitely a closeness that we have that makes it not so uncomfortable, and we get along really well,' explained Winona. 'I've known him since he was that little boy from *Witness*, which I'm sure he gets so sick of hearing.' Even if Haas did, he didn't let it show. 'This is,' he said, 'my first leading man role, and to be Winona in that, is just the best there could be.'

On location in the cold October breeze of Baltimore, Winona bundled herself into a bulky green parka, and spent much of her time perched up against David Pirner whenever he visited the set. He is, she enthused, 'the only happy-go-lucky, jolly musician I know.' When Winona wasn't working, the couple would more often than not watch old movies on television until at least three in the morning, and when she was, he would simply visit her on the location set enduring the tedium with infinite patience.

At other times Winona would delight the cast and crew with her engaging stories. She was, remarked most, an excellent storyteller even though she was inclined to embellish here and there. But that was all part of the allure. 'I like to enhance, but I don't ever lie.'

One, she told gravely like a ghost story was a dream she had of Richard Attenborough dying in a plane crash against a snow-capped mountain. It was 'so weird', she recalled, that she decided to call the Attenborough office, not sure what she was going to say, nor how she would explain it was just a dream, but she needed to tell him not to take a flight that day.

To her relief, she discovered that he had already cancelled. But later she heard the plane the director had in fact been booked

on did indeed crash – and, into a snowy mountain. Although for journalists to whom Winona related the story, it may not have carried as much seriousness as it did for Winona herself, it demonstrated how quickly she acted upon an almost psychic warning of an incident, an ability that many possess, but most dismiss as coincidence, and even fewer act upon. Winona however did.

She also found other ways to indulge herself and her young cast in between takes of the actual filming. On one occasion, she urged Spencer Vrooman, who played the part of John Murphy, to learn a musical instrument. 'Choose your weapon,' she demanded. 'Gee-tar!' replied Spencer. That was all Winona needed to acquaint Vrooman with a lesson on how to hold and handle the instrument. 'You totally have more of a knack than most people I know,' she raved. 'You were born to rock!' And if that wasn't enough to engage his delight, days later, she bought him one of his very own. It was yet further proof, if any were needed, of Winona's almost mystical reverence for children and teenagers. She was passionate about their freshness and candour, something that spilled over outside of film sets.

Some of Winona's closest friends are, in fact, under the age of twelve, an age for which she has an enduring respect. It is when she started acting, but it's also an age, her mother Cindy believes, when you can start relating outside your family. 'How you relate to people is formed then. The more you understand that, the more you're able to correct. Very often we duplicate negative relationships we had in the first twelve years of life.'

Winona however, doesn't entirely agree. 'I don't do that,' she explains, 'because every time something I don't like happens in a relationship, I'm careful never to take that from someone again.' But that, she confessed, could largely come from working in movies. 'When you've been an actor your whole life, your emotions

and the acting get confused. When you fight with your boyfriend, you start acting. It's like work.'

Boys was originally scheduled to open within weeks of *How To Make An American Quilt*, but ultimately it was delayed until May 1996 in America, and in Britain received only a selected release in September of the same year, and by the time *Boys* finally made it out onto the screens, it had undergone two title changes from *The Girl In His Room* to *The Girl You Want*, before reverting back to it's original title. With only lukewarm reviews at best, and a poor box office performance, the film quickly became forgotten, and as Winona had already pointed out, it was a big mistake. From that point of view, when Winona walked off the set, maybe she should have stayed off!

Next time, 'I get a script for a tiny movie, I'll have to have a serious contract drawn up saying nothing can be changed without my approval. Except, I don't want to have that kind of power when it's somebody else's movie. I don't want to start taking control away from the director.' But she also recognised, as she had done with *Reality Bites*, that 'if those movies had an unknown actress in the lead, they would have stuck more to the script, but because they got a known actress, they tried to capitalise on that and make them big movies, and in the case of *Boys*, completely destroyed it.'

In America, the movie's release coincided with the delayed trial of Polly Klaas's killer, Richard Allen Davis, which by this time had moved around Californian courts as the defence sought a jury that could give the self-confessed murderer a fair hearing. For Polly's family, the trial would at last offer them an opportunity to finally lay the horror of it all to rest.

Winona watched the proceedings, gratified that her contribution to the search effort had at least helped bring about this resolution of the tragedy, and at the same time, relieved that the media was not forever on her back for some kind of comment. What after all, could she say? Davis had confessed to the killing, and he was

inextricably tied to it by a palm print found in Polly's bedroom. All the trial would really resolve was whether or not Davis would die for his crime. The court resolved that he would, and to this day, awaits his execution at San Quentin prison.

Winona nevertheless maintained a low profile throughout the trial's duration, confining any high-profile appearance to the Academy Award ceremony in Los Angeles that March 1995. Then, no sooner was her work wrapped up on *Boys*, than she was starting work on yet another movie. Her most challenging role so far and the one most deserving of the Oscar. And although in future years Winona will doubtless become the winning choice for the Academy voters, such acknowledgement for what Twentieth Century Fox President Tom Rothman called 'a virtuoso performance' remained an elusive prize.

To Be Continued

'Her playing field is getting bigger and bigger. I can't imagine anything that she couldn't take on now.' – **Daniel Day-Lewis**

Before heading out to the Massachusetts coast to film *The Crucible*, Winona had already found the house she wanted to locate herself in during filming. She paid the owner eighteen thousand dollars to move out as she turned the place into what she called home by hanging old movie posters in the bedroom, installing curtains, and a security system.

It was a white Colonial property built in 1727, and within easy reach of the set on Hog Island. But, complained Winona, 'people were looking at me all the time, peering through my windows.' To her real estate agent, that seemed a preposterous notion. 'People wouldn't stare if Elvis showed up.' It was, after all, sophisticated New England, scarcely in awe of the glitter of West Coast culture. All the same, Winona still felt uneasy about the possibility of intrusion, and taking great pains to eliminate such distractions posted a full-time security guard at the bottom of the driveway to protect herself from any such curiosity. There were, however, times when she would break her own cardinal rule to excite local teenagers by handing out souvenir guitar picks whenever she and David Pirner, back together for the moment, stepped out for takeaways.

The idea of making a movie version of Arthur Miller's *The Crucible* was the brainchild of Miller's son, Robert. He had first discussed the project of turning his father's play from stage to screen in the late 1980s when he was still up and coming in his respective field of production.

In fact, it was a screenplay that lingered around Hollywood for years untouched. Winona was first sent the script at the end of the

eighties when she was eighteen. No one, she said was ever going to make it. 'It was a really heavy subject without a happy ending.' Besides, she continued, 'I think the McCarthy era was something that Hollywood was a little ashamed of. A lot of our favourite actors testified against a lot of our other favourite actors, and great writers were persecuted and black-listed. It was a very uncomfortable story. Not the type that Hollywood favours.'

Indeed, making *The Crucible* for the screen was a gamble. One of the twentieth century's greatest plays, it has never been short of controversy since it opened on the New York stage in 1953, and had only ever spawned one other, but rarely commented upon, French film, *The Witches of Salem* with a screenplay by Jean-Paul Sarte, but that offered nothing as promising, or as powerful as the upcoming movie would.

Indeed, in Miller's adapted screenplay there was a devotion to what he had written in his play, to most pointedly highlight the elements of passion, jealousy, and paranoia that surface in a small Puritan town when life, dedicated very much to the service of God is threatened when several teenage girls headed by seventeen year old servant girl Abigail Williams (Winona) already spurned by her married lover, John Proctor (Daniel Day-Lewis) are discovered dancing in the woods and are swiftly accused of engaging in the Devil's work. An accusation that no less consumes the villagers into cries of witchcraft that spurred the girls on even further naming anyone they ever resented, until one by one, the blameless victims are torn from their homes and families in the wake of the mass hysteria that Abigail fuels to avenge Proctor's wife (Joan Allen) through the nineteen persecution and hangings posted by Judge Danforth (Paul Scofield), a deputy governor determined to mark his reputation as much as McCarthy himself did.

Even when Twentieth Century-Fox finally did agree to greenlight the project, it was as studio president Tom Rothman pointed out, hard to get going. 'It's not *101 Dalmations*. It's a

completely uncompromised version of the play. Daniel doesn't ride off happy in the end.' Even marketing the completed movie's release was no less demanding. But mass market reviewers and researchers reported that the best bet was for something along the lines of *Fatal Attraction*. If that was true, there were certainly similarities blazing though the trailer of 'what some hearts desire they must possess and what they can't possess they must destroy.' It was the classic, but also timeless tale of a woman scorned, seeking revenge on the man who is left for dead.

Finding a suitable director was equally arduous. Fox had already flirted with the idea of names such as Norman Jewison, Pat O'Connor, and Kenneth Branagh before finally approaching Nicholas Hytner. Born and raised in Britain, Hytner's career had been dedicated to the theatrical stage from which he earned his reputation as one of the most applauded directors in that field. He came to public attention with Joshua Sobol's *Ghetto*, and Alan Bennett's adaptation of *The Wind in The Willows* before making his international mark on Broadway with *Miss Saigon* and *Carousel*.

More importantly, he had worked with Rothman only years before when he directed his first cinematic feature, 1994's *The Madness of King George*. And by the time *The Crucible* came up for grabs, he was already talking about his passion to work on another period piece, and Rothman, equally enthusiastic about working with Hytner again, confirmed that he was the one director to make *The Crucible* work.

In fact, the day *The Crucible* screenplay dropped through Hytner's door, he was still on the outlook for his next project. Up to then he had only been flooded with what he calls really terrible conventional Hollywood scripts. But opening and reading Miller's screenplay he was, he admits, physically seized by the material. 'As I turned the pages, my heart beat faster, my palms sweated, and I felt in my gut the ancient stirrings of terror and pity that you associate with all great tragedy,' From that moment he knew he wanted to

make the film. 'The sad truth about this story is that it will always be topical.' Even today, continued Hytner, 'the Salem witch hunt conforms to a pattern which keeps repeating itself.' Winona agrees. 'It's frightening how relevant the story is. I think that the idea of whipping up mass hysteria against a scapegoat is all over the place today.' No less alarming was the character she would be playing. Abigail was, confirmed Winona, 'one of the most complex roles ever written, certainly for a woman.'

For Hytner, strangely enough, Winona was not at first an obvious choice. He had met her by chance at an Oscar party soon after casting began in 1995, and today admits, 'seeing her in party gear, I found it hard to make the connection with the Puritan teenager, Abigail.' Winona, too, was convinced she had lost out. 'I had a Martini in one hand, and a cigarette in the other. I looked like Joan Collins.'

Nevertheless, Hytner remembers, 'we arranged to meet for lunch a couple of days later, and I found myself sitting opposite a waif in a big white T-shirt who looked on the younger side of twelve,' or as Winona puts it, 'wearing pigtails and no make.' For the first time in her career Winona was trying to look younger. All the same, 'I kind of thought that I had lost my chance.' But even then, and after landing the part two months later, Winona knew she would be facing her greatest challenge yet. 'I was petrified,' she remembers, 'I thought I'd get fired right away.'

Hytner, however, knew different. 'I thought her performances in *Little Women* and *The Age of Innocence* were pretty remarkable, but she never had to put herself at such an emotional and sexual extreme as she did in *The Crucible*. She was able to convey precise focus, precise desire, very, very well indeed.' He also knew that apart from anything else, Winona could be relied upon to turn Abigail Williams into what one reviewer described 'a transfixing portrait of warped innocence.' A far cry from any role Winona had played in the past.

185

'I think it's always complicated to play someone who's insane,' confirmed Winona, 'but you have to understand their insanity,' Neither had Winona been asked to act acting in any of her previous roles. That too was equally complex. In one scene when Abigail fabricates seeing a yellow bird on the courthouse ceiling, 'Nick asked me to play it like we were hallucinating. You're acting, but you're still saying, "okay, this is really happening," but eventually she believes her own lies.' She was, continued Winona, 'completely insane.'

But everything she did, said Winona, 'was completely justified.' In reality, Abigail was twelve, and John Proctor, sixty five. 'He's been fucking her since she was a little girl, and all of a sudden she's kicked out, and he says, "Nothing happened, we never touched." And she is left saying, "But wait, we did, and you said that you loved me, and you were going to be with me." It's so sick, so abusive, it would be enough to send anyone spinning because I think she was very much in love with him. And in her mind, that was going crazy at that time, she was trying to get him back, and it's her reaction to that.'

It was also the centrepiece of the movie. Hytner expounded, 'the girls at the beginning of the picture are starting to throb with a sexuality that grows in all of us when we come of age. But in Salem 1692, there was no place for them to put that. When they dance in the woods, it's so alarming to the rest of the community that it's identified as witchcraft. It's a story about how sex can bring a whole community crumbling down.'

No less attempting than bringing *The Crucible* to the screen was the casting process itself. 'Nothing about the shoot was more dependable than the quality of the acting,' confirmed Hytner. 'Every actor in the English speaking world seemed to want to be in the film, so the elaborate courtship usually required to persuade movie stars to take part in a film went by the board.'

A simple meeting with Hytner over tea in a London café brought Daniel Day-Lewis, Winona's old ally from *The Age of Innocence* to the role of John Proctor. A choice that pleased Winona as much as it did Hytner. 'I'm simply besotted with him,' she vowed. 'Walking in, I knew what he liked and didn't like, what distracted him and what worked. There was no walking on eggshells.' He's so good, she continues, 'he forces you to give the best performance, you want to please him. It's almost like a supernatural experience. Your mind cannot leave a scene when you're with him, it's like he has you by the throat, and you give everything to him because he deserves it. He is riveting.'

Equally riveting for Hytner was the participation of Paul Scofield as Judge Danforth. 'Coming as I do from the English theatre nothing excited me more.' Scofield had for some years been known to work only when he genuinely thought it worthwhile. His instinct for *The Crucible* was right on target. Another actress Hytner highly praised was Joan Allen who was recruited to as Proctor's wife, Elizabeth, although according to a preliminary cast list that appeared on the Internet some months before filming got under way, Britain's Emma Thompson was named for the role. Allen though, like Winona, admired Hytner, was 'the finest actress of her generation,' and like Winona, was a previous Academy Award nominee.

Slowly, the rest of the cast took shape around the core of the lead players. Rob Campbell would portray Reverend Hale; Bruce Davison became Reverend Parris; Jeffrey Jones, who played Winona's father, Charles Deetz in *Beetlejuice* was chosen for the role of Thomas Puttnam; Charlayne Woodard would play Tituba, the black slave from Barbados, Frances Conroy as Ann Putnam; and Karren Graves was cast as Mary Warren. Overall it was a marvellous mix of talent representing winners and nominees of every conceivable film, theatre, and television award possible.

On location on Hog island where shooting commenced in September 1995, the 180-acre wildlife refuge was transformed into seventeenth-century Salem. Twelve clapboard buildings, stained and aged were constructed, while pigsties, chicken coops and corrals were erected and gardens framed with period fences were filled with herbs and vegetables common with the period.

Nonetheless filming was not without it's difficulties. For Winona, some that probably evoked memories of her own communal upbringing. There was no electricity, for instance, or running water. No telephones, and no access to the island other than by the floating bridge enlisted to ferry everything that wouldn't fit onto the pontoon boats that carried cast and crew across the water each dawn for the early morning set call.

Arrival there began with the actors being weathered to reflect their character's lifestyle, pulling in elements of the grime and dirt they would have sported in that time. Everyone got the treatment. Fingernails were cut short and made to look grubby, callouses painted on, teeth tinted yellow, and for some, even a prosthetic set of rotten ones. Winona's Abigail though seemed to have a far less toned down version. But maybe that had something to do with the character she was playing. 'She develops these psychosomatic reactions like giving herself a fever,' explained Winona. 'And she really starts to believe she's a saint, and that the village ought to be cleansed.'

Medical teams too, were kept unexpectedly busy. Their prime concern was the onslaught of large and aggressive insects constantly delivering painful bites to the cast and crew. Sea Breeze soaked towels, calamine lotion and insect repellent were all recruited to relieve irritation.

No less demanding was the attention to detail that carried over as an integral part of the filming. Under the watchful eye of designer Bob Cowley, almost every costume on the set was handcrafted from the rarest antique linen sheets and natural fabrics, stained to

match the colours of the same vegetable dyes of the period. And the ones that weren't were rented hand-me-downs from *The Scarlet Letter*, a film also set in seventeenth-century Massachusetts, with Demi Moore and Winona's old *Dracula* ally Gary Oldman, that had finished filming only a few months earlier.

For one scene that lies as the most climatic and finest moment in the movie, when Winona and cast run screaming into the waters lapping the edge of the Puritan village, doubles and triples of the costumes were made for the three consecutive days of shooting required to authenticate the sequence. That in itself placed a lot of pressure on Crowley's shoulders, but also on the wardrobe team. In reflective mood, Winona remembers, 'the cast was walking around like strung-out zombies for four months,' She herself wouldn't work again for an entire year after finishing the film. 'That's probably something to do with the movie. I went through a very bad depression afterwards, fled home to my family, ate a lot of chicken soup, and got my feet rubbed, but it was probably one of the best experiences of my life, acting-wise and creatively.'

After six weeks on Hog Island, production moved to Beverly in Massachusetts, for three weeks of interior shooting on a sound stage rigged up in an old abandoned shoe manufacturing plant. It was here that Arthur Miller celebrated his eightieth birthday completely transfixed by the transformation of his play from stage into motion picture.

It was a reality that thrilled Winona too. With the film completed, and it's premiere screening at the Sundance Film Festival, and internationally at Cannes, she was quick to attribute her relationship with Hytner as the best she'd ever had with a director. 'I feel like I've really found someone who understands me and communicates perfectly with me.' In fact, she enjoyed her time so much on the set of *The Crucible* that unconfirmed rumours began to circulate linking her alongside Hytner for a film version of Stephen McCauley's comic novel of sexual manners, *The*

Object of My Affection, long before principal photography on *Alien Resurrection* had even been completed.

She was also being named as the actress tipped to play Luke Skywalker's mother in the *Star Wars* prequel just as *The Crucible* premiered in London. The film had already opened in America to mass critical acclaim, but with far less commercial appeal than Winona had hoped for. 'I've never been more kind of heartbroken in that way. To me, it's one of my favourite movies that I've ever done. When we made it, we were all thinking, this is it, this is gonna be *the* movie.'

But, in fact, the Los Angeles premiere audience that November 1996 responded so poorly that Winona was quick to recognise that *The Crucible* was doomed to be, as far as Hollywood blockbusters go, an unlikely contender. Apparently one of the biggest stumbling blocks for audiences was the conclusion of Proctor's death at the end of the movie, and Abigail not getting her just deserts. But when you consider that Arthur Miller's McCarthy-esque study of the seventeenth century Salem witch trials was in fact one of the most remarkable and darkest episodes in American history where in reality twenty accused of witchcraft were executed, how could there possibly be any other ending? As Nicholas Hytner reasoned at the time, saving Proctor from his inevitable death sentence would be comparable to giving Hamlet a Porsche to drive off in at the end of that tragedy.

Seemingly another stumbling block for audiences was the complex dialogue, but for Hytner, it was simply resourceful. 'I was the lucky one,' he says, even if 'they didn't realise that language of this force and this poetic power, in the hands of the right actors, is a real asset.' Winona confirms Hytner's impression. 'It was one of those movies where you couldn't wait to get to work because you had such great things to say.'

All the same, 'it really bummed me out that the movie didn't do better,' said Winona later. 'If it had been a huge hit, it would have

meant the world to me because I think it's an important movie, and says a hell of a lot more about the First Amendment than *Larry Flynt* does.' But in the end, 'I think that it's gonna be one of those movies that in time will be a classic and will be shown in schools and recognised as a really great movie.'

Indeed, as Winona says, *The Crucible* was a great movie, so isn't it surprising that it entered 1997 with no more than just a couple of Academy Award nominations that in the end won no Oscars at all, not even for Miller's Best Screenplay or Joan Allen's Best Supporting Actress. Equally astounding was how Winona's performance, the best Miller said he had ever seen, was also completely overlooked without even a mention. It didn't seem feasible that Winona, a clear favourite in many people's eyes to walk away with the Best Actress Oscar wasn't even nominated.

Nevertheless, the reviews were ecstatic. 'Electric!' shouted *Rolling Stone* magazine, 'a seductively exciting film that crackles with visual energy, passionate provocation and incendiary acting.' *The New York Observer* agreed. 'A powerful film of great artistry and passion,' while the *New York Times* in their review of the film said it 'moves with the dangerous momentum of a runaway train.'

Entertainment Weekly shared the comments of *Rolling Stone*, 'electrifying!' hailed critic Owen Gleiberman, 'startling... pulsates with dramatic energy.' *Newsweek* as well called it 'passionate and moving... gets your blood boiling.' In Britain the reception shouted much the same message. Everything from, 'masterful, vibrant and compelling' to 'one of the hottest tickets of the year.' But not everyone thought so.

When *Harpers & Queen* magazine caught up with Winona for a March 1997 feature, she was amused. 'Did you hear why we didn't have the royal premiere?' teased Winona. 'The Queen viewed the movie and nixed it. Yeah! Apparently it is because it's about infidelity,' she chuckled, 'and there's too much of that going on already.'

'She's having such a good career,' observed Hytner, 'because she never worries about her career. She does what interests her rather than what looks like just another step on the Hollywood chessboard.' That is certainly true. She does what her instincts tell her by discriminating over the films she chooses to do. She did after all turn down Sydney Pollack's remake of *Sabrina*. Audrey Hepburn, thought Winona, so defined the role that she would feel uneasy about creating it again. Besides, she worried over the fact that Sabrina is treated like a 'prize' shuttled between two brothers. One rule she was pleased to have consistently applied was to refuse any role that she considered sexist, silly or gratuitously violent.

But Winona was equally pleased to have maintained the integrity in which she entered Hollywood in the first place, and of remaining true to her vow that she would never stoop to small screen work as she considered it 'lame.' She did however bend her rule when she agreed to 'star' in *The Simpsons* as the voice of a new arrival at Lisa Simpson's school, a girl who is even more gifted than the multi-talented Lisa. Once again, Winona demonstrated just how impeccable her taste was. First broadcast in America on 11 September 1994, the episode remains among the best loved of all Simpson adventures. She repeated the success with a cartoon of herself in an episode of *Dr Katz*, first broadcast on the US Comedy Central channel on 6 October 1996.

She did however turn down the role of Joan of Arc in *Company of Angels* apparently alongside Sean Connery, recommending her friend Claire Danes in her stead. But even then, there was no let up in her schedule. A sequel to *Heathers* was apparently under discussion following Winona's Best Actress nomination for the original at the 1995 Independent Spirit Awards, the premier annual event in the independent film community that recognises exceptional efforts and rewards visionary filmmaking. Three years later, Winona's passion for a sequel remained unabated, and according to the *New York Post*, she had told *Cinemania's* Roger Friedman that she was

already working on the idea with Michael Lehmann and Daniel Waters, the director and scriptwriter of the original film. And no sooner was her work completed on *Alien Resurrection* than Winona was reported to be in negotiation for Woody Allen's *Celebrity*, his then untitled fall project that would put her alongside Kenneth Branagh and Leonardo DiCaprio. Shooting was slated to start in autumn 1997, and Winona was in talks to step in to replace Drew Barrymore who had to withdraw from playing one of the lead roles because of conflicting film schedules. Winona too, had at one time, similar opposing commitments.

She had, in fact, been approached by Allen earlier for the ensemble film, but was unavailable because of her plan to star in the untitled film based on the life and murder of Irish investigative journalist Veronica Guerin, also due to start shooting at the same time as Allen's. But due to a script rewrite, production was delayed, and made it possible for Winona to do the Allen picture. She accepted, and shot most of her scenes opposite Branagh quickly, in two weeks, during October with the usual location for an Allen movie of New York. Afterwards, Winona expounded, 'doing his film was much more fun than I thought it would be because I heard that Woody doesn't talk to you very much, but he was very nice to me.'

As for the Guerin project, Winona eventually turned down the role as the revised script was not in keeping with how she perceived her character being portrayed. 'Winona had seen Guerin as the kind of person who kicks down doors,' explained executive producer Peter Newman, 'which isn't what Veronica's story is really about.' She would, decided Newman, be better portrayed as the mother and wife she really was than as a single woman.

But Winona was not concerned. She had already optioned the movie rights to several projects she had been developing. Although beaten to the optioning post by producer Douglas Wick, one that she settled on for her next movie project, but now both as star and

executive producer, would be Susanna Kaysen's *Girl, Interrupted.* Based on the true account of Kaysen's two-year long stay in a mental institution, not only for her half-hearted suicide attempt of washing down a bottle of aspirin with a bottle of vodka, but also for her inappropriate behaviour that had become a constant worry and upset to her Boston blueblood parents.

'It's about this girl's experiences more than insanity,' explained Winona in the early stages of her desperation to turn the memoir into a movie. 'I've wanted to do it for so long and (now) it's finally happening. It's very psychological, but very funny.'

Winona's passion is incredible, continues producer Cathy Conrad. 'She was the reason the project found its way to Columbia. This film is the definition of a labour of love project for an actress.' Conrad who previously produced *Scream* and *Scream 2* would again link alongside her fiancé, director James Mangold for the project following their successful team work on Sylvester Stallone's *Copland,* and were reported to have found developing *Girl, Interrupted* simply uplifting despite the sombre tone of the story.

All the same, the film had been one of those projects that Hollywood insiders call 'development hell.' After scripts by three different writers failed to make the book workable as a movie, *Girl, Interrupted* was relegated to the back burner. Not to be dissuaded, Winona eventually approached Mangold, even though he was initially hesitant to it take on, he still agreed to meet with her. 'I've always thought she was a brilliant actress. There's something very silent movie about Noni's acting style, a quality I really adore. It's not a style in the sense of a pose or put-on, but something very organic and completely unique to her. I'm also fascinated by this fragile energy that follows her through all her films, regardless of genre.'

But several months before filming on *Girl, Interrupted* was due to get underway, it was reported that Columbia were preparing to alter

their schedule to allow Winona to star in the psychological thriller, *Lost Souls*, the directing debut of Oscar-winning cameraman Janusz Kaminski for which she was in final negotiations for. According to *Variety*, Winona would play Maya, a former troublemaker who has reformed and now works as a teacher at a seminary. Armed with the knowledge of Satanic rites, she is charged with convincing a high-powered attorney that he is the target of a conspiracy to enable the devil to walk the Earth in human form – and must help him defeat the powers of evil before his thirty third birthday.

At the same time, though, London's *Sunday Telegraph* were reporting that Miramax Pictures were apparently lining up Winona alongside her friend Gwyneth Paltrow for a new feminist version of 1964s *My Fair Lady* based on George Bernard Shaw's play *Pygmalion*. Gwyneth, wrote arts correspondent Catherine Milner, 'has been approached for the female equivalent of the Rex Harrison role, Professor Higgins, and Winona is tipped to act the Dr Pickering role.' According to an early synopsis, she continued '*The Man on Platform Five* would tell the story of an "It" girl, Euphemie Betterment, who makes a bet with her friend Gresham Hollingford that she can transform a spotty trainspotter they have met on Milton Keynes station into a dazzling ladykiller in time for a high society engagement party.'

Another one set for production at Twentieth Century Fox, but without confirmation of schedule, was Idanna Pucci's *The Trials of Maria Barbella*. Another true account, this time of the culture clash that results when a turn-of-the-century Italian immigrant woman murders her American lover. 'It never makes anybody the victim,' explained Winona. 'And it never says whether what she did was right or wrong. It's only about the concept of innocence.'

Still, Winona's commitment was understandable. It was something she confirmed even as she talked to director Giusppe Tornatore. 'I told him it's to ensure that you're making your movie, to protect you from people who would want to change it. I want

the director to make the movie he wants to make.' Besides, she continued, 'It's very exciting to be involved in matching up great writers with great directors. I'm not doing the dirty work, of course, but it's nice to feel your input means something.'

She also optioned two others for the same reason. Michelle Chalfoun's *Roustabout*, definitely not a remake of the 1964 Elvis Presley musical, but the story of a young woman raised in a circus, and the project Winona intended to follow *Girl, Interrupted* with, Marlene Day's *Lambs of God*, the focal point of which is three nuns existence in an abandoned monastery on a tropical island, that once again would see Winona working alongside Gillian Armstrong, her old ally from *Little Women* whom she had already recruited for the directional seat.

Already acquired by Fox 2000, Winona was being slated not only to star in the pictures, but also to produce both projects alongside Ross Bell, and Carol Bodie, her manager and former agent whom she elected to represent her ever since leaving CAA in February 1996. But after two years without an agency, Winona signed on again with ICM, the same one she switched to after the *Godfather III* debacle but departed after *Night On Earth*. According to *Variety*, the agency had been pursuing Winona for some time, and her signing marked quite a coup for them.

Winona was also allowing herself some time for Hollywood style frivolities. No longer concerned about about working herself to the point of exhaustion, or about her shyness of stepping out into public life, and now quite capable of looking after herself, she opened up her social life at some of New York's trendiest nightclubsss with friend and formeroom-matetete, actress Gwyneth Paltrow, best known for her role opposite, then soon to be, fiancé Brad Pitt in 1995's *Seven*, and a year later in Jane Austen's *Emma* that truly established her a new fully formed star. 'I guess I'm just learning to have fun,' Winona said. 'I've always had a sense

of humour, but people just wanted to pigeon hole me as "Little Winona, the serious and sensitive one." '

She would also have a considerable presence at the 1997 Academy Award ceremony in March, but retained her highest profile appearance that same month for the ShoWest movie event in Las Vegas where she was presented with the Actress of the Year Award from her one of her most cherished peers and *Alien Resurrection* co-star Sigourney Weaver. That alone was more than just icing on the cake. The award embraced the recognition she so rightfully deserved for her work in *The Crucible*, and at the same time enforced the suggestion that her performance had not gone completely unnoticed or unappreciated. Winona responded with sheer delight. 'This is really wonderful because it's from the National Association of Theater Owners, and I'm one of those people who goes to the movies all the time. It's my hobby.'

Besides, she continued, 'I thought these awards went to the most successful box office people, and I haven't been in very many successful movies. *The Crucible* really didn't do very well, so the fact that they are giving it to me this year means a lot. I feel honoured because I've made choices in my work that a lot of people have thought are really risky. They're honouring me for the movies I've made, and the movies I've made, have been my choices.'

Little more than a month later, she returned to the gambling city to indulge herself in some rock concert frivolity. At the opening night of U2's *PopMart* world tour, Winona was spotted dancing on the band's sound desk throughout the show proving, as one journalist put it, 'the band's number one fan.' And soon after she was quick to grab a ticket for Fleetwood Mac's MTV *Unplugged* performance in Los Angeles.

At the same time, A.C.T. announced they would be honouring Winona with an honorary master of fine arts degree at their San Francisco Geary Theater during the graduation ceremony for the Advanced Training Programme class of 1997. Her already

distinguished career, remarked A.C.T. conservatory director, Melissa Smith, 'serves as an extraordinary model for our students, and I am thrilled that the conservatory is honouring one of this country's finest and most versatile actors whom we are proud to include as a member of A.C.T's extended family.' For Winona, this additional acclaim of her individual contribution to the advancement and educational goals of A.C.T. and the arts in America couldn't be better.

She would not, however, be so happy with the anti-smoking petition circulated in a Petaluma high school that demanded she quit smoking. In a story on CBS *Sixty Minutes* that debated the influential effect of smoking in Hollywood, former Secretary of Health, Education and Welfare, Joseph Califano singled out Winona as the role model who has done 'more damage to young girls' than any other actress 'because she does smoke all the time in every single movie she makes.' Not entirely true. Winona, in fact, had only chain-smoked in two of her roles. As Corky in *Night On Earth*, and Lelaina Pearce in *Reality Bites*. Obviously Califano clearly had not considered Winona's non smoking roles in *Edward Scissorhands*, *The Age of Innocence*, or *Bram Stoker's Dracula* among others.

From that point alone Califano's statement was simply outrageous. And there were many who agreed. They demanded the city of Petaluma apologise to Winona. It is, remarked one, 'an atrocious way for a city to treat a home-town girl who became a star and who played an important emotional role during a recent Petaluma kidnapping tragedy.' An attempt to ridicule Winona Ryder, said another, 'demonstrated the skewering of priorities that take place when anti-smoking policies take precedence over education and common decency.'

Winona was equally outraged. 'I'm sick of this Winona smokes thing,' she told *USA Today*. 'I smoke like once in a while socially, and I don't apologise for smoking on screen. It should be our

choice, and I don't think we influence people to smoke. When I grew up, I did not smoke, and I was not influenced to smoke by watching eight thousand Humphrey Bogart movies.' She too demanded an apology.

With far less characteristic fire, Winona was feeling more than just nervous about the new black Mercedes that she also seemed slightly embarrassed about owning. Although only a few weeks old when she met up with journalist John Powers for a December 1996 *American Vogue* feature, the passenger side was already dented. 'Chatting away, she drives like she's auditioning for the remake of *Annie Hall*,' observed Powers. 'Turning left, she cuts off a driver who begins leaning on his horn. "That's so-o unfair," Winona moans. "I didn't do anything wrong." Unsettled by his furious honking, she promptly runs a red light. Moments later her cellular phone rings and she can't figure out where it is – in a panic, she starts swatting the dashboard as if she's trying to kill a bee. When we finally reach the safe haven of valet parking, only slightly frazzled by the trip, she gives me a dazzling grin, "We made it!" '

Even as she worked on the Woody Allen movie, and awaited the release of *Alien Resurrection*, Winona was organising a benefit alongside friend and musical hero, Stephan Jenkins of Third Eye Blind, for 31 January at San Francisco's Warfield Theater. 'It's an event to raise money for a clinic that my mother runs in Haight Ashbury,' explained Winona. 'It's the only one that does not turn anyone away, regardless of lack of money or insurance. It's patients mostly consist of young people with HIV, and the homeless. It is a wonderful and very human place that relies largely on private donations, and I'm working to promote the event and to encourage people to donate and get involved.'

And a little over a few weeks later, on Valentine's Day, Winona, joining Glenn Close, Whoopi Goldberg, Rosie Perez, Lily Tomlin, and Susan Sarandon among others headed towards the Hammerstein Ballroom Theatre in New York City for a benefit

performance of readings from Eve Ensler's award winning play, *The Vagina Monologues*. Winona's decision to step into live theatre to perform a monologue from the play about a raped Bosnian woman alongside Calista Flockhart, of television's *Ally McBeal*, must rank among the most courageous decisions she has made, all the more so, since it was the one area of performance she had not pursued since devising the Salinger monologue she performed at A.C.T. She did however have her reasons.

The event would benefit the V-Day Fund allowing grants to be donated to established local, national, and international organisations that combat violence against women and girls. Indeed, it was for that which Winona was working, to support the campaign to end sexual abuse, and to proclaim Valentine's Day as the day to celebrate women. 'I'd say most of my female friends have either been raped, hit or beaten up by boyfriends, a date, or something horrible,' she once explained. 'It's amazing to me. It happens much more than we think.'

Even when Winona did find a break in her schedule, she always seemed to fill it with routines that were no less engaging. 'If I'm not working, I get up around 10am, and make a cup of Celestial Seasonings Morning Thunder Tea. Then I lie around and read the *New York Times*. I spend the rest of the morning making and returning phone calls and taking care of various business things.'

She continues, 'If I'm in LA, sometimes I will take a walk behind my house, either in the morning to get going, or in the evening to relax and wind down. At some point, my assistant, Sandra, comes over to help me with calls and sorting out scripts, and anything organisational. Depending on the day, I either have lunch with friends or attend business meetings. And then in the latter part of the afternoon, I'll read a book or a script, or I'll go shopping.' In the evening, 'I order food, and rent *Prime Suspect*, or another show called *Cracker*, listen to music, read or play drums,

put on a comfortable pair of pyjamas, have a cup of hot tea, and reach for the remote control.'

Winona would do much the same whenever she was in New York. 'I like to take walks, go to museums, and go to my favourite restaurant near my house. They have delicious grilled chicken and homemade biscuits.' Then, 'I'll go to a premiere if a friend has worked on the film and I want to support them. And I go to my own because they make you, but you want to go if you're proud of the movie you're in.'

She was of *Alien Resurrection*, but was far less gratuitous about herself, 'I personally love the movie, but I'm not crazy about myself in it. I kind of stick out as someone who doesn't really belong there. My role is secondary, it's Ripley's movie, and I'm there as the sidekick, running around and chasing after her.' Certainly that is how Winona played the part. And although there were 'a lot of interesting parts about Call, I knew it would different and a challenge, and I didn't want to die without trying everything as an actress.'

The greatest challenge however demanded that Winona bond not only physically but also intellectually with her character. 'Dialogue makes far more sense to me in contemporary or period pieces,' she confessed, 'so I wanted to see if I could make the technobabble in an *Alien* film, the stuff that doesn't make sense at all, sound real and normal coming out of my mouth. I don't know if it worked.' But her concerns may have been misplaced. As producer Bill Badalato explains, 'Ripley is so strong in these films that you have to have somebody as strong in another way, and I think that's what Winona is.' Further evidence if any were needed that this remarkable actress is also remarkably instinctive.

There were, of course, those who voiced surprise at her acceptance of the role long before the film was even released. 'It's so funny what people have said to me. I've even heard, "she's doing this big blockbuster because *The Crucible* flopped," but it's not a

strategic move. It's just really cool to be asked to do something no one would ever think of you for. I was just very excited that I was going to be in a science fiction movie. I think it was a great movie to be in. Maybe I prefer movies that wouldn't involve having to look at a piece of tape and pretending it was a monster, but I think it was a great experience.'

For a time though , she had completely removed herself from the fact that she was even in the movie. Some weeks before its opening she was passing her brother's comic book store. 'He had a display of *Alien Resurrection* in the window,' she remembers, 'and I said to my friend, "Oh! *Aliens* is coming out!" I was talking like I wasn't even in it. I really did say "I can't wait to see it!" '

Neither apparently could anyone else. With a twenty five million dollar gross in it's first weekend in America, and another twenty six million overseas *Alien Resurrection* stormed into the box-office listings in the Thanksgiving weekend, November 1997. And although it would be completely overlooked by the both the Golden Globe and Oscar committees, Winona would sweep the Favourite Supporting Actress nomination in the Science Fiction category at the Fourth Annual Blockbuster Entertainment Awards ceremony.

Writing in *Flicks* in December, critic Quentin Falk offered one of the most concise summaries. 'While it may be fashionable now to enthuse about *Alien 3*, this outing puts it very firmly in the shade, and for this critic at least, Jeunet's jaunt also gives *Aliens* – where more equalled less – a pasting. However it still remains several shrieks short of Ridley Scott's peerless original screamer.'

Another review in *Maxim* more or less agreed with Falk. 'Perhaps not quite in the same league as *Alien* and *Aliens*, this is nonetheless a fun space adventure, with more than enough blood-splattered, brain-splattering squishy bits to put the most hardened sci-fi horror fan off his popcorn.' *Sky* magazine called it 'a biff-bang-pow-urk! of a movie after a year of lazy blockbusters,' but

noted that it was 'a sympathy of luscious visuals, and top notch acting,' observing that 'Weaver and Ryder kick ass John Woo style with double gun action a go-go. The underwater sequences are so claustrophobic you'll forget to breathe.'

The review in *Premiere* magazine was along the same lines. Visually, it was 'darkly wonderful,' and for gore and grossness, it 'graphically outdoes its three predecessors. *Total Film* magazine shared in this wave of enthusiasm for the movie. 'All the edge-of-the-seat intensity of the first film with the gun-blazing action of the second.' *Rolling Stone* agreed. 'Full of surprises... a visual marvel... worthy of its predecessors.'

But not all the reviews were so complimentary, the Mail's *Night & Day* Sunday supplement critic, Anthony Quinn, wrote, 'something's not quite right with this sequel. It feels flabby and effortful where the other three films were sleek and sinister, and while the film delivers thrills pretty much on cue, the bulk of *Alien Resurrection* shows signs of generic fatigue.'

But as with *Bram Stoker's Dracula*, it didn't really matter what the critics reckoned. *Alien Resurrection* was among some of the most successful non-summertime openings, and one which spun off everything from a commemorative clock to an exclusive limited edition series of action figures.

It also gave rise to rumours of another sequel. 'All I can say,' remarked Tom Rothman, head of production at Fox, is 'that the end of *Alien Resurrection* points you toward the locale of *Alien 5*. We firmly expect to do another one, Joss Whedon will write it, and we expect to have Sigourney and Winona if they're up for it.' Whedon agreed. 'There's a big story to tell in another sequel. The fourth film is really a prologue to a movie set on Earth.' Winona too, was equally enthusiastic. 'I hope it keeps going as I would certainly love to be involved with it.'

Whether involved or not, Winona would be spending as much time as she could with her family. 'I'm extremely close to them,

and whenever I'm in San Francisco, we'll all have dinner together every night. It's very centering and comforting. They are amazing people.' Indeed, joining her brother, Jubal, at one of his two comic book stores was equally enjoyable of her freedom between movies. 'I usually go there and work behind the register for a couple of hours, which is fun. Then I'll go out with friends.' But even then she managed to maintain a comparatively low profile. According to her parents, Winona doesn't even keep a scrapbook of her career. Further evidence that this intensely private person is also intensely modest. 'I still can't believe I get to be in movies. Every time I see a poster for a movie I'm in, or go to a premiere it's like, "Oh my god! I did that!"'

She was also working to support the American Indian College Fund with fundraising and public awareness missions on behalf of the nation's thirty tribal colleges. She had already made several donations, but now wanted to know more of how she could help. Not surprising when you consider that the Northern California Indians were also the neighbouring community to the commune where Winona herself grew up. The similarities between the two could hardly be greater. Both shared an undying love for community spirit, simplicity and, respect for the earth.

Even as she joined Sigourney Weaver, Chiara Mastroinanni, Lena Olin, Zoe Valdes, Alain Corneau, Michael Winterbottom and Chen Kaige on Martin Scorsese's competition jury at the 1998 Cannes Film Festival, Winona was being tentatively linked to Michaelangelo Antonioni's latest film, *Just To Be Together*, a romantic drama that if true would reunite her with ex-fiance and *Edward Scissorhands* co-star, Johnny Depp, but then again, Winona had been linked to projects before that never came to anything. At the 1996 Festival, for instance, she was being linked alongside Andy Garcia for a film version of William Boyd's novel *The Blue Afternoon*, an epic set in the Philippine capital of Manilla around the time of it's annexation by the United States. But whatever the

rumours, Winona's voracious appetite for work a decade after she started still remained unabated. 'That's how acting is with me. I have to do it, I have to,' she insists. 'I feel like my life depends on it. It's my passion. It's what I crave. I don't think I could live without it.'

There had even been talk of Winona starring in Tom Stoppard's, *Shakespeare In Love*, a romantic comedy that imagines an affair the Bard had with a young beauty that inspired him to pen *Romeo And Juliet*. Apparently Winona was offered the role but became resistant after Harvey Weinstein of Miramax Films asked her for a script reading to establish whether she could wrap her distinctive Midwest tone around an English accent. Winona's rebuttal was understandable since she had already demonstrated her ability in *Bram Stoker's Dracula*. Indeed, it was, observed *Vox* magazine, 'impossible to fault.'

Needless to say, she was reported to have turned down the role that was later offered to Gwyneth Paltrow. But, the problems seemed far from over. Rumours of a conflict between the two actresses suggested their friendship had even 'dimmed slightly' as a result of Paltrow taking the role. And if the rumours were to be believed, that their affection for each other was nothing more than illusive, that they weren't even close, not even best buddies, and on top of everything else, that Winona was scared of Paltrow, then 'taking' would be the word that best describes the ending of their friendship.

In general, Winona explains, 'I'm scared of believing people and being let down – in every avenue of life. I like to consider myself a really good judge of character and I did for years. I thought I could always know if someone was lying and could detect bullshit. And then when it happens once, you question every time you've believed anything. I think once it happens to you, once, once you're betrayed, then you question everything. You think: How many times has this happened to me and I didn't know? I've had endless

conversations about this with friends, and they all say you can't go through life without trusting people. It's just really hard to find the balance, I guess. That's what I'm really looking for right now. It's like the hardest thing. Because I never really thought about it before, I just believed people.'

One cannot help wondering though if that is why today she is constantly asked about her 'falling-out' with Paltrow, and why, when *Vogue* magazine caught up with her, she became slightly more vocal than she had in the past. True, they were no longer friends. But according to journalist Jonathan Van Meter, 'It's not as dramatic as you think, but it's complicated. Don't ask.'

One theory is that when Brad Pitt broke up with Paltrow, she was distraught, and stayed with Winona. At that time she apparently didn't have any regular digs of her own, except for her parents place, and Winona being a friend, offered her not only a shoulder to cry on, but also allowed Paltrow to stay at her New York apartment while she went on a movie shoot. Before leaving for the West Coast, Winona had been sent the script for *Shakespeare in Love*, and while Winona was gone, Paltrow found the script lying around, read it, and then evidently contacted Weinstein, and somehow got the role, before Winona knew what was going on. Winona, of course, had nothing to say, but just cooled the friendship, but when Paltrow won the Oscar for her performance in the film, Winona decided that she would finally kill it off completely.

Strange when you consider that Paltrow had found nothing but solace with Winona, and was, as she put it, 'very supportive and a very dear friend' after she and Pitt broke off their engagement in the full glare of Hollywood's tabloid press. 'There aren't many people who can understand that,' explained Paltrow gratefully at the time. 'When you've just broken up with a boyfriend, and it's been on magazine covers the world over.' Winona however did. She

had, after all, been through her own high profile separation from Johnny Depp.

'Being with Johnny broke me in, but it was rough on us because there was so much attention being paid to our personal life. We couldn't go a week without reading something that either wasn't true, or was only half true, or was taken out of context.' But looking back, she continued, 'I can see that it did affect our relationship. I was at an age when I was really insecure, but in retrospect I'm grateful for the experience. By the time I was twenty-one, nothing could faze me.

It would be early 1998 before Winona was again publicly involved. This time with *Good Will Hunting* star Matt Damon. As usual, she had nothing to say on the matter. The Hollywood grapevine however was quick to notice that the couple were keeping company with each other ever since Gwyneth Paltrow, now romantically linked with Damon's childhood friend, co-star and screenwriting partner, Ben Affleck, introduced Winona to Damon after he had broken off dating *Good Will Hunting* leading lady, Minnie Driver. Something he confirmed on a television appearance on the Oprah Winfrey talk show when he freely admitted on air that he was again single and unattached. No explanations were offered, however, even though some reports were suggesting that he apparently broke off dating Driver to be with Winona as a result of Paltrow pairing the couple up after double dating Damon and Driver, and thinking he would like Winona better. But according to some, it was just Paltrow's way of patching up her friendship after the *Shakespeare in Love* debacle.

Whatever the reasons, it was probably Winona's appearance at Morton's *Vanity Fair* Oscar party and meeting up with Damon inside that revealed what press speculation had been insisting on for weeks – that she and Matt Damon were indeed 'seriously dating.' Within the month, the *New York Post* was reporting as much. But still Winona had nothing to say on the subject. What she did do,

however, was reinforce that the stories of her dating everyone from David Duchovny to Johnny Zander had simply been untrue. 'I had like two dates in the last year,' vowed Winona, 'and they weren't with anyone famous. If I was getting all the action they say, I would die.' Besides, she added, 'a date doesn't mean you kiss or sleep with the person.'

Elsewhere, there were reports that the couple were playing house in Winona's new Beverly Hills home, a 1930s eight bedroom Spanish styled property with panoramic city to ocean views that she purchased around the same time, and even one of those pervasive "friends" who always seem to be on hand to comment on showbiz affairs of the heart confirmed they were already inseparable. 'Their relationship is very sweet and loving and very new love.'

They were even spotted, as one journalist put it, 'stocking up on household goods as they strolled around local shops looking just like any other young couple in love.' That maybe true, but for the time being, at least, it was apparent that Winona and Damon were not in a hurry to scream their business from the top of the Hollywood Hills.

Neither were they in a hurry to offer any confirmation to stories of being engaged. From her first very public relationship with Depp, she had adhered to the lessons of public scrutiny, and how never to let her guard down. 'You learn always to leave and go places separately, live like a spy, and make plans like "Meet you at two o'clock by the restroom of the Cineplex." And you learn never to talk about it.' Even journalists were warned that Matt Damon was strictly off-limits for discussion. But According to *Now* magazine, Damon had traditionally asked Winona's father before he had even asked Winona, proposed to her on one knee, given her a solid gold engagement band and was now ready to name the day for what journalist Simon Trent called 'a match made in Hollywood.'

Although for the moment Winona simply let the speculation drift over her head, she was less reticent, of course, on the subject

of her career. 'I feel I'm in a great position because I started out very young and I've never been in any big blockbuster that was a success because of me. *Dracula* wasn't a hit because I was in it, and if *Beetlejuice* was successful, it was because it was a Tim Burton movie.' More than that, Winona continues, 'I was always the girl from *Beetlejuice,* or *Heathers* or *Mermaids.* Audiences got to know me as a person and not a star. When people approach me on the street, it's very familiar, it's like they know me, like "Oh hi!" so I don't feel so threatened.'

It was an observation shared by two of America's most respected film critics, Scott and Barbra Seigel. 'She remains a movie star in the truest sense of the word and brings with her attributes that few other celebrities have. Intelligence, friendliness, and approachability.' That certainly seems to be true. 'If I got more famous,' says Winona, 'it would be very hard to live my life.' That too maybe the key to her success. For Winona is now in the viable position of not having to worry about how others see her. As long as she is happy with her performance, that is all that matters. It is a remarkably mature attitude for someone so young. All the more so since Winona works in an industry that appears to discourage such individuality.

Equally true is her promising future. Promising because whatever she chooses to do, her own instincts will remain sharp, and her own abilities intact. 'I'll read something and I want to do it, or I won't want to do it. If I have to think about it, I know I shouldn't do it. It's usually a bad sign when an actor agonises over whether or not to do something.'

Besides, she continues, 'a well-written script is the most important thing, although sometimes you get in trouble if you commit to a good idea that isn't on paper yet, but it is all a good learning process.' That alone will ensure that Winona Ryder will remain the most important and admired of all actresses in Hollywood.

Filmography

Lucas (1986)

USA 1986. 104 minutes. Written and Directed by David Seltzer. Production Company: Twentieth Century Fox. Cast: Corey Haim (Lucas), Kerri Green (Maggie), Charlie Sheen (Cappie), Courtney Thorne-Smith (Alise), *Winona Ryder (Rina),* Thomas E Hodges (Bruno), Guy Boyd (Coach), Jeremy Piven (Spike), Kevin Gerard Wixted (Tonto).

US Box Office: $ 8.0 million

Square Dance (1987) [Also known as Home Is Where The Heart Is]

USA, 1987. 112 minutes. Directed by Daniel Petrie. Screenplay by Alan Hines. Production Company: Island Pictures. Cast: Jason Robards (Dillard), Jane Alexander (Juanelle), *Winona Ryder (Gemma),* Rob Lowe (Rory), Deborah Richter (Gwen), Guich Koock (Frank), Elbert Lewis (Beecham), Charlotte Stanton (Aggie).

US Box Office: $ 0.2 million

Beetlejuice (1988)

USA, 1988. 92 minutes. Directed by Tim Burton. Screenplay by Michael McDowell and Warren Skarren. Production Company: The Geffen Film Company. Cast: Alec Baldwin (Adam Maitland), Geena Davis (Barbara Maitland), Jeffrey Jones (Charles Deetz), Catherine O'Hara (Delia Deetz), *Winona Ryder (Lydia Deetz),* Sylvia Sidney (Juno), Robert Goulet (Maxie Dean), Glen Shadix (Otho), Maurice Page (Ernie), Michael Keaton (Betelguise).

US Box Office: $ 73.3 million

1969 (1988)

USA, 1988. 93 minutes. Directed by Ernest Thompson. Screenplay by Ernest Thompson. Production Company: Atlantic Entertainment Group. Cast: Kiefer Sutherland (Scott), Robert Downey Jnr (Ralph), *Winona Ryder (Beth),* Bruce Dern (Cliff), Joanne Cassidy (Ev), Marjette Hartley (Jessie), Christopher Wynne (Alden).

US Box Office: $ 5.0 million

Heathers (1989)

USA 1989. 102 minutes. Directed by Michael Lehmann. Screenplay by Daniel Waters. Production Company: New World Pictures. Cast: *Winona Ryder (Veronica Sawyer),* Christian Slater (Jason Dean), Shannon Doherty (Heather Duke), Kim Walker (Heather Chandler), Lisanne Falk (Heather McNamara), Penelope Milford (Pauline Fleming), Glenn Shadix (Father Ripper), Lance Fenton (Kurt Kelly), Patrick Labyorteaux (Ram).

US Box Office: $ 1.1 million

Great Balls of Fire (1989)

USA 1989. 102 minutes. Directed by Jim McBride. Screenplay by Jack Baran and Jim McBride, based on the book by Myra Lewis with Murray Silver. Production Company: Orion Pictures. Cast: Dennis Quaid (Jerry Lee Lewis), *Winona Ryder (Myra Gale Lewis),* John Doe (J W Brown), Stephen Tobolowsky (Jud Phillips), Trey Wilson (Sam Phillips), Alec Baldwin (Jimmy Swaggart), Lisa Blount (Lois Brown).

US Box Office: $ 13.7 million

Welcome Home, Roxy Carmichael (1990)

USA 1990. 98 minutes. Directed by Jim Abrahams. Screenplay by Karen Leigh Hopkins. Production Company: Embassy/ITC Entertainment Group/Nelson Entertainment. Cast: *Winona Ryder (Dinky Bossetti)*, Jeff Daniels (Denton Webb), Laila Robins (Elizabeth Zaks), Thomas Wilson Brown (Gerald Howells), Joan McMurtey (Barbara Webb), Graham Beckel (Les Bossetti), Francis Fisher (Rochelle Bossetti).

US Box Office: $ 3.5 million

Mermaids (1990)

USA 1990. 111 minutes. Directed by Richard Benjamin. Screenplay by June Roberts, based on the novel by Patty Dane. Production Company: Orion Pictures. Cast: Cher (Mrs Flax), Bob Hoskins (Lou Landsky), *Winona Ryder (Charlotte Flax)*, Christina Ricci (Kate Flax), Michael Schoeffling (Joe Peretti), Caroline McWilliams (Carrie), Jan Miner (Mother Superior), Betsy Townsend (Mary O'Brien).

US Box office: $ 35.1 million

Edward Scissorhands (1990)

USA 1990. 90 minutes. Directed by Tim Burton. Screenplay by Caroline Thompson, based on a story by Tim Burton and Caroline Thompson. Production Company: Twentieth Century Fox. Cast: Johnny Depp (Edward Scissorhands), *Winona Ryder (Kim Boggs)*, Dianne Wiest (Peg Boggs), Anthony Michael Hall (Jim), Kathy Baker (Joyce Monroe), Robert Oliveri (Kevin Boggs), Vincent Price (The Inventor), Alan Arkin (Bill Boggs).

US Box Office: $ 54.2 million

Night On Earth (1991)

USA/Japan 1991. 125 minutes. Directed by Jim Jarmusch. Screenplay by Jim Jarmusch. Production Company: JVC Entertainment/Locus Solus. Cast: Gena Rowlands (Victoria Snelling), *Winona Ryder (Corky)*, Lisanne Falk (Rock Manager), Alan Randolph Scott (Rock Musician), Anthony Portillo (Rock Musician).

US Box Office: $2.0 million

Bram Stoker's Dracula (1992)

USA 1992. 120 minutes. Directed by Francis Ford Coppola. Screenplay by Jim Hart, based on the novel by Bram Stoker. Production Company: Columbia Pictures. Cast: Gary Oldman (Dracula), *Winona Ryder (Mina Murray/Elisabeta)*, Anthony Hopkins (Van Helsing), Keanu Reeves (Jonathan Harker), Sadie Frost (Lucy Westerna), Richard E Grant (Dr Jack Seward), Bill Campbell(Quincey P Morris), Tom Waits (R M Renfield).

US Box Office: $ 82.4 million

The Age of Innocence (1993)

USA 1993. 139 minutes (USA). 133 minutes (UK). Directed by Martin Scorsese. Screenplay by Jay Cocks, Martin Scorsese, based on the novel by Edith Wharton. Production Company: Columbia Pictures. Cast: Daniel Day-Lewis (Newland Archer), Michelle Pfeiffer (Ellen Olenska), *Winona Ryder (May Welland)*, Richard E Grant (Larry Lefferts), Alec McCowen (Sillerton Jackson), Geraldine Chaplin (Mrs Welland), Mary Beth Hurt (Regina Beaufort).

US Box Office: $ 32.0 million

The House of the Spirits (1993)

Denmark/Germany/Portugal 1993. 145 minutes. Directed by Bille August. Screenplay by Isabel Allende and Bille August, based on the novel by Isabel Allende. Production Company: Costa do Castelo Filmes/House of Spirits Film/Neue Constantin Film. Cast: Meryl Streep (Clara), Jeremy Irons (Esteban Trueba) Glenn Close (Ferula), *Winona Ryder (Blanca)*, Antonio Banderas (Pedro), Vanessa Redgrave (Nivea), Vincent Gallo (Esteban Garcia).

US Box Office: $ 6.3 million

Reality Bites (1994)

USA, 1994. 99 minutes. Directed by Ben Stiller. Screenplay by Helen Childress. Production Company: Universal. Cast: *Winona Ryder (Lelaina Pierce)*, Ethan Hawke (Troy Dyer), Janeane Garofalo (Vickie Miner), Steve Zahn (Sammy Gray), Ben Stiller (Michael Grates), Swoosie Kurtz (CharleneCharlene McGregor), Harry O'Reilly (Wes McGregor).

US Box Office: $20.0 million

Little Women (1994)

USA 1994. 115 minutes (USA). 118 minutes (UK). Directed by Gillian Armstrong. Screenplay by Robin Swicord, based on the novel by Louisa May Alcott. Production Company: Columbia Pictures/Di Novi Pictures. Cast: *Winona Ryder (Jo March)*, Gabriel Byrne (Friedrich Bhaer), Trini Alvardo (Meg March), Samantha Mathis (Amy March as an adult), Kirsten Dunst (Amy March age 10), Claire Danes (Beth March), Christian Bale (Laurie), Eric Stoltz (John Brooke), John Neville (Grandpa Lawrence).

US Box Office: $ 50.0 million

How To Make An American Quilt (1995)

USA 1995. 109 minutes. Directed by Jocelyn Moorhouse. Screenplay by Jane Anderson, based on the novel by Whitney Otto. Cast: *Winona Ryder (Finn),* Maya Angelou (Anna), Anne Bancroft (Glady Joe), Ellen Burstyn (Hy), Kate Nelligan (Constance), Jean Simmons (Em), Lois Smith (Sophia), Alfre Woodard (Marianna), Dermot Mulroney (Sam), Johnathon Schaech (Leon), Rip Torn (Arthur), Denis Arnot (James), Derrick O'Connor (Dean), Sammantha Mathis (Young Sophia).

US Box Office: $ 23.6 million

Looking For Richard (1996)

USA 1996. 108 minutes. Directed by Al Pacino. Screenplay by Al Pacino. Production Company: Twentieth Century Fox. Cast: Al Pacino (Richard III), Estelle Parsons (Queen Margaret), Alec Baldwin (Clarence), Kevin Spacey (Buckingham), *Winona Ryder (Lady Anne),* Aidan Quinn (Richmond), Penelope Allen (Queen Elizabeth), Kevin Conway (Hastings), Harris Yulin (King Edward).

US Box Office: $ 1.2 million

Boys (1996)

USA 1996. 82 minutes. Directed by Stacy Cochran. Screenplay by Stacy Cochran, based on the short story "Twenty Minutes" by James Salter from his book "Dusk". Production Company: Polygram Filmed Entertainment/Interscope Communications. Cast: *Winona Ryder (Patty Vare), Lukas* Haas (John Baker Jnr), John C Reilly (Officer Kellogg Curry), James Legros (Fenton Ray), Skeet Ulrich (Bud Valentine), Spencer Vrooman (John Murphy).

US Box Office: $ 0.5 million

The Crucible (1996)

USA 1996. 124 minutes. Directed by Nicholas Hytner. Screenplay by Arthur Miller. Production Company: Twentieth Century Fox. Cast:Daniel Day-Lewis (John Proctor), *Winona Ryder (Abigail Williams)*, Paul Scofield (Judge Danforth), Joan Ellen (Elizabeth Proctor), Bruce Davison (Reverend Parris), Rob Campbell (Reverend Hale), Jeffrey Jones (Thomas Putnam), Frances Conroy (Ann Putnam), Charlayne Woodard (Tituba), George Gaynes (Judge Sewall), Peter Vaughan (Giles Corey).

US Box Office: $ 7.3 million

Alien Resurrection (1997)

USA 1997. 104 minutes. Directed by Jean-Pierre Jeunet. Screenplay by Joss Whedon. Production Company: Twentieth Century Fox. Cast: Sigourney Weaver (Ripley), *Winona Ryder (Call)*, Dominique Pinon (Vriess), Ron Perlman (Johner), Gary Doudan (Christie), Michael Wincott (Elgyn), Kim Flowers (Hillard), Dan Hedaya (General Perez), J E Freeman (Dr Wren).

US Box Office: $47.8 million

Celebrity (1998)

USA 1998. Black and white. Directed by Woody Allen. Production Company: Magnolia Productions Inc and Sweetland Films B.V.Screenplay by Woody Allen. Cast: Hank Azaria (David), Kenneth Branagh (Lee Simon), Judy Davis (Robin Simon), Leonardo DiCaprio (Brandon Darrow), Melanie Griffith (Nicole Oliver), Famke Janssen (Bonnie), Michael Lerner (Dr Lupus), Joe Manegna (Tony Gardella), Bebe Neuwirth (Hooker), *Winona Ryder (Nola)*, Charlize Theron (Supermodel).

US Box Office: $ 5.0 million

Nominations and Awards

Golden Globe

1991 – *Mermaids* -Nominated for Best Supporting Actress

1994 – *The Age of Innocence* – Nominated for Best Supporting Actress – *Winner*

Academy Awards

1994 – *The Age of Innocence* – Nominated for Best Supporting Actress

1995 – *Little Women* – Nominated for Best Actress

Grammy

1996 – *Anne Frank's The Diary of a Young Girl* – Nominated for Best Spoken Performance for Children

National Board of Review

1990 – *Mermaids* – Nominated for Best Supporting Actress – *Winner*

1993 – *The Age of Innocence* – Nominated for Best Supporting Actress – *Winner*

Miscellaneous

1990 – ShoWest Awards – Nominated for Female Star of Tomorrow – *Winner*

1990 – Independent Spirit Awards – *Heathers* – Nominated for Best Female Lead

1994 – British Academy Awards (BAFTA) – *The Age of Innocence* – Nominated for Best Supporting Actress

1995 – Independent Spirit Awards – *Heathers* – Nominated for Belated Best Actress

1997 – ShoWest Awards – Nominated for Actress of the Year – *Winner*

1997 – Motion Picture Club – Nominated for Female Star of the Year – *Winner*

1997 – American Conservatory Theatre – Honorary Master of Fine Arts Degree

1998 – Blockbuster Entertainment Awards – *Alien Resurrection* – Nominated for Favourite Supporting Actress: Science Fiction – *Winner*

Miscellaneous Appearances

1989 – *Debbie Gibson Is Pregnant With My Two Headed Love Child* – Cameo in Mojo Nixon music video

1990 – *The Shoop Shoop Song* – Cameo in Cher music video

1992 – *Without A Trace* – Cameo in Soul Asylum music video

1993 – *U2 Zoo-TV Tour* – Cameo in "Desire" video footage

1994 – *The Simpsons* – Episode 105: "Lisa's Rival" – Guest voice-over

1994 – *Nature's Way* – Director for Victoria Williams music video

1995 – *The Diary Of A Young Girl by Anne Frank* – Spoken word performance for audio book publication

1996 – *Dr Katz* – Episode 301: "Pickups" – Cartoon spoof and guest voice-over

1996 – *The Works: Video Diaries of Richard E Grant* – Cameo in UK television documentary

1998 – *The Vagina Monologues* – New York stage performance

1999 – *Christopher Reeve: A Celebration of Hope* – Cameo in US television special

1999 – *Talk About The Blues* – Cameo in Jon Spencer Blues Explosion music video

1999 – Survivors: Testimonies of the Holocaust – CD-Rom Spoken word performance (with Leonardo DiCaprio)

1999 – *The Larry Sanders Show* – Episode: The List – Guest television appearance

Also Available from Andrews UK

Demi Moore
The Most Powerful
Woman in Hollywood

by Nigel Goodall

From her Hollywood debut at the age of 19 to her latest venture, this biography traces the events and circumstances that have shaped Demi Moore's extraordinary character and propelled her from aspiring model to movie superstar. The book describes Demi's troubled childhood and her crusade to quit high school to find a career in modelling, as well as the trauma of her stepfather's suicide two years later. It reveals the truth behind her relationship with actor Emilio Estevez and why she broke off their engagement, her up-and-down relationship with husband Bruce Willis and her alleged affair with Leornardo DiCaprio. It also: relates how Demi's drug and alcohol addiction almost led to her departure from the set of "St Elmo's Fire"; looks at the history behind her nude appearances both on and off screen; and details behind-the-scenes information from the sets of her movies past and present, including her roles in "Indecent Proposal", "Striptease" and Woody Allen's "Deconstructing Harry".

Also Available from Andrews UK

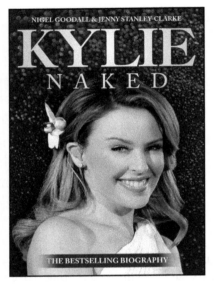

Kylie
Naked

by Nigel Goodall

Kylie Naked is the bestselling biography of Kylie Minogue. First published in 2002 to coincide with her massive Fever arena tour of the UK and Europe, the book was the first to tell the story of her well publicised relationships with Michael Hutchence, Jason Donovan and James Gooding. From Neighbours to Stock Aitken and Waterman to her disco revival at the top of the charts, this intimate biography, applauded by Kylie's manager for its accuracy, explores the real woman behind the public image. Drawn from interviews with key players in the industry, Kylie, friends and colleagues, Kylie Naked was the first book to delve into the real Kylie, from her success as a soap star to her assault on the UK charts, and to this day is still regarded as the most authorative and in-depth portait of one of pop music's most private stars.

Lightning Source UK Ltd.
Milton Keynes UK
UKHW020346111019
351362UK00010B/2226/P